REDUCE
£2.

CW00493613

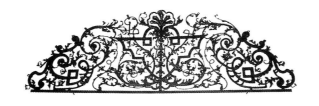

ART METALFORGING

David Hawkins

A&C BLACK

LONDON

First published in Great Britain 2002
A & C Black Publishers Limited
Alderman House
37 Soho Square
London W1D 3QZ

www.acblack.com

ISBN 0-7136-4948-8

A CIP catalogue record for this book is available from the British Library

David Hawkins has asserted his right under the Copyright, Design and Patents Act, 1988,
to be identified as the author of this work

Cover illustrations:
Front: Early ironwork by Albert Paley, completed on a study visit to Manfred Bredohl's Vulkanschmiedein Aachen, Germany
Back: Waterfall Chandelier by Peter Osborne, 1998. Glass by Neil Wilkin

Cover design by Dorothy Moir
Designed by Penny and Tony Mills

Printed and bound in Singapore by Tien Wah Press Limited

A & C Black uses paper produced with elemental chlorine-free pulp, harvested from managed sustainable forests

Contents

Acknowledgements

Particular thanks to my wife Clare and sons Martin and Felix for their support, tolerance and help. Special thanks to my parents for all their help and support – and in particular my father Neil, whose skill, artistry and dedication provided the inspiration for this work. Linda Lambert and Michelle Tiernan at A & C Black for their encouragement and help. Professor David Jeremiah of the University of Plymouth for supervising my PhD. Paul Allen and the Productivity section of the Rural Development Commission (now the Countryside Agency) for help, access to the library and material. Marian Campbell and the Victoria and Albert Museum for help and material. Dick Quinnell for his advice and assistance. Alan Evans for material and conversation. Jim Horrobin for supplying so much material. Keith and Treez Thomas for hospitality, material and help. BABA and it's members for inspiration and friendship. Courtenay Paull - Past Master of the Wessex Guild. David Buss, of the Kent Institute of Art and Design for support and encouragement. The late Tommy Tucker for interviews, comment and encouragement. Albert Paley for inspiration. Serge Marchal, for hospitality and help. David Petersen for help and inspiration. Guisseppe Lund for help inspiration and many emails. Musée le Secq des Tournelles, Rouen, France for allowing me to photograph their exhibits. Serge Pascal of Metalliers Champenois, France for material. Oskar Hafen, Matthias Peters and the late Manfred Bredohl of Germany for help, inspiration and conversation. Sam Garbutt and Dean Wilson for assistance and material. David Patten and Plymouth College of Art and Design for material and encouragement. Adrian Legge of Hereford Technical College for material, hospitality and help. Peter Osborne, Malcolm Chave, Terrence Clark and Raymond Morales for material. Les Compagnons Du Devoir for assistance and material. Mike Petersen, Tracey Clement, Yori Kharlamov and Heigo Jelle for material.

This book is dedicated to Clare, Martin and Felix.

Preface

The title *Art Metalforging* was chosen to reflect the changes which have taken place during the last 25 years or so in the practice of handmade or craft metalforging. Having said that, most of the work featued is by those who would describe themselves as blacksmiths of one sort or another. A blacksmith, historically, is one who smites, or smiths, iron (also known as 'black metal'). Work displaying a variety of social, functional and artistic intentions is featured but all of the makers share an enthusiasm and empathy for working metal in a plastic state – metalforging.

Makers using stainless steel, non-ferrous metals, or metals in conjunction with other materials

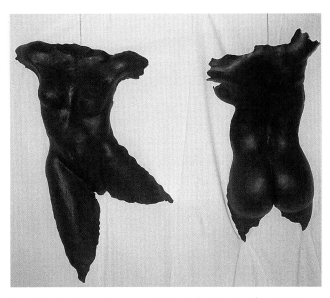

Steel body forms shown at Stia, Italy, September 2001

such as glass, wood and ceramics, have produced some exciting and innovative pieces in recent years. Much of this work builds directly upon the working methods and traditions of the blacksmith, and is made by artist blacksmiths. Historical and cultural developments are considered and there is a brief look at some of the many parallels and links with the changes brought on by industrialisation, in particular, the changes in the work and practices of the blacksmith in the 20th century.

A technical chapter gives an overview of blacksmithing methods and equipment; it is not intended to be a comprehensive how-to guide, but it does describe the basic techniques by which the pieces illustrated were made. I hope this will lead to a greater appreciation of the skill and artistry used in the production of forged metalwork.

The later chapters show the work of makers from a number of countries creating work in a variety of ways and on different scales. Workshops, drawings and part-finished work are also shown, as they can give insight into intentions and working practices. There are many thousands of talented and committed makers and designers worldwide, and a book of this size can only provide a brief introduction to some of the strands of practice and some of the more interesting work. A bibliography lists a number of other publications and electronic sources that might be of interest.

Gate latch at Hore Oak in the middle of Exmoor, UK –
an example of a simple and elegant utilitarian piece.

There have been blacksmiths in my family for at
least the last 250 years, so I grew up with forge work.

My father's old forge used to have a hearth with a
hand blower, and at an early age I learnt how to
control the blast and work the fire for decorative work
or for making horseshoes for the week's shoeing
(farriery). The new forge, now over 20 years old, has a
coal forge with an electric blower, a ceramic chip
forge, power hammer, lathes, pillar drills, and a
variety of welding, cutting and forming equipment, in
line with many other modern blacksmith's shops. The
way in which my father's blacksmithing practice has
changed over the last 50 years or so mirrors many of
the changes in blacksmithing generally; a description
of this forms a short chapter of the book.

This publication is developed from work I did
for my PhD thesis *The Trade Manufacture and Design of
English Blacksmithing in the Post War Period*. However,
many of the conclusions, and much of the material is
new, in particular that from other countries, such as
Australia, Germany, France, USA, Russia, and
Canada, reflecting the many worldwide links that
exist between blacksmiths and other artists and
makers working in metal.

Some Historical Issues...

Until recently, blacksmithing has generally been more functional than artistic. This book discusses the extent to which the demise of traditional practices and products, allied to recognition of the expressive potential of forged metalwork, has led to the rise of the artist blacksmith. As the agricultural and industrial need for blacksmithing has declined, so there has been an increasing demand for bespoke and innovative ironwork. Starkie Gardner noted in 1892 (in *Ironwork Part 1*, V&A): 'It [iron] is the cheapest and most ubiquitous of metals, lacking, moreover, many of the intrinsic qualities of the precious metals, it nevertheless immeasurably surpasses the whole of them together in interest and in its value and utility to us.'

Alex Bealer, in his book *The Art of Blacksmithing* – one of the catalysts of the revival in interest in blacksmithing in the USA in the 1970s – summarised blacksmithing's dilemma:

Too often ironworking is referred to as a trade rather than an art. Actually it is both. Utility articles were so important to the progress of society all over the world that the trade aspects of the blacksmith's work dominated the aesthetic aspects in the public eye. Only so many men had the talent to be good blacksmiths, and, regardless of how artistic

their intentions, they were needed to supply the tools and weapons and hardware of society.

The historical section of this book considers the slow development of blacksmithing as a creative practice. The continued association with farriery, agriculture and industry, and the mass production by fabricators of reproduction ironwork, usually cold-bent, can be seen as detrimental.

The roots of modern practice in continental Europe and the USA.

The roots of contemporary artist blacksmithing practice lie both in traditional values and techniques, and in a pragmatic, forward-looking view of the smith's role following from developments in Europe and the USA. These developments have had fundamental and positive effects upon practice worldwide.

Modern day metalcraft has its origins in the early Mediterranean civilisations, developing first with copper and bronze, and then with the much rarer iron 'black metal'. At first, iron was rare and used for ornamental and similar purposes, and tools – iron from meteorites was highly prized for ornamental wares. It is possible that iron was a by-product of the production of ceramic ware, and later

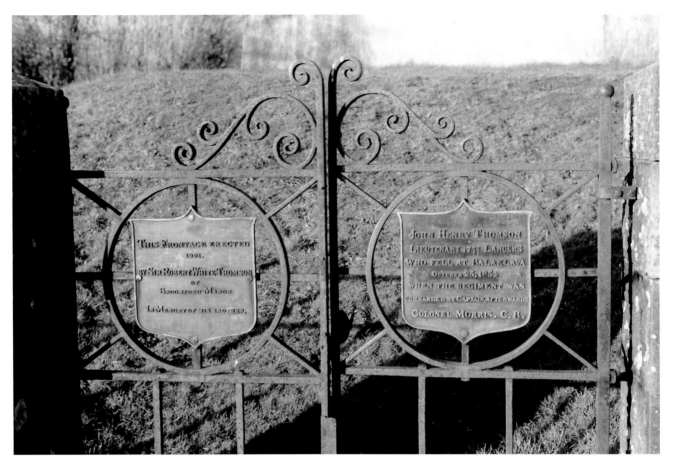

(*Above*) Entrance gates to a memorial to commemorate a John Thomson who died at the battle of Balaclava. Hatherleigh Moor, Devon, UK.
(*Right*) Simple window grille, Domme, France.
(*Opposite page*) One of the famous doors of Nôtre Dame Cathedral, Paris, France. A 19th century replica of 12th century original ironwork. The door furniture is forged, stamped, fullered, chiselled and punched for decorative effect.

of copper alloys, where high temperatures and a reductive atmosphere might result in metallic iron being made. Eventually, techniques were developed to smelt it in larger quantities from iron ore, although for many thousands of years these processes could only yield a little iron at a time. Its comparative rarity in metallic form and its utility for weapons and tools made iron a valuable material, so that the techniques developed for working it were intended to use the material carefully and economically.

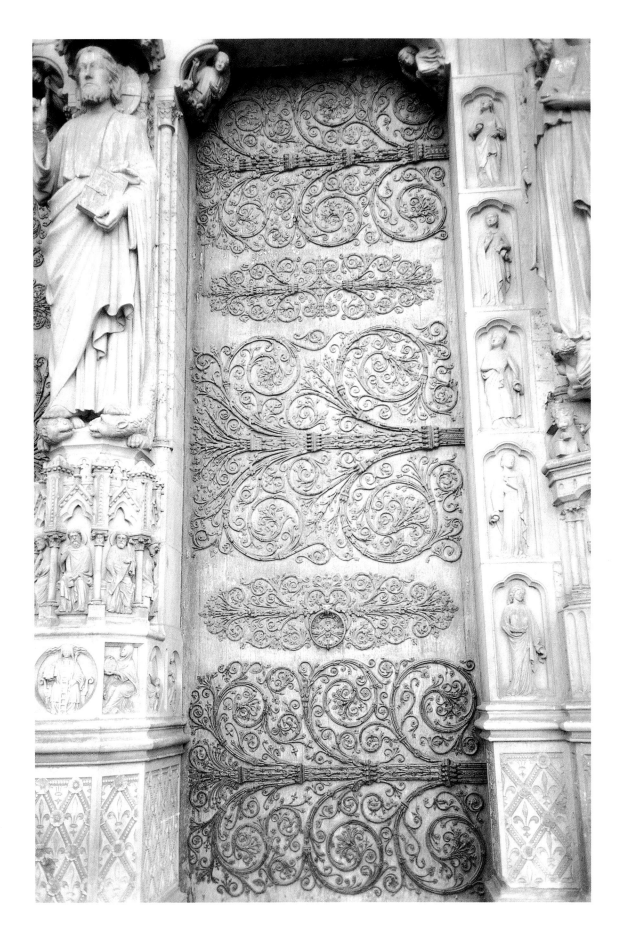

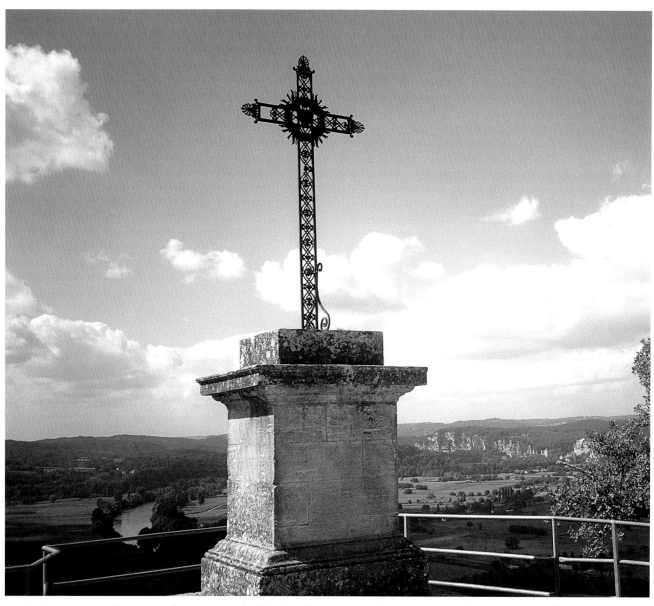

An iron cross at Domme, a former stronghold of the Knights Templar overlooking the Dordogne valley in France.

The basic principles of forging, developed during iron's early use still apply today – although the form and scale of work has changed considerably. Myths and legends developed around blacksmithing – particularly about the gods Thor and Hephaestus. These were often linked to explanations of thunderstorms and volcanoes. Much of the very early ironwork has not survived in Europe – although some very impressive early work survives in India. Much surviving older work tends to be from after the 12th century and is associated with churches – and in particular, church doors and their hinges and fittings.

Tom Joyce described, in *Life Force at the Anvil* which was published on the *ArtMetal* web-site, the ritual significance both of the work produced by blacksmiths and the blacksmiths themselves, amongst the Dogon people of western Africa. Dogon priests use ritual iron objects; for example, a ceremonial adze is seen as a means to connect to the spirit world, alongside bells and ladders. The iron smelting process itself and the form of the furnaces are all

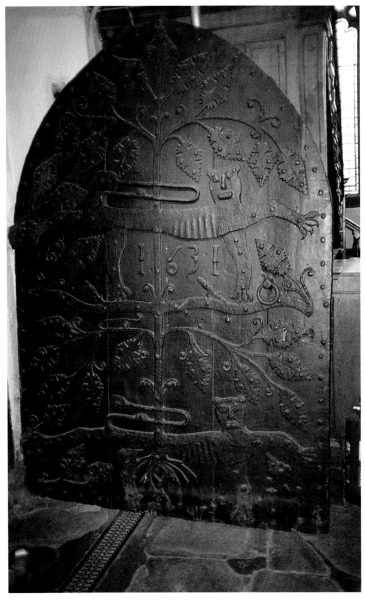

An ancient entrance door at Dartmouth Church, Devon, UK. Much of the oldest ironwork is to be found on old doors, but not many doors are as spectacular.

regarded as having symbolic significance. Iron smelting and forging reached Africa at around 500bc, after being developed by the Hittites, some 1000 years earlier. Later in 15th century Africa iron began to be used as a popular trading token, linked to the slave and spice trades – a practice also found in other countries and continents.

As the use of iron evolved, specialist skills and techniques allowed its use for a wide variety of tools, equipment and weapons. The development of the iron plough-share was vital to the success of agriculture; nails, hammers, saw, files, drills, fish-hooks, cooking implements, wagon fittings and tyres for cartwheels were essential in other aspects of daily life. The ability of iron to be hardened was important in the refinement of weapons and edge tools in particular. Specialisms grew throughout the world, and within regions and countries, trade and conflict were responsible in part for their development and for communication about them. Stunningly effective and beautiful swords were made from early times in Japan, and in the Damascus area, for example.

Some examples of work from Roman times are preserved in museums, but rather more from later periods. For example, the tent rings and supports in the Viking Ship Museum in Oslo, Norway, and the Viking swords and other artefacts such as shackles in the National Museum of Ireland in Dublin. The 12th century screen in Hildesheim Cathedral, gate at Lüneburg, the door of Erfurt Cathedral, and the artefacts in the National Museum in Nuremburg, all provide examples of high quality early work in Germany. Early church work in the UK includes the doors of Dartmouth Church in Devon, and at Stillingfleet in Yorkshire.

German work from Renaissance times has been described by Zimelli and Vergerio as calligraphic and influenced by draughtsmen such as Dürer and Martin Schongaurer. The Augsberg Cathedral choir screen is seen as a fine example of the style – work of this period held in the Victoria and Albert Museum in London also shows the influence of the drawn line and uses round iron sections with extensive interlinking via key-punched holes. There has been a fine tradition of ironwork in Germany over the centuries and it is hardly surprising that much recent work has been influenced by it.

Baroque ironwork throughout Europe was influenced by Jean Lamour's ironwork for the Place Stanislas at Nancy – restored in the 1980s by

18 - GRILLE DE CHOEUR
Abbaye d'Ourscamps (Oise, vers 1202

8

Metaliers Champenois. This flamboyant style made extensive use of flat work, scrolls and repoussé features and through Jean Tijou had a fundamental and enduring impact upon the style of ironwork in the UK. In Germany, the gothic tradition continued in parallel with the development of baroque styles.

Although decorative elements were common in early work, straight bars often featured. Before the advent of slitting and rolling mills, straight bars had to be forged by the smith in the section required – a process requiring considerable effort and time. This contrasts with more recent times and the provision of the accurate sections of metal used by most smiths today as raw material – the sections of material are controlled and produced industrially, and then changed to fit the design intention.

Smooth surfaces, free of hammer marks, were regarded until recently by many smiths as being an indication that a piece has been well made – in line with the difficulty of achieving this. The very careful control of tapers and sections was a feature of the very best quality work in the baroque style, exemplified by the work of Jean Tijou and his associates for St. Paul's Cathedral and Hampton Court Palace in the UK.

The value of skills in a pre-industrial economy was great and guilds and associations grew to protect what were known as 'the secrets and mysteries of trades'. In Europe the mechanisation and better organisation of agriculture, improved food production and made available the workforce required to exploit the technological advances following the 18th century. The 19th century development of industrial processes led to many craft processes being superseded by mass-production. An effect of this was to put out of business smiths whose work was wholly replaced by cheaper mass-produced products. Industrialisation also forced craft makers to become increasingly specialised or to concentrate upon bespoke work; some smiths worked in industrial forges, workshops and shipyards; some managed to continue as rural general blacksmiths. The Chatham Historic Dockyard in Kent in the UK, once one of the Royal Navy's foremost bases, now houses many historic buildings and artefacts – amongst them is the massive *Number One Forge*, once used to produce anchors, chains and fittings for warships

Around the end of the 19th century there was

(*Above*) Handrail by Brian Russell for the Fe exhibition, 1996.
(*Opposite page*) Screen from the 13th century, Rouen, France.

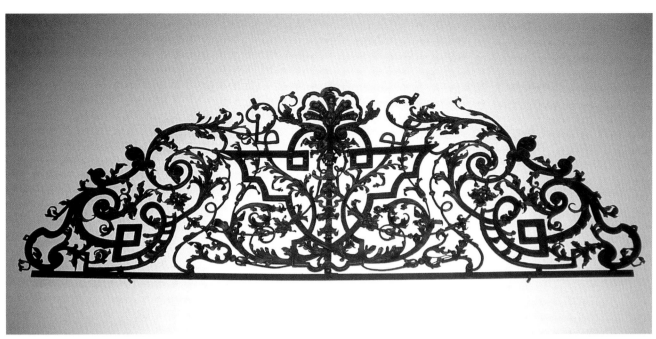

(*Top*) Decorative piece from the V&A's ironwork gallery
(*Above*) Decorative feature, Tournelles Museum, Rouen.

something of a revival in the artistic working of iron. The building styles of the day – including *Arts and Crafts* influenced and *Art Nouveau* styles lent themselves to the decorative use of forged iron – as opposed to cast alternatives. The work of Emile Roberts was well received at the Paris Exhibition of 1889. At the same time Edgar Brandt and his contemporaries were doing much high quality work, and Victor Horta was designing some exciting ironwork in Belgium. Antonio Gaudi – the son of a blacksmith – embellished his wonderful buildings with original and exciting ironwork – much of it even now seems adventurous in style and technique. With the exception of the excellent work of Charles Rennie Mackintosh and his Glasgow contemporaries, for example at the Glasgow School of Art, this work in broadly Art Nouveau styles sadly had little impact in the UK.

The gradual change from the power of the horse to mechanical horsepower clearly changed the work of rural blacksmiths who depended upon farriery for a substantial part of their income. As Williams noted of UK smiths in *The Country Craftsman*:

> In the nineteenth century many rural craftsmen worked for country estates; their welfare was largely the concern of the squire and the large landowner. Others were village craftsmen who catered for the needs of their own localities; the growth of industry and transport was only beginning to threaten their livelihood when the century ended. In the next ten years cheap rapid transport and increasing quantities of factory-made goods brought competition to the village craftsmen's doorstep and their numbers began to decline. At the same time estates were being split up into single farms and their craftsmen were forced to fend for themselves.

The war years 1914–1918 were to provide an interlude of demand in Europe, with many farriers serving at the Front, where horses were often the main or only viable means of transport. Others did war work, others still made do and mended, and addressed the needs of farmers. In the post-war years farm prices fell, and tax and other factors caused the break up of many farms and businesses. This accelerated the problems facing rural crafts and industries.

Despite these changes in the rural economy through farm mechanisation and the increased popularity of motor transportation, the work of the country general blacksmith was still very much determined by the agricultural cycle: spring tilling, hay, corn, root crops, winter. In winter, there was the shoeing of horses for hunting and not much else, so there was time for ironwork and tool making. Spending only part of the year working on wrought ironwork, and not having any education in design, it is not surprising that the pieces made during these winters tended to be derivative of, or identical to, previous or established work.

The rapid wartime mechanisation of farming had provided much repair work, in particular of tractors, whilst reducing the work in repairing horse-drawn equipment. Employment in farming was affected both by mechanisation and improvements in fertilisers, both of which made the land more productive. Bailey (*Journal of Design History*, 9, 1996) noted that tractors in the 1930s: '…were still a rarity in fields managed by 'horse and hand', numbering only 60,000 in 1939. By 1945 the 'lend lease' scheme to support self-sufficiency in food during wartime had put 260 000 tractors on the land.'

Alessandro Mazzucotelli, founder of the Monza Higher Institute of Decorative Arts, was responsible for some very attractive work both in Europe and South America. He was enthusiastic about the authentic work of the smith, as he saw it, being true to the nature of the material and using fire and hammer to form it. This approach to truth to

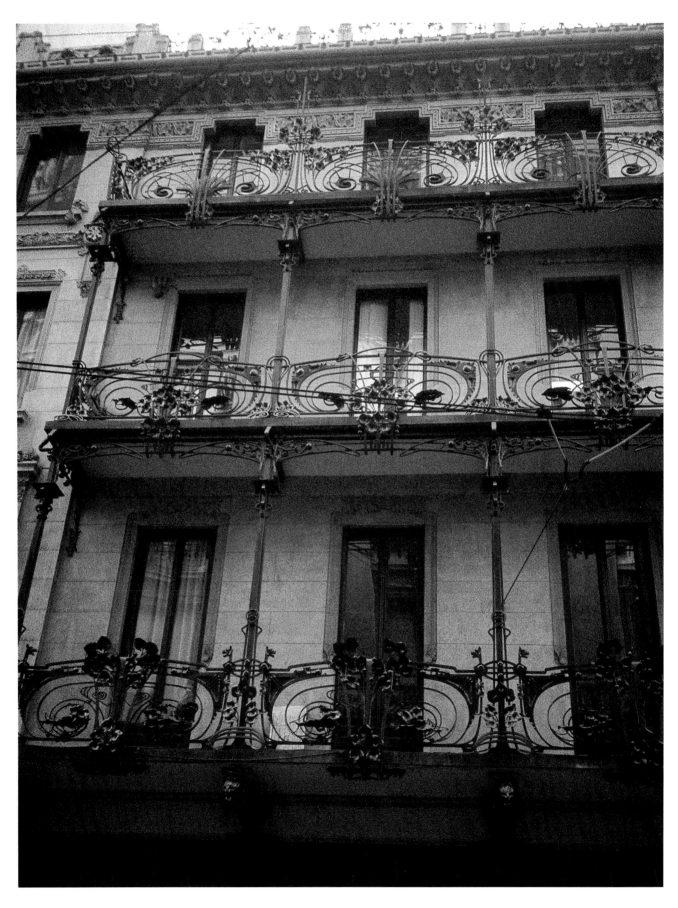

materials was also part of the Arts and Crafts creed and was echoed in much of the work and teaching of the Bauhaus design school in 1920s and 1930s Germany.

The political regimes of the 1930s in both Germany and Italy promoted a mixture of styles of work to suit their purposes, but World War Two ended the revival in the production of decorative ironwork until some time after the cessation of hostilities. After WW2, there was a great deal of necessary reconstruction, often in modern styles that had no room for decorative ironwork. However, there was work in the context of churches and memorials, but mainly in countries such as Germany and Austria where there was a strong tradition of using ironwork in domestic building for furniture and fittings.

Matthias Peters, of Stolberg in Germany, has noted that there is an importance attached to the entrance or the outside appearance of houses, particularly in the more southern regions of Germany which meant there was always work for smiths — grave crosses also providing work. The strong traditions of metalworking in Germany continued after World War Two, but, as Peters noted, there was a conscious attempt to combine these with a forward-looking design approach, not rooted in the styles associated with the immediate pre-war period. The influence of the Bauhaus upon art and design education was also a factor in this new tradition.

Julius Schramm, seen as the doyen of smiths in Germany during the 1920s and 1930s, was a major influence upon Fritz Kühn, who was later to be such an influence upon UK and US smiths through his books and photographs. Kühn's writing echoes many

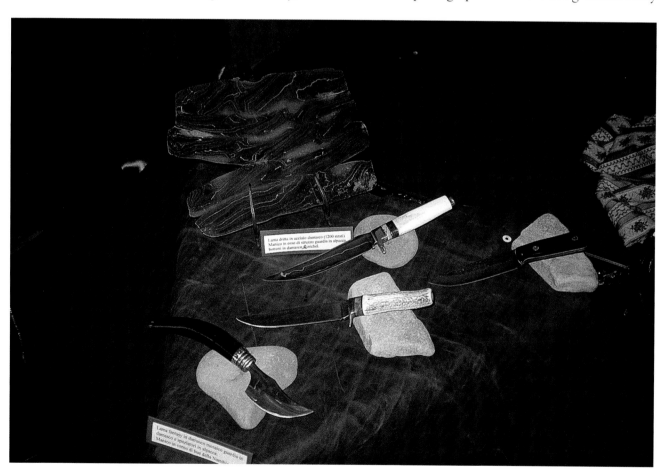

(*Above*) Pattern-welded steel ingot and blades, shown at Stia, Italy, September 2001.
(*Opposite page*) Art Nouveau style ironwork in Milan, Itlay.

of the comments made earlier by John Ruskin about the materials, design and workmanship. Kühn's work was linked, as he saw it, with nature and natural forms – the nature photographs of Karl Blossfeldt, providing much inspiration. Kühn spoke of 'personalising' bars of iron by forging and marking them before constructing work – and his own work showed a narrative quality in that the methods of working were celebrated rather than concealed as had been the baroque tradition. Kühn called smiths to 'give vital form to the iron by means of simple yet technically proper designs' – something also emphasised by J. A. R. Stevenson in his *Din of the Smithy* from the 1920s. Kühn berated the use of machine-made or mass-produced elements and the passing them off as craftsmanship, and was, like Ruskin, opposed to iron imitating other materials.

Fritz Ulrich of Aachen, who died in 1975, was another major early influence upon the development of blacksmithing both in Germany and abroad.

The work of sculptors, especially in the post-war period was to have an important influence upon the way in which iron and steel were once again seen as appropriate media for artwork. Many, including Calder, Chadwick, Picasso, Chillida, Caro, Gonzalez, Butler, Hauser, Pomodoro, Smith and Benetton, popularised sculpture in iron and steel. Antonio Benetton – who was later to have such a direct influence upon UK blacksmiths, with his use of modern technology allied to traditional forging technology – worked on a very large scale with blocks of iron and huge sheets taken from scrapped battleships. Chillida works with enormous sections of material and uses shipbuilding technology to

(*Above*) Flame-cut and forged steel fire grate, by Stuart Hill. Photographed at the Fire and iron Gallery, Leatherhead, Surrey, UK, 1995.
(*Opposite page*) Victoria Plaza gates – forged mild steel, by Giuseppe Lund, London, UK.

construct forms. David Smith also made use of large industrial forgings, as has Anthony Caro. The use of texture by sculptors, and post-war German smiths, was very influential upon early artist blacksmith work of the 1980s in particular.

Italian sculptor Toni Benetton was influential in encouraging smiths to consider the nature of steel and its expressive potential: 'My difficulty has always been that of leaving iron in its original state, intervening with moderation, almost with discretion, but also with authority and personality.'

Echoing Fritz Kühn's desire to personalise bars of iron, Benetton noted, 'The iron I receive from the manufacturer is smooth, polished, unnatural and I have to carry out the inverse operation to bring it back to its natural state, to give it back its soul'.

In the USA, blacksmithing also has utilitarian roots, with the requirement for tools, equipment and weapons being foremost in early colonial times. The craftwork of the USA has always benefited from numerous traditions, and in this ironwork is no exception. From the 1830s, and until the late 19th century, cast iron was dominant in terms of decorative work such as gates and railings. From the 1870s there was an increasing interest – as in Europe – in a revival of medieval craft techniques, and in wrought ironwork in particular. Gothic Revival, and Arts and Crafts approaches were combined with Classical, and Colonial Revival designs at this time. A. W. N. Pugin's Gothic Revival work in the UK did much to influence styles in the USA, as did the writings of John Ruskin.

Samuel Yellin, perhaps the most important American blacksmith of the first half of the 20th century was born in Russia, and trained in Europe, before emigrating to the USA around 1906. He worked in Philadelphia, and used both his collection of antique European work and his library as an inspiration for his work. By around 1920 he was operating 60 forges and employing 200 workers – eventually expanding to 300 workers. He died in 1940, but left a legacy of work which still provides inspiration for many smiths worldwide. There is some similarity between the forms and techniques used by Yellin and those adopted by Kühn in that they both worked with a profound knowledge of materials, techniques and forms, backed up by visual research in the form of drawings and photographs.

The craft revival of the 1920s in the USA was important in establishing the place of craft work in later decades. After 1945 the crafts were beginning to be taken seriously and gaining status as activities within the arts. Country craft training schools such as Penland, Haystack and John C. Campbell, started to revive interest from the 1960s. L. Brent Kington – a professor in metalwork at Southern Illinois University – began to make wrought ironwork in the 1960s, and organised the first workshops at SIU in Spring 1970. In March 1973 at the Westville Blacksmiths' Convention, the Artist Blacksmiths' Association of North America (ABANA) was formed. ABANA has had a profound effect upon the development of blacksmithing around the world in the last 25 years, as have a number of US smiths.

From Conservatism to Contemporary Practice

The transition from traditional and earlier modes of practice has been particularly interesting in the UK, where it has been shaped by a combination of cultural, economic, technical and political factors. In Britain, the 17th and 18th century canons of Baroque and Rococo work, and styles of working, held such sway throughout the Victorian and Edwardian eras that little blacksmithing was done in the Art Nouveau style – despite its suitability for expression through the medium of forged metal. With one or two notable exceptions, such as Charles Rennie Mackintosh and his Glasgow contemporaries, the important and exciting work of Gaudi, Horta,

Brandt and Mazzucotelli had little impact in the UK; perhaps interest and pride in Empire and industry meant less interest in European trends. The powerful influence of the traditional canon continued right up until the 1980s when significant quantities of contemporary work began to be produced.

Tanya Harrod in her book *The Crafts in Britain in the 20th Century* (Yale, 1999) noted that craft disciplines often operate as 'separate worlds, each with their own particular standards and concerns' – something which could certainly be said of blacksmiths worldwide until quite recently.

Changes in economic and social conditions have always had a profound effect upon the fortunes of blacksmiths and other makers. Industrial production has made everyday items more affordable, and eventually the work of craft migrated from being in general utilitarian, to mostly decorative or bespoke. The 1930s saw in the beginnings of Modernism and the internationalisation of styles. There was a trend away from the hand-made – at least in stylistic terms – and machine-made items were seen as more appropriate. The crafts generally responded by moving towards an association with art, and there was a notion that they were therapeutic. In effect, this is a reverse of the split between craft and art which began in Renaissance times and was exemplified by Lorenzo Ghiberti's production of bronze doors for a Florence Baptistry. Blacksmithing was not generally part of this 1930s movement back to art, as except in the case of a small number of makers, most were engaged in industrial and agricultural areas of work during this time.

The Bauhaus *Basic Design* and Modernist principles continued to dominate until well into the 1960s as the basis for design and architecture, leaving little room for decorative blacksmithing. In the 1960s ecological concerns began to raise

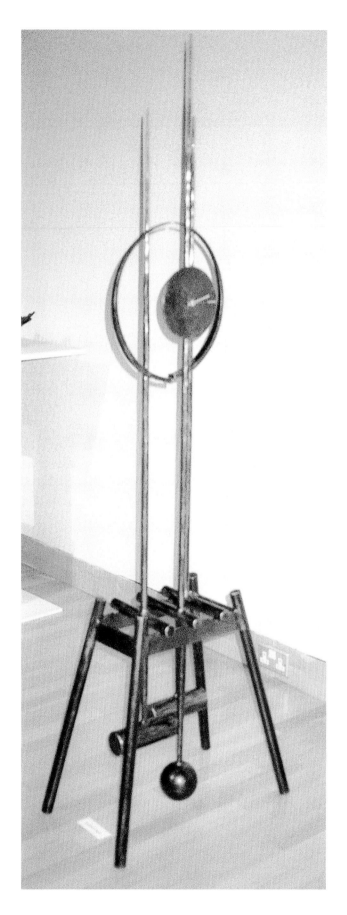

(*Right*) Pendulum clock by Paul Margetts for the Fe exhibition, Shown at Tully House, Carlisle, UK, 1996

questions about mass production and standard-isation, leading to a revival of interest in hand-made and decorative production.

An essential, but much more recent, part of the transition to contemporary artist-blacksmithing practice, in common with earlier moves by other crafts, has been an association with and emulation of the culture of art and its critical and promotional structures. The reasoning behind this being that if work was to be sold for the higher prices commanded by 'art' in order to make it economically viable, a process of judgement or selection by those seen as 'experts' or critics would be needed. To a certain extent, the process of selection and exhibition in galleries and the production of art-like craftwork has been successful, and makers have been able to convert the resultant cultural capital to economic capital.

Bernard Leach, for example, saw this association with art as an essential prerequisite for the success of studio pottery, and by extension other kinds of craftwork – although in practice he depended upon a combination of sponsorship, batch production, tourism and artistic production. In Germany, for example, the well-known Lindau and Friedrichshafen sculpture exhibitions have done much over the years towards making this connection with art-orientated practice.

Although an association with art has been useful in differentiating the new art-blacksmithing from its utilitarian roots, the link has failed to do justice to the nature of the work and the intentions of makers. Pamela Johnson (*Crafts,* July/August 1995) has questioned how the discourse of art criticism, designed to investigate meaning, could be used on objects which were not, in the main, attempting to produce meaning. Practitioners are urged to use a more theoretical approach to articulate their worth as '… repositories of knowledge of materials and processes. As such craft makers could occupy a range of positions within contemporary culture.'

Writing in 1988, Theo Crosby, an architect and partner in the Pentagram design group, noted that the ideological collapse of Modernist architecture had made a space for action and involvement from many directions. Crafts were flourishing and architects were taking seriously their reintegration with building. Alan Dawson noted, in an essay for the *Forging Links* project in 1990, that the birth of the British Artist Blacksmiths Association (BABA) in the late 1970s coincided with the growing pains of a general change of architectural style. He commented that in more recent times the establishment of BABA, the energy and enthusiasm of its members, and help from the Crafts Council, had transformed the situation.

The crafts began to be associated from the 1960s, with alternative philosophies of everyday living, a growing sense of tradition through heritage and notions of *green* living, allied to a cynicism towards technology and the purposes to which it had been put.

Contemporary practice in many crafts shows the growing importance of the relationship between methods of working and the product, and the extent to which the product is indicative of a working philosophy. The distinguishing feature of the work of the artist blacksmith lies in the intention, and not the use of machinery, so that making a distinction between hand and machine working becomes less relevant than is the case with many other craft-related activities.

The creation or development of a personal working philosophy or ideology related to a vision or notion of self through work, and a relationship with

(*Opposite page*) East doors of the Baptistry in Florence's Piazza Di Giovanni by Lorenzo Ghiberti, 1424–1452. Often noted as one of the first products of the renaissance and symbolic of the split beginning between fine art and craft practice.

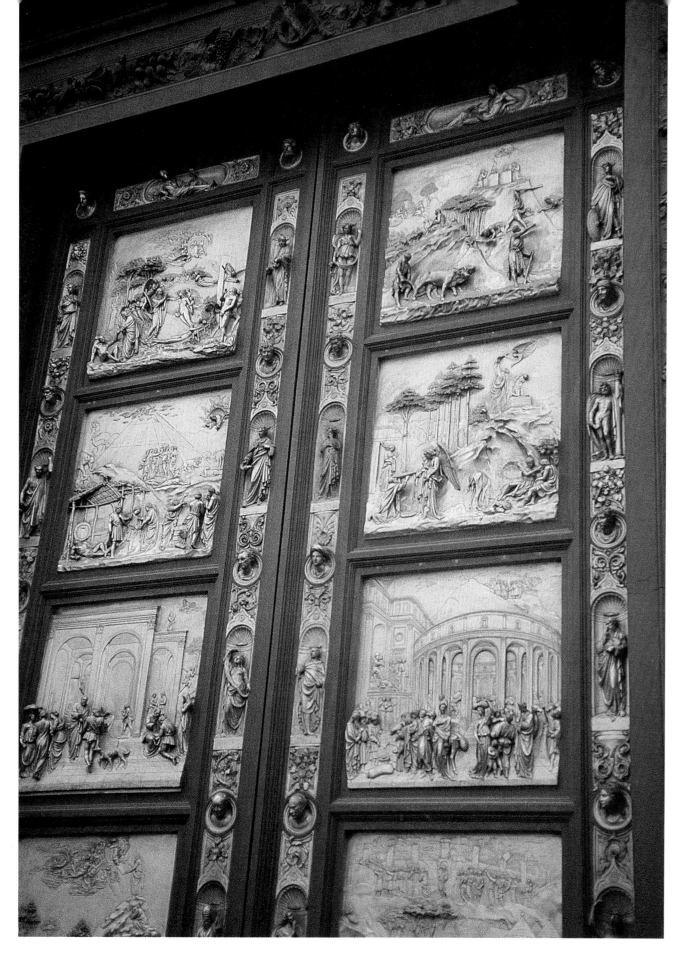

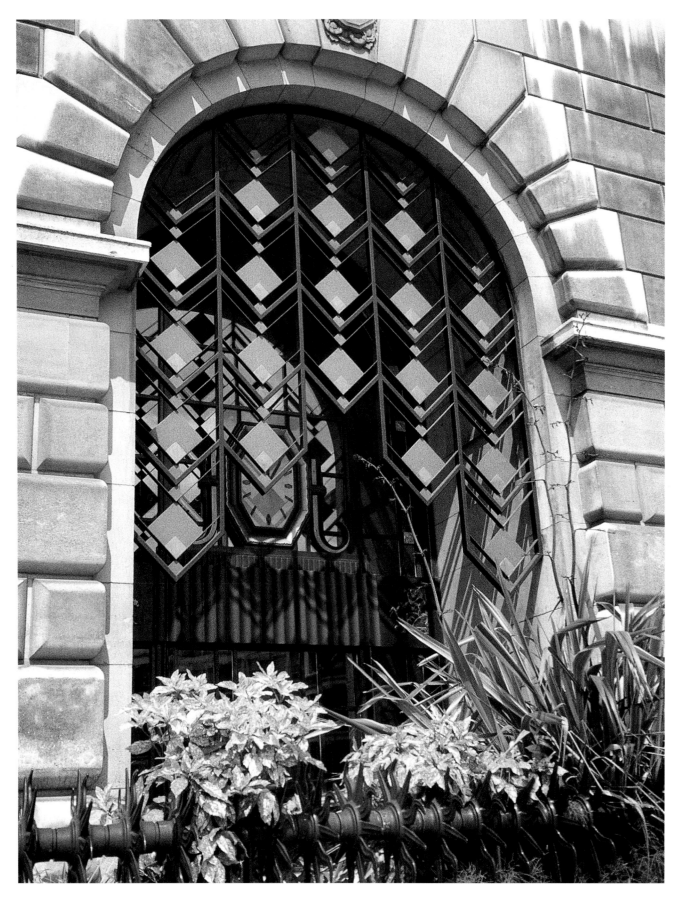

the material and traditions of working, has become important to artist blacksmiths, contributing to an understanding of blacksmithing's position between art and architecture. In turn this has increasingly distinguished such practices from those who continue to operate outside a design framework as traditional smiths.

Fitness for purpose has been shown to be an important issue, in terms of both decorative and practical functionalism. In contemporary blacksmithing there is a new notion of site specificity, borrowed to an extent from the concerns of architecture and art, but linked in a new way to the economics of production. Work may be designed to fit the place, rather than the place adapted to fit the object, which is often the case when using mass-produced products. Aside from aesthetic considerations, this is a process that can be more cost-effective, because of the artist blacksmith's capacity to make purpose-built, high-quality, site-specific work, very often more cheaply than the mass-produced alternative, thereby signaling a new economic pattern.

Networking and group projects have become more common, taking advantage of the latest technology, including fax, email, electronic means of communication, powered equipment, welders and hoists, etc. In particular, this trend has been enhanced by the membership of associations and guilds. A pragmatic, and necessarily business-orientated, rather than ideologically or tradition-driven, approach has been a key factor in the use of newer equipment and methods. This equipment has enabled the smith, often working alone or in a small team, to undertake work on a scale, which previously would have been impossible outside of a heavy industry context. It is the association of these new technologies with traditional techniques within the context of design that produces the unique

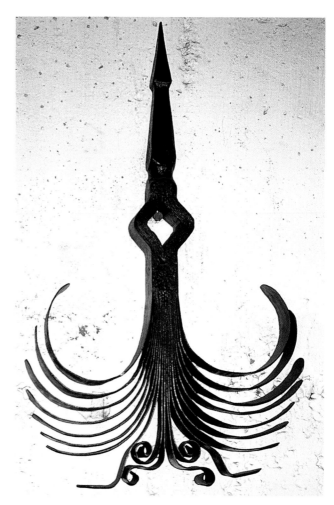

Forge-welded demonstration piece at the Paris HQ of the Compagnons du Devoir.

quality of the artist blacksmith's work. The tradition is seen as being in the skills, the relationship with the material, and in innovation, rather than in a particular style. Frequent changes of section, the use of relatively heavy bars and awareness, both of design and the traditions of the craft, characterise contemporary work. The artist blacksmith has evolved as one who operates within a set of values and a working culture, rather than a worker in a given style or specific commercial context, perhaps best illustrated by the wide variety of styles in the work that has been produced.

(*Opposite page*) Screen at Unilever House, London, UK. Made by Richard Quinnell Ltd to a design by Theo Crosby of Pentagram.

Associations, Institutions, Museums and Publications

C hanges in the practice of blacksmithing in the last 50 years or so have resulted from individual efforts but there have also been a number of factors that have had an important influence. These factors include the activities of museums, associations and institutions, and the effect of publications. Developments have been linked to technological change, patterns and modes of travel and communication, and to alterations in the culture and practice of making on a broader front.

The largest, and perhaps most influential, blacksmithing organisation is the Artist Blacksmith Association of North America (ABANA). It has a number of sections, or *Chapters,* in regions of the USA which contribute in their own right and as a part of ABANA to blacksmithing's development. The ABANA magazine *The Anvil's Ring* has been important in communicating views, information on techniques, events and processes, and has been the model for other blacksmithing magazines internationally. ABANA was the model for the British Artist Blacksmiths Association (BABA), and to some extent, the *International Association of Designing Blacksmiths* (IFGS) based in Germany. There are blacksmithing associations in many other countries, including Australia, Estonia, Canada, Ireland, France and Italy and there are extensive contacts between them and exchanges of

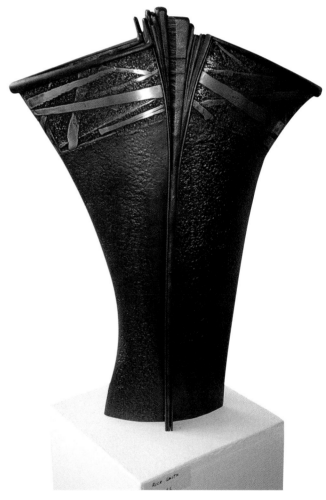

Vessel by Rick Smith, Carbondale, USA. BABA AGM exhibition, Cumbria College of Art and Design, UK, 1996. The upper portion was kiln-fused with a reducing atmosphere, the centre section was forge-welded, and the main body of the vessel was forged from sheets of steel pitted by corrosion.

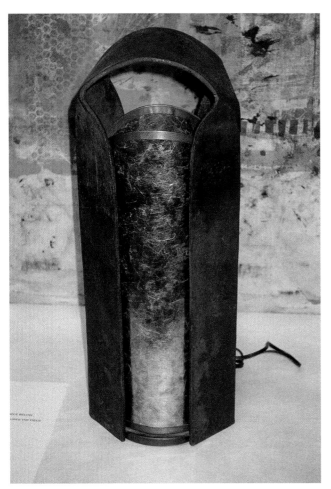

information, leading to a strong international community of blacksmiths.

The blacksmiths' association of Baden-Württemburg in southern Germany has been important and influential for many years because of its link with the successful Lindau and Friedrichshafen exhibitions, and the quality of the work of its members over the years. ABANA can be seen to have influenced practice internationally perhaps more than the German groups in recent years because of its size. However, it is clear from their long history of innovative contemporary work that the major influences upon the style and technique during the period from the 1960s until the 1980s were the German smiths and their neighbours in Europe, such as the Swiss, Italian, French and Czechoslovakian makers. Innovative work continues to be produced in Germany, but there is work which extends practice being done in many countries at present.

There have been associations and guilds related to blacksmithing for centuries in many countries, but they have traditionally been linked to preserving and

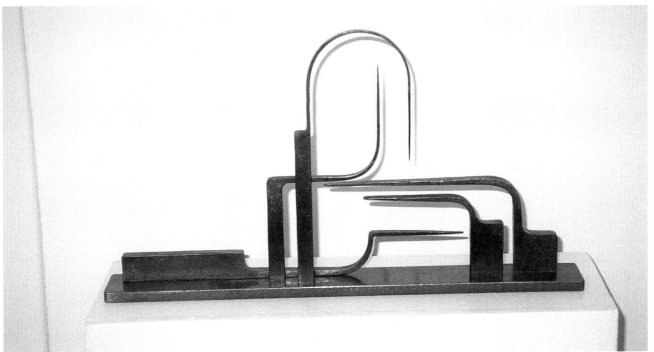

(*Top*) Lamp with a mica diffuser made as a demonstration piece by Tom Joyce at BABA's Ironbridge AGM.
(*Above*) Sculptural piece by Christophe Friedrich, Switzerland, exhibited at Cumbria College of Art and Design, 1996.

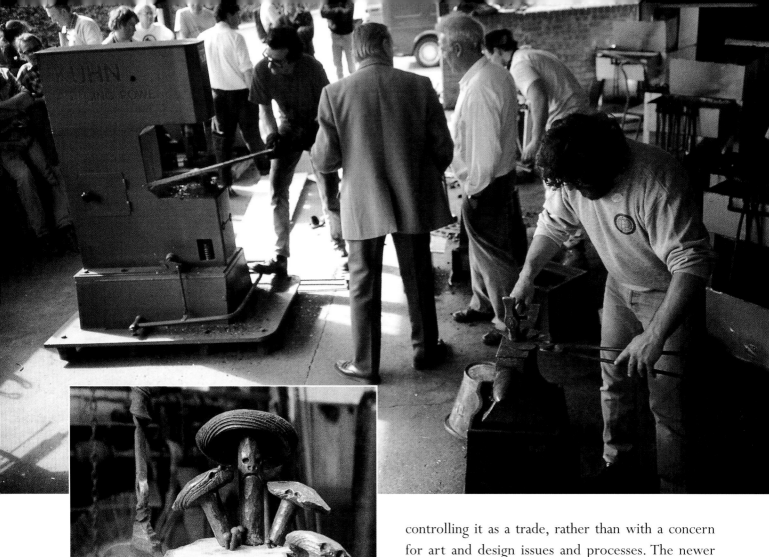

(*Top*) BABA AGM forge-in, held at Stoneleigh (NAFBAE HQ) , UK, July 1990.
(*Above*) Forged mushrooms produced at a forge-in at David Petersen's workshops in St Clear, Wales, 1993.
(*Opposite page*) Blacksmiths' needle, now at Newcastle quayside, in construction, 1996.

controlling it as a trade, rather than with a concern for art and design issues and processes. The newer associations have been concerned with the needs and priorities of art-blacksmithing. The older bodies have often evolved into largely social organisations because the trade they were formed to regulate and promote has changed profoundly. In very recent times, as members of the newer associations have also joined their more ancient counterparts, these older bodies have begun to adapt to new practices themselves.

Blacksmiths' organisations in the UK, prior to the development of BABA, had been concerned overwhelmingly with commercial, employment and trade issues. These guilds, livery companies, trade unions and associations presided over the decline of blacksmithing, and failed to recognise the opportunities presented by a culturally aware, designer-maker approach to work. The recent development of the artist blacksmith in the UK has been linked closely to BABA.

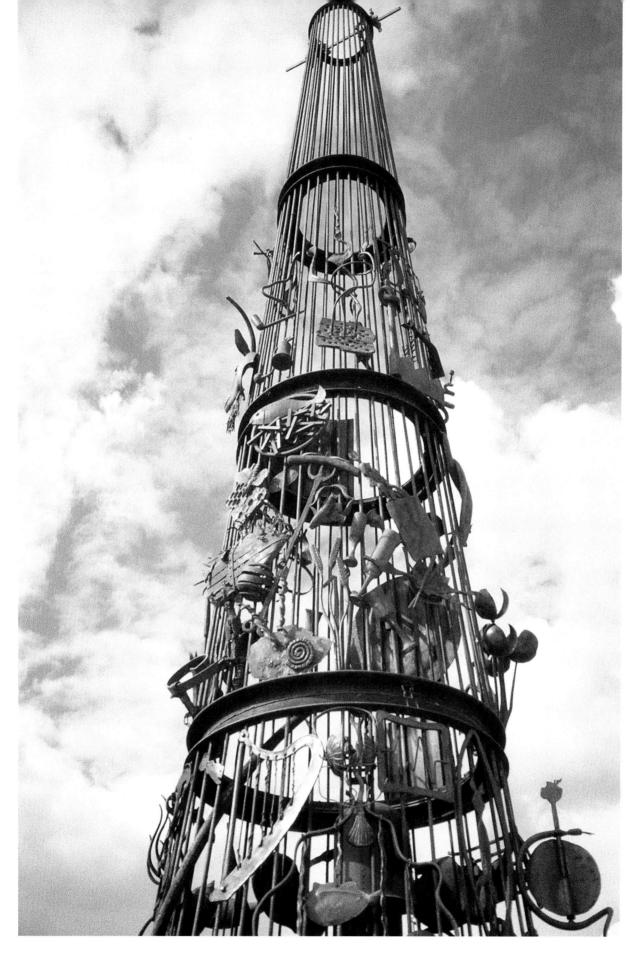

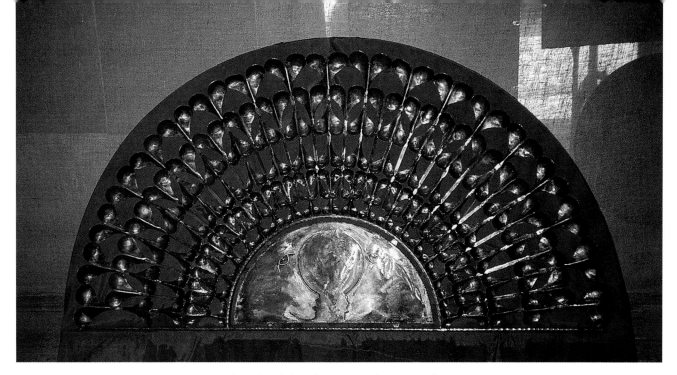

Forged work exhibited at Stia, Italy, September 2001

Farmers were forming organised and powerful lobby groups towards the end of the 19th century, and so blacksmiths, because of their strong links with agriculture, formed organisations outside of the existing, but by now obsolete guild structure. The National Master Farriers Blacksmiths and Agricultural Engineers Association (later NAFBAE) was formed in 1905 in the UK to promote, develop and protect their interests on a national basis.

Although UK blacksmiths have been important members of multi-craft guilds and associations such as the Devon Guild of Craftsmen, the Society of Designer Craftsmen and the Art Workers Guild, it is the specialist blacksmiths' organisations that have been most important and influential. They have been most effective when working with bodies such as the Crafts Council and the Rural Development Commission. Since its formation in 1978, the most important and progressive organisation has been the British Artist Blacksmiths Association (BABA).

As those with art and design training were increasingly dominating the new marketplace for the crafts, the need for a new approach became self-evident. BABA has proved to be the organisation in the UK best able to relate these aspirations to the highly regarded traditions of the craft and operate as an agent of change and a promoter of the blacksmith's work. A new tradition of self-conscious working allied to creativity, business awareness, and commercially appropriate use of blacksmithing skills had begun to form.

The Blacksmiths of Tuscany and Northern Italy

Iron has been produced and forged in Tuscany in Italy for centuries. Stia has a strong tradition of forge-work and had, for example, 32 working smiths in 1841, when its population was just 2911.

The *Biennale Europea D'Arte Fabrile* has been held at Stia on the edge of the Casentinesi National Forest for the past 25 years. In 2001, it included a series of exhibitions, many stands of ironwork, sculptures and demonstrations spread throughout the town. A large number of exhibits from Italian smiths showed a variety of approaches, but the influence of German smiths and those from the USA could clearly be seen in the work. Albert Paley, Brad Silberberg and Tom Joyce's work had clearly influenced the designs of

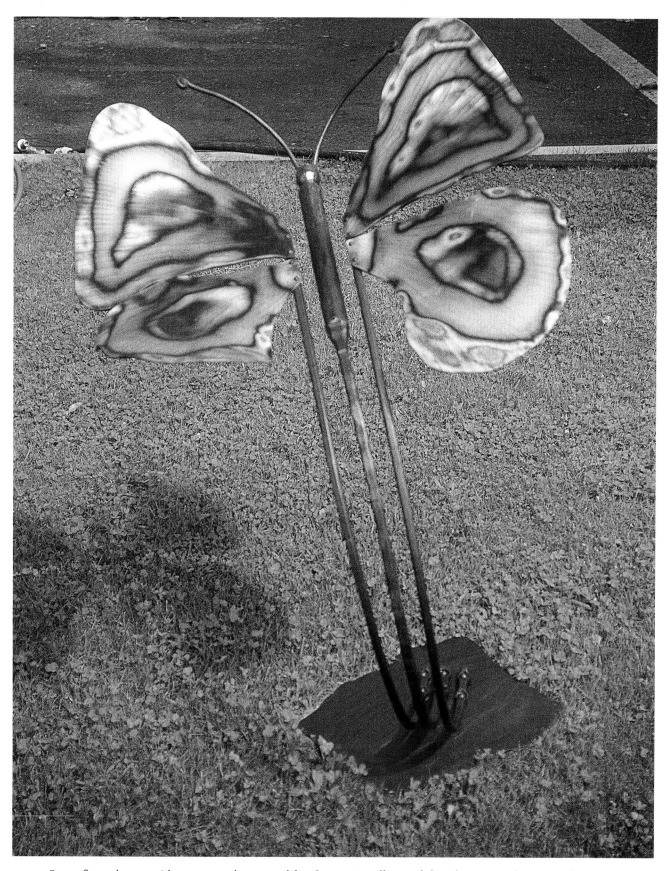

Butterfly sculpture with temper colours used for decorative effect. Exhibited at Stia, Italy, September 2001.

some of the participants. Events such as this act as a catalyst for communication between smiths from many countries – although the 2001 Stia event was attended by more smiths from Italy and Germany than from other countries, many other nationalities were represented.

Livery Companies and Guilds

Livery companies, guilds and their equivalents in other towns and cities throughout Europe used, during the Middle Ages, to control entry to trades and the quality of work, imposing fines for sub-standard work and granting the freedom to trade in a particular place. To some extent this tradition is continued in Germany by the requirement to be appropriately qualified before setting up in business in many trades and professions.

Bunch of forged flowers shown at Stia, Italy, September 2001.

By the end of the 17th century the grip of the guilds was severely weakened in the UK and for the past 200 years or so they have been little more than ceremonial institutions and City luncheon clubs. The Ironmongers have been active since the inception of BABA in promoting the work of smiths through the provision of funds, and mounting a permanent exhibition of the work of BABA members at Ironmongers' Hall. The Worshipful Company of Blacksmiths (WCB) since the 1980s in particular, have taken a more active role by becoming involved in awards, committees and bodies relevant to blacksmithing.

In France, the Compagnons du Devoir, in particular through their training network based around residential centres, has had an important influence upon style, techniques and business practices. The Compagnons are effectively an amalgam of the trade guilds associated with architecture. They have a national organisation and a network of training centres providing educational facilities and accommodation. Training is provided in the evenings, as the participants work during the day at their various trades and crafts. After completing a basic course of study, it is possible to enter into the journeyman stage and work at a variety of workshops – traditionally around France, but increasingly in other countries – to become a *Compagnon du Tour de France*, effectively qualifying as a Master in the Guild tradition. This higher qualification is highly regarded, and demonstrated traditionally in the display by farriers of a sign containing many styles of horseshoe, taken from the regions they worked in on their tour. The Serrurier (locksmithing) section of the Compagnons has been responsible for training many of France's foremost blacksmiths over the years, including Serge Marchal and Daniel Souriou. The Compagnons now have a British branch of their operations, and collaborate with BABA and others in arranging work experience for journeymen and students.

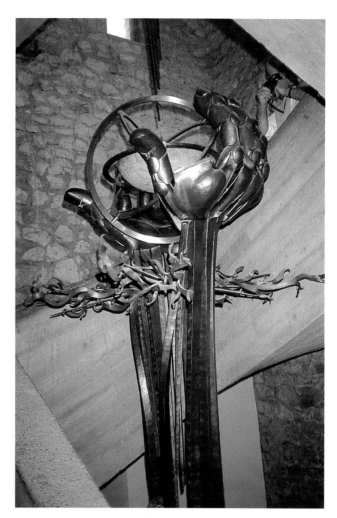

Sculpture by Serge Marchal at the Compagnons House, Nîmes, France. A huge sculptural piece completed single-handedly over a three-year period.

The Rural Development Commission

The UK Rural Development Commission (RDC), recently incorporated into the new Countryside Agency – a government body with a role in training, advice and marketing for a number of crafts and rural activities – has been important to UK smiths for over 90 years.

A library of scale drawings was available from the RDC, and many copies of drawings were sent out to

blacksmiths and others. These drawings continue to be available both in the form of books and as working drawings. Through their catalogues and drawing service, the drawing and design service of the RIB and later CoSIRA had perhaps the most important influence on the style of ironwork in the UK, certainly up until the 1980s, and for many smiths working in a more traditional style, into the 1990s.

In the UK the *Bolton Report on Small Firms* was an influential report set up by Rt. Hon. Anthony Crosland, President of the Board of Trade on 23 July 1969. It indicated that the value of craft industries was far beyond that of monetary potential and included quality of life and tourism. The report led to both the setting up of the regional Small Firms Advisory Bureaux of the Department of Industry (now the small firms service of the DTI) and the Crafts Advisory Committee (the precursor of the Crafts Council) who had:

> …a remit to promote the work of Artist Craftsmen… CoSIRA has long had a special interest in craft industries and will work closely with the new body. The dovetailing of the work of the two bodies will be ensured by the fact that the chairman of CoSIRA has been appointed as the Chairman of the Crafts Advisory Committee (Sir Paul Sinker).

British Artist Blacksmiths Association (BABA)

Much of the best quality British contemporary work has been designed and made by those who are, or have been, members of BABA. Communication and the exchange of views through meetings, exhibitions, conferences, masterclasses and a wide variety of other activities such as collaborative working have all contributed. BABA is unusual in that it is not a 'trade association' as such, as it includes anyone who would

like to be a member and does not permit the use of its name or logo for the promotion of individual businesses. It exists for the promotion of blacksmithing, not individual blacksmiths *per se*.

While many people have contributed to its development over the years, Richard Quinnell and his late wife Jinny were responsible for its foundation. Quinnell received his invitation to the USA from Ivan Bailey, a student blacksmith who had trained with Fritz Ulrich at Aachen in Germany. The Artist Blacksmiths Association of North America (ABANA) was founded in 1972. In 1974 they had invited Fritz Ulrich over to demonstrate, although he has since died of the effects of mercury gilding in his youth. Alex Bealer, one of the founders of ABANA, wrote a book which was picked up by Brent Kington, a Professor of Silversmithing at Carbondale, who asked if he could introduce his students to some of the 'dying old blacksmiths'; it developed from there into an association.

The next year Quinnell returned to the USA with his wife Jinny, to Carbondale in Illinois, which is often referred to as the 'Woodstock of American blacksmithing', where 500 people gathered. There was an exhibition featuring some large pieces by Albert Paley and a positive, energetic atmosphere: 'On the plane home Jinny said "you know its got to work in the UK, we've got to do something about it". So that is late 1976, and I have to say, I didn't really do anything about it, although she kept nagging at me to do something.'

After a study visit to Europe with Caroline Pearce-Higgins, Quinnell contacted (with the help of Tommy Tucker of CoSIRA) 50 blacksmiths and organised the first 'forge-in' at which BABA was formed. When writing about the early development of BABA, Alan Dawson recalled in *British Blacksmith*, No.53, 1989:

> I was working in isolation in a collapsing cowshed, thinking that I was the only decorative blacksmith in the world when, in

1978, I heard through CoSIRA that a Mr. Richard Quinnell was organising a gathering of blacksmiths. Scraping enough pennies together I managed to attend this inaugural meeting, which was soon to become the British Artist Blacksmiths Association, and my life changed.

The first few years of BABA's development saw some important events which were to shape the organisation and, to an extent, the practice of blacksmithing in the UK. 1980 saw the important Hereford conference, *Forging Iron,* which was influential for many present and which served to strengthen BABA. As a result of improved communication with European smiths some BABA members began to enter competitions and exhibitions in other countries. In 1980 Stuart Hill entered his *Frog Metamorphosis* table and won the major prize at the Lindau exhibition in southern Germany. Tony Robinson's *Resurrection* sculpture was purchased from the 1987 Friedrichshafen exhibition and is sited on the shore of the Bodensee.

BABA has published its magazine, *British Blacksmith* (renamed *Artist Blacksmith* in 2000) on a quarterly basis since its formation. It represents one of the most complete records of blacksmiths' work and events both in the UK and abroad since 1979. It is characterised by openness about methods of working and techniques, alongside good quality illustrations and photographs of work. The *Anvil's Ring,* the ABANA equivalent, is also read by many British blacksmiths and operates a reciprocal information exchange with *British Blacksmith.* In 1991, when it was first published, *Hephaistos* the German-language blacksmiths' magazine also began to be an important source of information and debate.

Blacksmithing organisations worldwide went a stage further in the mid-1990s and put information, including portfolios of work and English-language translations of *Hephaistos,* on the Internet as part of a website known as the *ArtMetal Project,* based at

Washington State University, USA. This is a continuation of the very strong tradition of international communication between blacksmiths that has developed in the last 20 years.

Work from BABA members has influenced work in other countries as well as the converse, but it hasn't resulted in a single 'international style'. There are certain prevalent tendencies, such as the interest in pattern-welding and the importance of individual expression in the USA, or the extensive use of hammered surface texture in German work. However, there is such a diversity of styles and methods in many countries that it is more appropriate to look at developments in the work of individuals, than at national styles.

The Impact of Crafts Organisations

Government, regional and local crafts organisations have played an important part in the development of blacksmithing world-wide, whether by providing opportunities to exhibit, grant aid, promoting their work in other ways, or lobbying. Particularly at the early stages of the operation of BABA, the Crafts Council was important in helping to revitalise blacksmithing in Britain, and to an extent in the rest of Europe. Prompted by Ivan Smith, the Crafts Council was able to assist through organising events the development of blacksmithing as it had earlier helped hot glass working. A first, exploratory conference was held in August 1979 as a precursor to the main conference, held at Hereford Technical College in July 1980. Simon and Toni Benetton of Italy were influential during and after their time at the Hereford experimental workshop. Their distinctive use of texture and flame-cut forms was particularly important and very different from the work of the traditional British smith. Antony Robinson, with whom Giusseppe Lund worked for some time, has cited the Benettons as important in

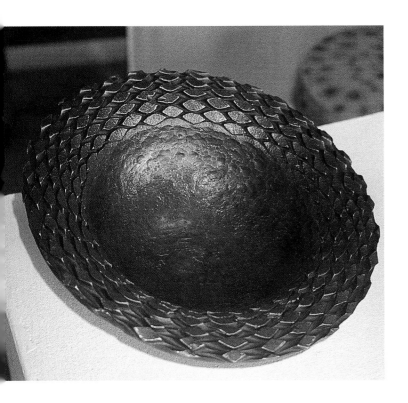

(*Above and left*) Bowls by Claudio Borrero exhibited at Stia, Itlay, September 2001.

influencing his own work. Giusseppe Lund was one of the first to investigate modern Continental work and was quoted in a profile article in *Crafts* in 1979 as speaking, '… enthusiastically of Fritz Kühn's practice of submitting the whole iron bar to heat and hammering before use, in order to 'personalise' it'. This working of bars has become characteristic of Lund's work, his gates for Victoria Plaza in London from 1985 continuing the theme. It is clear that the visual language of the blacksmith's work was entering an innovative period in both style and technique, despite the reaction of the traditionalists.

The attitude that, if at all possible, it is preferable when producing new designs to use traditional techniques, in combination with newer ones, when producing new designs, is dominant amongst BABA members and is an identifying characteristic of modern British work. There is a strong conservative streak in technical terms in British blacksmithing, although much innovation in stylistic terms, reflecting the diverse nature of modern commercial practice.

Publications

Specialist blacksmithing publications are relatively scarce and fall within the broad categories of technical instruction, historical surveys, general introductory texts, part-autobiographies, books of designs or photographs of work, and monographs, complemented by journals and general craft publications, including in broadcast or electronic formats. As Frayling and Snowdon have noted (in *Crafts* 59, December 1982), much available literature relates to the circumstances *surrounding* the crafts — recipes, catalogues, coffee-table surveys of one particular craft — and there is a paucity of information relating to the activity of craft with its tacit, tactile and informal qualities. Design work, on the other hand, can be more easily formalised: 'Whether or not we accept such a hard-and-fast distinction, it's clear that the concept of craft as a special kind of knowledge has proved extremely difficult to write about. Which in some cases makes it vulnerable.'

Alex Bealer's book *The Art of Blacksmithing* was influential in stimulating a revival of interest in blacksmithing in the USA and contains historical material and some descriptions of techniques. Fritz Kühn's books were important in showing contemporary work and describing influences and sources of inspiration. Julius Hoffman's *Schmiedearbeiten von heute,* and other German books were also important in shaping practice. Technical books from the UK Countryside Agency, although they were first published over 20 years ago, remain an important resource and are read worldwide. Critical publications are almost absent, perhaps with the exception of exhibition catalogues and magazine reviews. Dona Meilach's books *Decorative and Sculptural Ironwork*, and *The Contemporary Blacksmith* illustrate works by category, such as furniture, lighting, etc. and include some biographical information.

Amina Chatwin's *Into the New Iron Age: Modern British Blacksmiths* includes biographical information, and many photographs of work with descriptions, and is an important resource. Until the mid-1970s, historical surveys such as those by Starkie Gardner, Lister and Campbell were almost all that UK smiths

A selection of polished mild steel fire irons, as shown at the 'Makers Eye' exhibition, by Neil Hawkins.

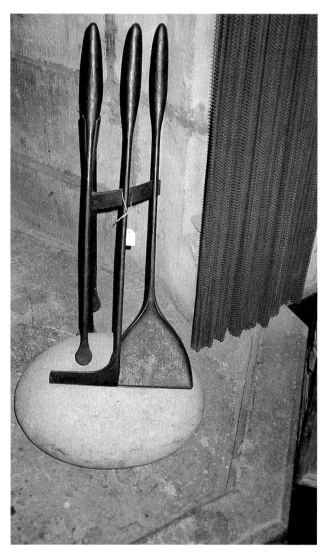

Set of fire irons on a steel and stone stand. A beautifully made piece by Jan Dubochec, photographed at the Fire and Iron Gallery, Leatherhead, Surrey, UK.

Trivet, Rouen, France.

had to inform their work, and both experienced and aspiring blacksmiths emulated or copied work from them regularly. The smith was presented, therefore, with an accepted and constantly reinforced canon of 'good work', without a critical framework.

German and US practitioners had begun from the 1970s to have access to publications showing contemporary work, providing – alongside exhibitions and associated catalogues – informed discussion and critique. The availability of this information, alongside activities which built networks, such as exhibitions and meetings, undoubtedly broadened the design horizons of practitioners.

The Impact of Museums

There are a number of important collections of forged metalwork, throughout the World, collected by individuals, organisations, and often by passive acquisition. They represent an important resource for study and to inform practice, but they also influence through the process of indicating cultural values via collecting policies, commissioning, and the display or curation of work. The Victoria and Albert Museum in London, UK; the Musee Le Secq des Tournelles in Rouen, France; and the National Ornamental Metal Museum in Memphis, USA hold some of the most important collections of ironwork. France has a number of interesting collections in addition to that at Rouen, including those at Nancy, Avignon, Toulouse, Louviers, Paris, Grenoble and Poitiers.

Museums in general have their roots in the developing art collections of the Renaissance, where galleries were built in palaces and major houses, principally as decorative features. These were not on public view, and it was not until the late 18th century that the first purpose-built museums were constructed. Museums built for public use were intended to be 'palaces of culture' – often in the

Screen by Klaus Waltz, one of the earliest contemporary pieces purchased by the V&A.

form of imposing neo-classical structures, of which the British Museum is a prominent example.

Whilst elevating the taste of citizens might have been the intention of such museums, often only national collections are of a sufficiently high standard for this aspiration to be realistic. Much work of value, and in particular contemporary work, is not collected, or appreciated for what it is, unless it has been produced by a well-known 'name'. This has been the result of conservatism or snobbery but also, in the case of blacksmiths' work, a history of anonymity on the part of the maker.

Museums are involved in the process of cultural validation, as Susan Pierce writes in 'Studying Museum Material and Collections' (*International Journal of Heritage Studies*, No.1, 1994):

The entry of a piece into an established museum collection … conveys a kind of legitimacy, and also a kind of immortality. The piece is lifted from the world of the outmoded, the worn-out and the rubbish … and into that of the culturally durable, the 'heritage' as we now call it, to be studied and displayed, protected and defended as the raw material from which cultural values will be spun.

In more recent times, museums have become more diverse and have melded into a wider 'Heritage Industry' or discipline with its own academic courses, specialist journals, experts, and cultural momentum. The popularisation of 'heritage' has done much in recent times to reinforce in the minds of the public, who are often potential customers, the view of blacksmiths as quaint, timeless, upholders of village traditions, producing traditional products. Blacksmiths are seen, therefore, as part of a comfortable history.

Following the Victoria and Albert Museum's first exhibition of new 20th-century ironwork *Towards a New Iron Age*, Claude Blair, Keeper of Metalwork, instigated a limited competition in 1981 to design some gates for the entrance to the Ironwork Gallery from the Music Gallery. David Watkins, Antony Robinson and James Horrobin were short-listed. Horrobin's design was chosen and responds to shapes in musical notation, is large and heavy for security reasons and is in a distinctive, modern style, making extensive use of power-hammer techniques. The importance of this work is that it was the first piece of 20th-century ironwork to be commissioned by the V&A, placing it alongside works by established past masters and effectively giving an official 'stamp of approval' to contemporary work. Modern work is seen, as a result of this commission, as being of equivalent worth to historical pieces, and in a different, yet linked, genre.

In December 1994 Albert Paley, one of the

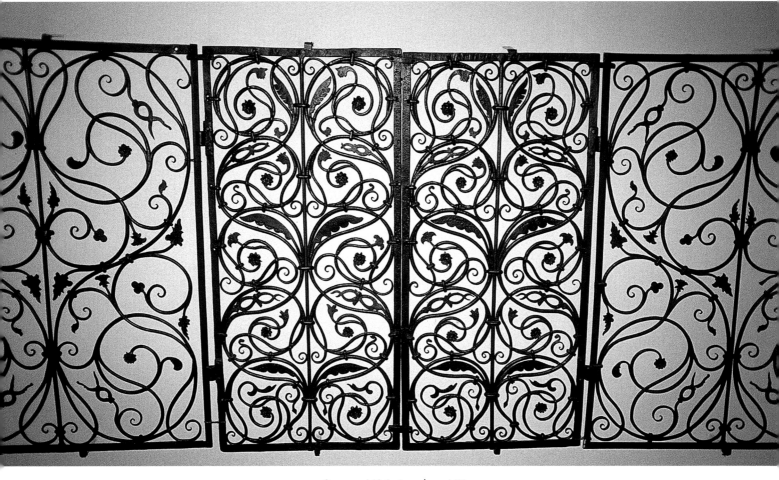

Screen, V&A, London, UK.

most innovative and important American blacksmiths and sculptors, delivered a bench for the Ironwork Gallery, to coincide with an ironwork symposium at the V&A museum.

Sir Roy Strong, former Director of the V&A writing in *The Times* (24 September) in 1983, put forward an argument for concentrating more upon the virtues of contemporary work, and less upon a distorted view of heritage: 'The word heritage is beginning to make me shudder … Heritage was essentially a 1970s cult, which has now spread down the social scale. … It is an industry kept going by a hundred and one societies from the National Trust onwards and hysteria about heritage is a permanent media feature. The worship of the past and what it created has been taken to an extreme unknown in any previous century.'

Strong also gave some insight into his view of the commissioning of new work by saying that:

I used to recoil at the introduction of new things into historic environments. I now realise that it was because they were the wrong new things not that they were new. Enormous sums are consumed in restoring and maintaining the status quo to the point of the past denying us a future. To my mind the balance has gone wrong. You see it in so many country houses. Apart from a superficial overlay of photographs and magazines, the clock stopped in 1914. There is the odd exception but one has to think hard.

There is no doubt that historicism *has* been a problem in terms of the development of

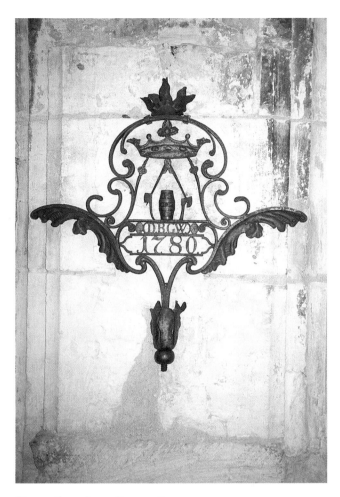

Decorative piece, Rouen, France.

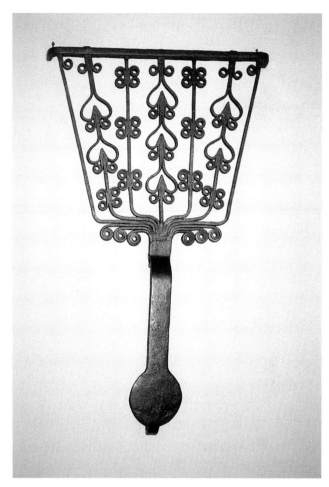

Trivet, Museé le Secq des Tournelles, Rouen.

blacksmithing during this century. But part of blacksmithing's appeal to many is that it *is* an ancient activity and blacksmiths, even modern ones, tend to play on this for commercial reasons. This sentimentality is important in the sale of many consciously hand-made items, but it could be argued that the benefits of such an approach are mixed, making the sale of contemporary work more difficult.

Museums can provide source material relating to design and sometimes technique or materials, and have been important in providing inspiration and visual reference material. In concentrating, for either reasons of policy or budget, upon historical work, there can be little encouragement for the contemporary practitioner.

The following sections of the book deal with the techniques and materials of metalforging, and with the work of a selection of makers from around the world.

Technical Information

Introduction

The methods and tools of metalforging are essentially quite straightforward and sensible and have evolved over the centuries to make effective and economical use of materials, which were often scarce or expensive. The most basic equipment required for forging is a source of heat, a hammer, a surface to strike upon (i.e. an anvil) and water for cooling. Although most of this chapter is about blacksmithing, many techniques can be applied to or adapted for metals other than iron or steel. It is not claimed that the techniques illustrated are always the best ones to produce a particular form or effect, as working style is such an individual thing. Many techniques and tools have often evolved to suit local conditions or been developed with what was available at the time to get the job finished. This section of the book is intended to give an overview of the basic considerations involved in metalforging and is not intended to be instructional, as many techniques depend upon 'feel', practise and haptic skills. Timing, rhythm, the weight of blows, etc. can only be developed through practice.

In the later chapters, the working methods, ideologies and work of a selection of makers are described and discussed. It is hoped that this technical chapter will enable a better understanding and appreciation of the knowledge, skill, design and artistic flair they exhibit in their work.

Materials

The main material of the blacksmith has been 'black metal' or iron in various alloy mixtures. Until recently most of the work was in *wrought iron,* although most contemporary work is done in mild steel, as it is cheaper, more consistent, and more easily available. There has been much confusion in recent years amongst the buying public about the term *wrought ironwork* – it has become a general term for decorative work in mild steel, much of it cold bent and mass-produced. There has been much debate and concern about how the work of the smith should be described in order to differentiate it from industrial products with a lower standard of design and construction, although when the mass-produced product is put alongside the smith's work there is little difficulty in judging the relative merits. One obstacle faced by smiths until recently – perhaps until 10 to 15 years ago – has been a general unawareness of forgework's potential, because of limited exposure to work of quality.

In recent years, alongside the new interest in forgework, there has been a revival in the use of genuine wrought iron, not just for the restoration of older work, but because of an appreciation of its technical and aesthetic potential. The spongy 'bloom' produced by puddling or in earlier times by direct re-duction, was forged or rolled into lengths which were then laminated together to produce iron of various qualities. The more layers, the better the quality, as the

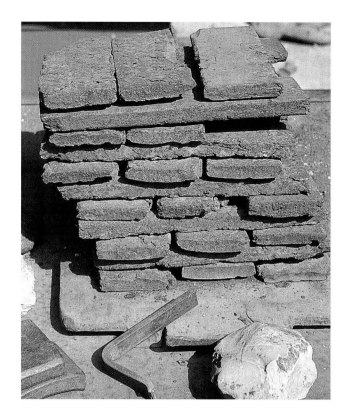

process of welding the layers together drove out some of the impurities at each stage. Grades of iron were known by names such as 'best', 'best-best', and 'crown' – which really was the best. You can often see that some older, slightly corroded items have been made from wrought iron as they have grain rather like wood. It can be seen in, for example, the ancient anchors often displayed at seaside resorts. The advantages often cited by enthusiasts, of wrought iron over mild steel are ease of forge welding, a slightly better resistance to corrosion, and historical authenticity. Blacksmiths such as Chris Topp have been promoting its use, and using it to good effect.

With the exception of gold, the natural state of

(*Left*) A pile of wrought iron, showing how it was layered. Ironbridge Gorge Museum, UK.
(*Below*) Wrought iron components made by Chris Topp – photo by Chris Topp.

metal is as a part of compound, often an oxide, so rust and corrosion (the reaction of metals with air to form an oxide) is a natural process. To produce metallic iron in a useful state (with the exception of that found in meteorites) it is necessary to put in energy to reverse the oxidation process – to reduce the oxide. Heating the ore with charcoal in a furnace is one of the most basic means of achieving this reduction.

From the earliest times until the Middle Ages the production of iron was essentially the same – ore was heated to produce a small 'bloom', a spongy mass of iron and various impurities weighing about two or three pounds. This then had to be hammered by hand into shape – and welded onto other iron if a large object was to be made. When water-powered trip hammers, such as those at the Finch Foundry at Sticklepath in Devon, UK, were made, it was possible to build larger kilns and forge blooms of 2 cwt. (100kg) or so. Until the Industrial Revolution and the use of coke for iron production, iron was a relatively rare and expensive material. This makes the use of iron on doors such as the one at Dartmouth Church even more impressive. As furnaces developed, it became possible to melt iron and produce 'cast iron' which has a higher carbon content and is rather brittle in comparison.

During the 16th century there was great concern that England's forests were being consumed to make charcoal for ironmaking. There was even a thriving import trade from Spain around the time of the Spanish Armada, which served to reduce the forestry losses to an extent. It was only when Abraham Darby and others discovered that coke, rather than charcoal could be used for iron production that iron and steel began to be produced in large quantities. This provided important catalysts for Britain's Industrial Revolution.

In earlier times, as well as being scarce in its usual form, hardenable steel – with a higher carbon content – could only be obtained by carburisation (essentially heating with charcoal) or by separating the centre of the bloom from the rest. The quality of steel was later improved by heating blooms in a finery which used a powerful air blast to oxidise excess carbon content. From the 18th century onwards, many improvements were made in the production of iron in many different countries. For example, the clockmaker Benjamin Huubman developed a reliable crucible steel process, and his insight that the iron and the fuel must be kept separate led to Henry Cort's puddling process. Pig iron (with about 4% carbon) was melted, and iron ore or hammer scale added to it; the mixture was stirred so that the carbon escaped in the form of carbon monoxide gas. The stirring caused some slag to be mixed into the iron; some of this was hammered out of the puddle ball, but it helps to give wrought iron its character. This mixture was rolled out then further layered by piling up puddle bars and rolling them out, causing the layers to weld together and produce the characteristically fibrous wrought iron. The inclusion of slag is often said to make corrosion advance over a broader area, in comparison to the pitting effect on mild steel with similar sulphur content. The slag layers, as they are more brittle than the iron layers, can lead to splitting along the grain, so to minimise the consequences of this characteristic many forging operations were developed over the centuries to work with the grain. Generally, as with a rope, the tensile strength is retained more effectively by not cutting through the strands. Holes may be punched by, in effect, prizing the strands apart; loops are best formed by welding bent-over sections together with their grains parallel to each other. Puddling replaced the finery process and was the most important process for around the next 100 years, until it was superseded by Henry Bessemer's air-blast conversion.

Many improvements have been made in more recent times and it is possible to specify very accurately what is the content of steel and other alloys. Modern steels are mainly produced using basic oxygen vessels, electric arc furnaces being used for special high carbon, alloy and tool steels. Many

Copper repoussé finial made for the New York Police HQ by Metaliers Champenois, Reims, France – who also made the new flame for the Statue of Liberty.

other elements are added to steels to achieve the desired properties, including manganese, silicon, chromium and nickel (especially in stainless and tool steels), tungsten, molybdenum and vanadium (in tool and harder steels), copper, niobium, vanadium, titanium (in strip and bar products but often in reinforcing steels, in which they may cause wrongly heated material to become more brittle).

Forging and forming may be done while the metal is hot or cold – sometimes, thin work is better bent cold as this tends to 'work harden' it and make it more structurally sound, although too much cold working will cause the material to crack. Work-hardened metal may be softened by heating it above its recrystallisation temperature and allowing it to cool, a process known as 'normalising' (cooled in air)

or 'annealing' (cooling slowly in a furnace). If you slightly bend an annealed piece of metal it will spring back into its original shape – this is known as elastic deformation. If you bend the material beyond what is known as its 'elastic limit' it will stay in the new shape, after springing back a little – this is known as 'plastic deformation'. Bending the metal beyond its plastic state will cause it to crack, so smiths are mostly in the business of plastically deforming metals. The springiness of materials is described by Young's Modulus which is a ratio of the stress (force applied) and the strain (the amount of deformation); this ratio is constant throughout the elastic range of the metal, but does not apply during plastic deformation or, more obviously, failure.

It is possible to cold work and anneal metals in

A piece of 18th century repoussé work held by Serge Pascal of Metaliers Champenois of Riems, France.

turn, the norm when working with copper sheet, for example. This can be a convenient way to work sheet steel, as with 'repoussé' where the back of the work is hammered cold onto a lead or pitch block. However, if the metal is plastically deformed at above the recrystallisation temperature – red hot – then when it cools down it is in a normalised state, and in its new shape. This hot forging is at the core of the work of the blacksmith.

Some cold bending and working is done by even the most enthusiastic hot forgers, to make adjustments, stiffen components or in operations such as repoussé. Hot forging processes depend upon softening caused by changes in the microstructure of the metal when it is heated. Hence the well known expression, 'strike while the iron is hot'.

Most common metals – for example copper, aluminium, or gold, can usually only be softened by heat treatment. Steel may be both softened and hardened by heat treatment; the extent and ease of hardening and softening – tempering – depend upon the amount of carbon. This a very complicated subject, but essentially, heat changes the crystal structures of iron and iron-carbon compounds from the ferrite form

with a body-centred cubic structure (at a microscopic level) to the softer austenite which has a face-centred cubic structure. As the steel is heated it forms an intermediate body-centred tetragonal structure known as martensite. The ease with which martensite is formed determines the ease of hardening.

The carbon content of the steel determines ease of formation of martensite and ease of hardening. Carbon dissolves in austenite, but not much in ferrite. If the steel is heated above 723°C (1333°F) and then cooled quickly, for example by quenching it in water or oil, then its structure is frozen in a slightly distorted state – it becomes hardened. To control how hard the steel is, it may be tempered or softened, which involves reheating it carefully, either to a known temperature in an industrial process, or until it is possible to see the distinctive tempering colours which signify the changes in crystal structure, and then the steel can be quenched once again. The higher the percentage of carbon (0.8% is the minimum for hardening) the easier it is to form martensite – although this can be affected by different alloy compositions including those with nickel, manganese, silicon etc. Cast iron generally has a carbon content of more than 4% and cannot be hardened and tempered in the same way as steel.

Carbon, or carbon-rich, material can be packed around steel as it is heated; at over 1000°C (1832°F) carbon diffuses into steel relatively easily. This is known as 'carburisation' or 'case hardening'; a process used in the production of swords. There are a number of industrial processes for hardening steel, but these and the more historical processes tend to leave the surface harder than the centre of the material – actually quite useful for an edge tool, where a hard edge is needed in addition to toughness – resulting in a product which will not shatter in normal use.

Non-ferrous metals – those other than iron and its alloys – can also be forged. The principles are similar, but the temperatures of forging and heat treatment differ. Forging brass and bronze is

possible, but some kinds tend to crack rather than deform plastically, so you should seek specialist advice about the composition of forgeable alloys. Aluminium bronze, which is an alloy of 8% copper and 92% aluminium may be forged, but it needs to be annealed after deformation of 20% or so. Naval brass may also be forged.

Forging bronze or brass tends to require the use of hammers whose surfaces are unblemished: Mike Roberts, who specialises in working with these alloys, stresses the importance of keeping the faces of his hammers polished in order to minimise cracking. The forging temperature range for copper alloys is lower than for steel, and the material will melt more easily. The rate of heat transfer is quicker than for steel, so you need to forge it more quickly, and make sure that you use tongs to hold hot workpieces. Care has to be taken not to forge copper alloys at too low a temperature, or they will crack. Aluminium, and many aluminium alloys, also forge very well, although at a lower temperature than steel.

(Above) Oskar Hafen, Friedrichshafen, Germany, 1988, gates in bronze.
(*Below*) Iron rolling at Coalbrookdale Museum.

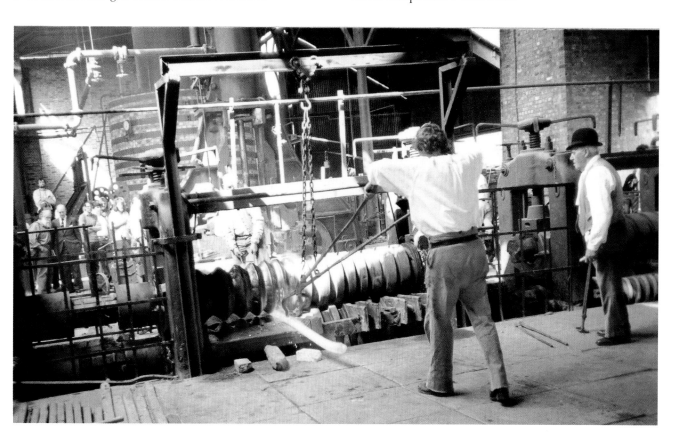

Heat Sources

Although electrical processes such as induction may be used in an industrial context, smiths normally use combustible fuels. Wood, peat and charcoal may be used, but coal, coke, oil and gas are the most popular fuels for forges and furnaces.

Charcoal

Before the widespread availability of coal and coke, charcoal was the most common fuel for forging. In recent years a number of smiths have increased their use of charcoal, for environmental reasons. It produces a good heat, and has both advantages and disadvantages over coal. It is perhaps too easily blown around by draughts or forge blowers for most people's taste, but has the advantage that you may produce cleaner forge welds using it. Japanese swords are forged using it, and many smiths add a piece of wood or charcoal when forge welding to help keep the fire a little cleaner (with less slag, which could contaminate welds).

Coal

Smiths' coal has been the blacksmith's main fuel source for many years. Small beans of relatively clean bituminous coal were favoured when available, but its availability in the UK has diminished in the last ten years. Its advantages for general smithing work are a fairly high burning temperature and the ability to coke-up, especially with the application of water. This means that the forge fire may be changed in shape relatively easily, to accommodate different types of heating requirement, although vigilance is required to make sure the fire does not go out of shape. An alternative to coking the coal is to use firebricks to deflect or contain the heat as required.

Coal is formed over many centuries from compressed plant matter, and its precursors include peat, lignite, sub-bituminous, bituminous, semi-bituminous coals, semi-anthracite, and anthracite. Peat, lignite, and sub-bituminous coal have high moisture content, but are rather low in fixed carbon, burning at a relatively low temperature. Semi-anthracite and anthracite are low in moisture, have plenty of carbon, and burn at a higher temperature, but they lack volatility and coking properties. Using anthracite also tends, because if its high carbon content, to lead to a rise in the carbon content of the item being forged through surface carburisation. Bituminous coal, therefore, makes the most suitable coal for the forge. Bituminous coal is available in various qualities and grades – coal dealers can advise on the best grades to use from those they stock.

Coke

This is partly burnt coal, and many smiths use it by choice, as it can be more consistent than coal and produces less smoke. Some smiths also like coke as it tends to flare up less than coal; this means that when working with a big fire, the forge produces less heat into the workplace and can make working more comfortable. Coke also produces less smoke and so might be preferred as more neighbour-friendly than coal, which can be very smoky, especially when 'lighting up'.

There are those who prefer coke and those who prefer coal, and those who use a mixture of fuels for different purposes, to mix coking properties and lower smoke emissions. In practice it depends on the exact composition of the fuel and individual preference or working style.

Gas

There is no doubt that gas furnaces have become more popular over the last few years, especially in the UK, as it has become increasingly difficult to get good quality smiths' coal, and environmental pollution laws and regulations have made using coal

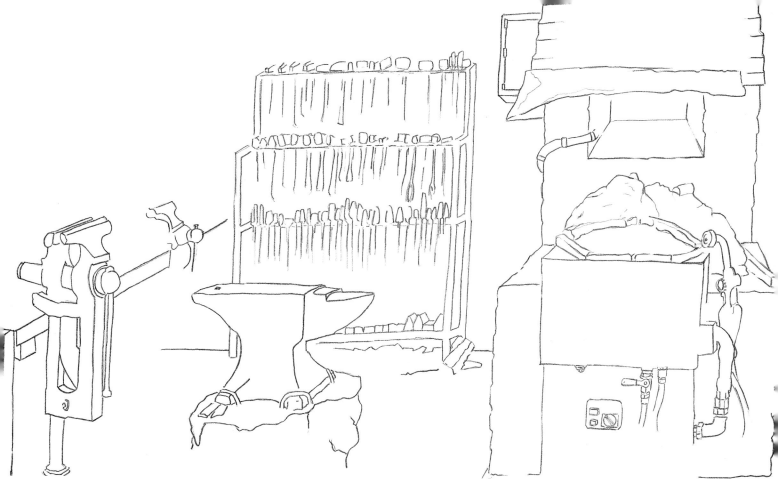

Drawing by Clare Hawkins of Neil Hawkins' studio workshop showing leg vice, bench, tool rack, London pattern anvil, coal forge, and ceramic chip forge.

more problematic. The number and quality of gas forges and furnaces aimed specifically at the blacksmith and farrier has increased to fill the fuel gap left by coal. Some smiths prefer to build their own, but the most common types of gas heating appliances are either furnaces or hearths. Furnaces are essentially insulated boxes with burner, and openings at one end or both ends to accommodate longer pieces that need to be heated in the middle. Gas furnaces may be useful for general work and for keeping a number of pieces consistently hot. They may be single-door or twin-door types – the latter allowing longer pieces to be heated – and come in a number of sizes. The walls of a gas forge glow, and the gas burns in a catalysed, or energised manner, creating efficient combustion.

Hearths are modelled on the traditional forge, but with a burner in the base and ceramic chips which are used in a similar way to coal or coke. Gas forges

using ceramic chips may be a convenient heat source. In use, the ceramic chips are much like a coke hearth, but the capital cost is a lot higher. Oil and liquid Petroleum versions are similar to gas furnaces and have similar applications. Both types of gas appliance have their attractions, and these days it is possible to forge weld with them; earlier ones were compared unfavourably to coal forges because they could not heat the metal sufficiently to forge weld. The box type gas forges are more efficient and maintain a more consistent temperature – useful when forging a number of components or pieces – but the ceramic chip type can cope with larger or more irregularly shaped work, an advantage they share with the conventional coal forge. In practice, it is quite usual for smiths to have a number of different heat sources for different purposes. My father, for example, has a coal forge, a ceramic chip forge, and oxy-acetylene and propane torches for various types of work.

Although coal and coke forges are still very popular, gas is becoming the most popular heat source. It is relatively clean, easy to use and can produce a consistent controlled heat, which would require considerable skill when using a solid fuel forge.

Oxy-acetylene torches, although they are used mainly for welding, brazing and cutting, may also be a useful localised heat source. Propane and natural gas torches can be useful for heating in awkward places, applying localised heat, bending, straightening, normalising or annealing sections of pieces. Propane gas has about twice the heating (calorific) value of acetylene, but burns more slowly, so less intensely.

Tools

ANVILS

The earliest anvils were stone and provided the basic function of being a heavy hard surface to hit something against – at first other stones. The classic Japanese or African anvil is a rectangular block set into the ground and is used while sitting or kneeling; this way of working was practiced in Ancient Greece and is also popular in India and Southeast Asia. These types of anvil, although they are highly suitable for their intended purpose, are less suitable for forging larger pieces, or for work such as horse shoeing, where frequent trips away from the anvil make it easier to work in a standing position.

The designs of most European and USA anvils have evolved from the need to work in a variety of ways, often involving general blacksmithing, repair work, decorative smithing and farriery (horseshoeing). The London pattern anvil, with a single beak, is the most popular kind in the UK, whereas in Continental Europe the double-beaked anvil is more popular, although many smiths use both. There are many variations in size, and in features added for specialist

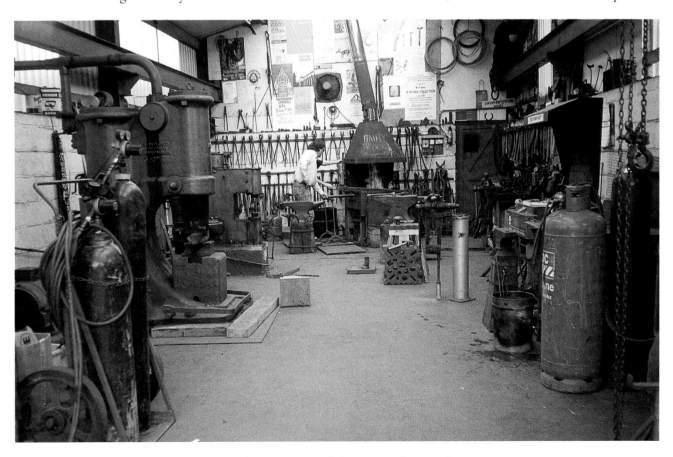

David Petersen's workshop in St Clear, Wales.

purposes, for example, a small square face at right angles to the main face, for welding links in chainmaking.

The size of the anvil depends upon the intended use – a typical general purpose one would be around 2 cwt. (about 100kg). A farrier's portable anvil might be nearer to half that weight or less. A lighter anvil will tend to bounce around on its stand if you do heavy forging or use a sledgehammer – especially on the ends, where greater leverage applies.

Good anvils generally have wrought iron or steel bodies, a hard steel face and a quick rebound when struck with a hard hammer. This rebound makes the work a little easier. Good anvils usually ring when struck gently on the face, showing that they have few cracks or imperfections – a dull sound is not a good sign. Small anvils will ring more, while large anvils ring less.

Most London-pattern anvils are intended for general blacksmithing and so have features useful for making horseshoes, in addition to other forging. There will often be a portion of the far edge radiused so that clips may be straightened without breaking. There are two holes in the heel; a larger square 'hardie hole' for mounting tools such as a hardie, heel cutter, or bottom fuller, and for general punching; and a smaller round 'pritchel hole' for punching nail holes in horseshoes whilst supporting the shoe so as to minimise distortion. Between the face and the beak is a small step-down, useful for bending and straightening and made of softer material than the main face; it's softness makes it useful for cutting and chiseling, minimising damage to the edge of the cutter or chisel, and so keeping the face of the anvil free of cut marks.

Perhaps the majority of people prefer to use a London pattern anvil with the beak on the left, but many put it on the right, a preference strangely unconnected to being right- or left-handed. I prefer to have the beak on the right most of the time, and my father prefers it on the left, but we are both right

handed. In practice a job may require the use of the anvil from both sides – for example when bevelling scroll forms. A double-beaked anvil might be best sometimes. The weight and shape of the anvil used might be varied with the work – for example, work with larger sections of material or with a striker might require a heavier one.

For comfort, especially with prolonged use, an anvil should be mounted so that the user can just touch the face with their fingertips when standing in front of it. If the anvil is too low, it can lead to back problems and if mounted too high, repetitive strain injuries are more likely in the shoulder region.

HAMMERS

Hammers are one of the tools most associated with the blacksmith – the motto of the Worshipful Company of Blacksmiths is *By Hammer and Hand All Arts Do Stand*. As with most tools, they evolved over the centuries to suit local conditions and patterns of work. Although the range available today is relatively limited, by around the turn of the last century, there were hundreds of patterns available for every conceivable purpose in a range of sizes. In the UK, hammers could be had in Lancashire, Kent, Canterbury, Sheffield and many other patterns, and were shown in a wide variety of catalogues. A basic kit for a smith requires several sizes and patterns of hammer to fulfil most functions. Many smiths still make their own hammers for particular purposes, or adapt existing ones for specific purposes. A photograph of one of my father's hammer-racks shows quite a range of shapes and sizes.

General-purpose forging hammers weigh around 2lb. (1kg) as an average size, but personal preference and the job in hand will cause this to vary. The length of the handle also varies; some smiths, like Terrence Clarke, prefer a heavier hammer with a short handle, as a longer hammer can get in the way. Others prefer a longer hammer shaft so that they can

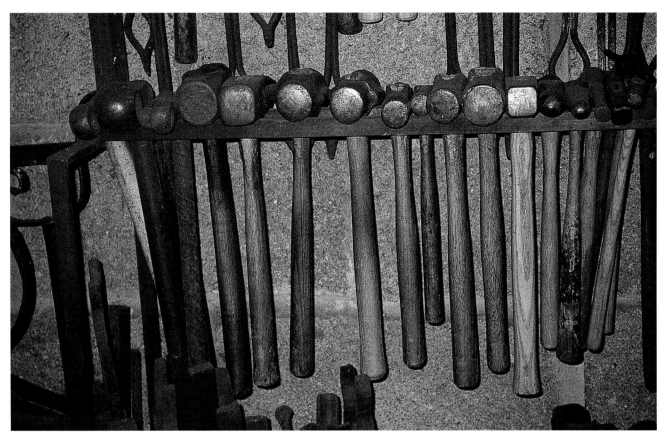

Rack of hammers, Neil Hawkins' studio, Devon.

stand back further from the work and make the hammer hit with a higher velocity. In practice, both approaches make sense according to the job in hand and the preference of the user.

The force of a hammer blow is described by Newtonian physics, such that the force is equal to half of the mass (weight) of the hammer multiplied by its velocity squared (velocity x velocity). In theory, therefore, the force is affected more strongly by the speed of the blow than by the weight of the hammer. However, hammer blows are rarely in a straight line, and get faster as the blow progresses, until the point where they hit and slow dramatically. The momentum (mass x velocity) is clearly an issue, otherwise one size of hammer would do most jobs, and all that you would have to do to change the weight of blows would be to vary their speed.

If the hammer blow is begun so that the forearm is vertical and the hammer over the shoulder, it can

then be continued almost vertically, the hammer being pulled down sharply towards the workpiece. The same principle applies to the use of two-handed sledgehammers, where pulling them down, rather than trying to push them is more effective. Hammer blows can be made so that they land on the workpiece at any angle required, but the idea of pulling rather than pushing works the same way.

The degree of control offered by hammers of different weights, sizes and shapes is important and can be a matter for preference. For example, a farrier's cat's-headed hammer is useful because it has a flat face, a curved face and on the other two sides effectively a cross-peen and a very small peen intended for making certain kinds of clips in horseshoes. In effect, the same hammer blow can be used to apply force over a wide area on the large flat face; a narrower area, giving greater penetration with the curved face, and still smaller areas using the

other two sides. In making and fitting horseshoes, and in particular the large shoes intended for carthorses and drays, the hammer may by twisted around in use to make different kinds of blows without changing hammers. Even for my father and I, neither of whom is involved with shoeing any longer, the cats-headed hammer is still a great general-purpose hammer. My father has two kinds, one that is squarer, so that all four sides are about the same distance from the shaft; and another kind (which I also have) in which the two main faces are substantially longer than the others. The squarer one feels well balanced and works well in all four directions, but isn't as good for making heavy blows,

as the faces are wider. It is easier to control, making it much better as a shoe-turning hammer. The longer-headed version is a little more of a 'blunt instrument', and is fine for heavy or general forging.

Perhaps the most common sort of general purpose hammers are square cross-peen varieties, two of which are illustrated here: a German one, with a flat face, and a Swedish-pattern one with a slightly curved face and distinctive bulge around the shaft. Engineers' ball-peen hammers are often used, but a square head can be useful when making some kinds of corner or bend. Many French hammers have an offset peen, which can give some advantage, rather like the traditional London-pattern hammer, in that the centre

(*Above*) Swedish style cross-peen hammer – this has a slightly curved face.

(*Opposite, above*) Cat's headed hammer.
(*Opposite, below*) German style cross-peen hammer – drawings by Clare Hawkins.

49

Ball-peen hammer – drawing by Clare Hawkins.

of gravity is not directly over the centre of the face.

For long term use it can be better to use a hammer shaft which is a little thinner than the ones commonly supplied with new hammers. A slightly thinner shaft has a little more spring, which can lessen the impact for the user's wrist, allowing them to work comfortably for longer- clearly not too much thinner or the wood will snap in use. Ash or hickory are often used for hammer shafts, and should have a straight, knot-free grain – although plastic or metal shafts are used for some other types of hammers, wood is preferable because it can absorb shock and doesn't melt.

For heavy-duty work a smith can work with a 'striker' using a heavy, two-handed sledgehammer (typically 10–14lbs or 4.5–6.5kg). Tools such as cutters, punches, sets, sirages, etc may be held by the smith as the striker executes a blow. A smith can work with a striker by making a blow with a hand hammer to show where the heavier strike should be made.

To achieve a surface finish free of hammer marks, the face of the hammer needs to be very slightly concave, or at least to have edges above the centre on impact with the workpiece. With prolonged use even the best hammer will tend to wear out a little in the centre of the face – making it slightly concave, and therefore more likely to mark the surface of a piece of work. Hammer faces – like all other tools need to be maintained periodically to maintain the quality of work, and to assist with safe working. The inspection, maintenance, and if necessary the replacement of tools, is all part of good workshop practice.

TONGS

When smaller or very hot pieces of metal to be forged, they can be held with or gripped with tongs. The are in effect a pair of pliers and because they have long handles and a short mouth, a firm grip can be taken on a workpiece. The mouth of the tongs should fit the workpiece well to ensure the best grip. Many smiths make or customise tongs for a particular job. Some tongs have a clip or a ring that can be slipped down the handles in order to grip a piece more firmly. A rack of tongs and hammers is illustrated, as is a pair of 'universal' tongs which have a series of notches and allow workpieces of various shapes and sizes to be gripped effectively. Because of the large forces and great speeds involved when using power hammers, it is important to ensure that the tongs gripping the workpiece encircle it

Universal tongs' – with indentations for gripping various shapes and sizes of workpiece – drawing by Clare Hawkins.

completely – otherwise control over the workpiece may be insufficient, compromising safe working.

VICES AND ROLLERS

Vices, and especially leg vices which are connected to the ground, allow work to be gripped at one end and bent or hammered whilst hot, to correct or adapt shapes or bends. Forks and wrenches can provide better leverage for bending. Although scroll forms may be achieved using the beak of the anvil

Leg vice – it is set into the ground and fixed to the bench to allow work to be hammered while being held in the jaws – Neil Hawkins' studio, Devon, UK.

alone, in order to aid repetition and accuracy, scroll formers may be used alongside wrenches and tongs. The indentations in a swage block, the step between the beak and face of the anvil, and – even for small pieces – the top of the hardie hole, are all useful aids for bending and straightening.

Rollers may also be useful, normally for curving cold bars. The sort used in previous times for rolling the metal tyres of wooden cartwheels are very useful if you can get hold of one, but there are also a number of contemporary products on the market.

FORGING TECHNIQUES

There are a number of important operations which, when combined, allow the smith to create a wide variety of shapes in metal; drawing down, bending, joining, cutting, punching, upsetting/jumping, twisting and welding are amongst them. Forge welding is one of the most interesting techniques, and merits separate consideration.

DRAWING DOWN

Essentially this is any operation which reduces the section of the material. It may be to change a round shape to a square one, a square to a round, or to taper or point a piece. This changing of section, with the obvious exception of pointing, may be done to any part of the metal, and is extremely useful. Although hammer and anvil are often sufficient to produce the effects, there are a number of other tools that allow the smith to produce more uniform or accurate results.

As you hit the top surface of the metal with the hammer, a very similar effect is achieved on the anvil side, so that striking with the workpiece parallel to the anvil will reduce the section evenly on both sides, to give two flat faces. If the workpiece is struck at an angle to the anvil, a taper or point will start to form.

Changing from square to round section is the

reverse of changing from round to square, where you first produce an octagonal section, then concentrate on making four of the sides larger to create the square. A square section can be struck with one corner uppermost and the opposite corner against the face of the anvil, then if the piece is rotated through 90° and struck again, an octagonal section will result. A similar operation with the eight new corners will leave an approximately round section which could be swaged, filed or hammered to improve the roundness.

Although drawing down results first in equal curvature or slope on opposite edges of the metal, it is quite straightforward to flatten one side on the face of the anvil if a one-sided effect is desired. Turning a workpiece over and hammering on alternate sides whilst holding it at an angle will create a point; if more work is put into two of the sides then a chisel shape will be the result. During either of these pointing operations, the end or tip will become hollow unless an occasional tap is given to the end.

BENDING

When softened by heat, there are numerous techniques for bending, to produce rougher or more precise effects. Hot forging allows you to bend rectangular bars, for example, around their longer or shorter edges, something not possible without considerable distortion when using cold bending. Several parts of the anvil may be used for bending, the effectiveness depending on the leverage offered. Essentially, bends may be made with the anvil by hitting the overhanging part of the workpiece; by supporting the end of the piece on the anvil and striking towards the middle of the piece; or, with less chance of controlling the bend, by supporting the piece and hitting it on the end. The beak of the anvil is especially useful for bending bars. Striking a workpiece with a convex fuller into a concave depression produces bowl shaped depressions. If the

work is struck as above, when not directly in contact with a surface, it will bend rather than reduce in section. Generally, striking an overhanging piece will bend it; striking it towards the middle when either one or both ends are supported will straighten it.

A mandrel – in effect a large floor mounted cone – can be useful for producing rings or curved forms and is used in a similar way to the beak of the anvil.

Water is especially useful when bending, as it can be used to cool sections of the workpiece which have already been formed, or that you don't wish to bend when forging the hot section. A trough of water near the forge is also useful for cooling finished work and for hardening and tempering higher carbon content steels, although for smaller pieces a metal bucket will do just as well. A small scoop or metal cup can be used to apply the water in exactly the right place – it is also useful for damping down and coking up green coal when working the fire.

FULLERING

Drawing down can be a little quicker if a hammer with a curved face is used, or a series of dents is made with the peen (the side of the hammer opposite to the face). A curved face will push the metal equally in all directions, whereas a cross peen will act rather like a fuller and mostly move the metal longitudinally. Using a curved face hammer on top of the beak of the anvil increases the effect, as does the alternative of using a curved anvil corner. When a section of the workpiece is reduced in any of these ways, any unwanted dents can be hammered smooth afterwards.

Fullers are in effect convex surfaces that increase the effect of hammer blows – they are available in a variety of radii. Typically, a bottom fuller is located in the Hardie hole of the anvil, so that a curve is underneath the piece to be forged, and the smith holds a top fuller with the same curvature over the

Bottom fuller – mounts in anvil hardie hole – drawing by Clare Hawkins.

Flatter with a wooden handle– drawing by Clare Hawkins.

top with a long wire or wooden handle. A striker, using a heavy sledgehammer may then strike a blow on the top fuller producing an indentation on both sides of the forging. A similar process is used for power hammering – the effect is to concentrate the blows and produce a predictable curvature on either side of the piece being forged. If a shoulder is required, perhaps to make a riveted or tenon joint, a side-set or cutter might be used – in effect a fuller with a very small radius. Fullers may be used across a piece, along its length or at other angles to produce grooves as desired. Horseshoes, for example, are normally fullered along the length of the metal to fit the nails, protect them from wear and give extra grip.

SWAGING

Swages are used in a similar manner to fullers, except that they have concave surfaces. They can be used to produce uniform cross-sections, often round, square or hexagonal. It is more usual to forge down to almost the right size, then use the swaging process to finish the piece. Top swages have long handles, rather like fullers, but the bottom part is usually a swage block – a large block of steel with a number of shapes in its sides and holes in its top and bottom surfaces, possibly with an additional dish shape in the top. The swage block is normally put on a stand, which raises its height (for ergonomic reasons) and allows it to be set down in various orientations. Shafts, tenons, bolt ends, finials, and many other components may be manufactured or finished by swaging.

FLATTERS

Flatters and set hammers are useful finishing tools, which can give greater control over surface finish. Flatters are mounted, as with top swages and fullers, on handles and are hit with a sledgehammer to give a flatter surface than would be achievable with ordinary hammering. Set hammers are smaller versions of

flatters that can be used to get into corners and places where accurate hammering is difficult.

JOINING

Some of the most interesting features of forged work are the joints of various kinds – most of which have long historical roots and were developed essentially for use with wrought iron, to minimise cutting through its longitudinal laminations. Mortise and tenon joints are amongst the most visually satisfying and are often used in preference to welded joints because of this. It is possible to pass a bar through another of smaller cross-section by using a punched hole as part of the mortise and tenon joint. Clips have been used extensively over the centuries, but it is important, as with all joints, to ensure adequate corrosion protection, enabling the piece to last if used outdoors. Rivets, hammered over when hot can provide a secure joint, especially as the rivet shrinks on cooling. Rivet heads can provide useful visual accents also. Wire may be wrapped around components to attach them, but this is perhaps best limited to indoor work. Welding, brazing and soldering may also be used to attach components of various sizes, but attention needs to be paid to the strength of the joint – seek expert advice if you are unsure.

CUTTING

Clearly oxy-acetylene, plasma-cutters, saws and cutting discs are useful, but there are other methods, both hot and cold, which may be used for structural and decorative effect. Chisels may be used, both hand-held and mounted on handles – both need to be struck with a hammer. Anvils often have a cutting plate, softer than the face to protect cutters and the anvil's face. A mild steel saddle can be put on the face of the anvil when cutting larger pieces. Chisels used for cutting hot metal have a narrow-angled cutting edge, and those for cold work have a wider angle. Such chisels, if mounted on long handles are known as 'hot set' and 'cold set' chisels. For cutting a bar to length a chisel, known as a Hardie, mounted on the anvil with its cutting edge facing upwards is very useful.

Using a hardie is potentially dangerous for spectators, if you attempt to cut all of the way through a piece from one side, and it will damage both the edge of the hardie and the face of the hammer. The end of the piece (which is probably still red hot) can fly at great speed away from the anvil! It is best to stop before you cut all the way through and turn the piece over and tap very gently to break it

Hot set – head.

Hot Set, including wooden handle – drawings by Clare Hawkins.

off, or alternatively cool the tip in some water and gently tap it off over the edge of the anvil.

Cutting can be used for decorative effect and in a variety of forging operations, to split bars lengthwise, create tapers, notches, etc; a piece partially cut through may be bent back over itself and forge welded together to create a thicker section.

Oxyacetylene cutting has been used for decorative and practical purposes for many years, but in recent years the plasma cutter has become more popular. Plasma cutting is an electrical process, where an electrode is used to melt metal on the top of a workpiece and compressed air is used to blow it out the other side, creating a thin slot as the torch is moved along. Plasma cutting produces a neater more localised cut than oxy-acetylene, and unlike it, may also be used to cut aluminium, and other non-ferrous metal.

Laser, water jet, and other cutting processes can produce even more precise work than plasma cutting but are normally only found in a large scale industrial context.

PUNCHING

Although hydraulic and pneumatic punches may be used, some of the most satisfying effects can be achieved by hot punching. The pritchel (a small, tapered rectangular section punch used to make the nail holes in horseshoes) hole and the Hardie hole in the anvil are very useful, as they allow a punch to be forced through a piece while the portion surrounding the hole is supported. Punching may be applied as surface decoration, as in the case of the ironwork on the doors of Nôtre Dame in Paris, or as used in a contemporary vein by Brad Silberberg of the USA.

To produce a punched hole it is first normally necessary to punch a slot, then open the slot out or stretch it to the desired size – the hole may be round, square or some other shape, and can be parallel or tapered. Punching is one of the few practical ways of forming a shaped tapered hole. When punching a hole, make sure the workpiece is hot, or penetration will be difficult. It is best to punch in a short way then remove the punch, perhaps reheating the piece, as it will shrink around the punch. A useful tip is to sprinkle a little dust from the forge into the hole before punching to prevent sticking. When you have almost punched through, you can reverse the piece and punch through on the other side to avoid damage. Punching over a swage block can also be useful if a hardie or pritchel hole is too small or absent.

Small punches, known as 'Drifts' can be

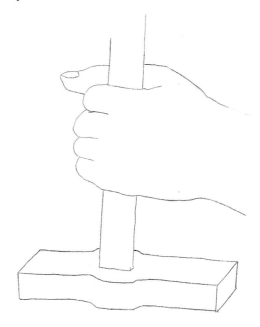

(*Left*) Square punch on a 'wire' handle.
(*Centre*) Hexagonal punch.
(*Right*) Hand-punching a hole in a bar – drawings by Clare Hawkins.

(*Left*) Key-punched bar – the first stage of hole punching. (*Centre*) Opening out – the second stage of hole punching (*Right*) Final stage of hole punching – opening out with a round punch – drawings by Clare Hawkins.

knocked all the way through punched holes to ensure they are the correct size. For round drifted holes, the length of the chisel cut is equal to the final diameter required multiplied by pi (π) and divided by two. For square holes, the slot needs to be one and a half times the length of the side of the hole.

UPSETTING AND JUMPING

The end or centre part of a bar can be swollen when heated – preferably to a bright yellow heat – if either end is hit on a cold part. This kind of operation is especially useful prior to punching a relatively large hole, as extra material is required in the areas to be punched. The effect is to squash the bar in the softer, hot section. The bar can be hit on the floor or the surface of the anvil or swage block so that its own weight assists, or hammered on the end. The force of the blow is used to deform the bar, although if a large bulge is required the piece will need to be heated a few times, and probably straightened on the anvil in between to prevent excessive distortion. Cooling with water can ensure the swelling only happens where required. Bars are normally 'upset' on their ends and 'jumped' towards the centre, but as with many things related to blacksmithing, it depends who you ask.

TWISTING

Twisting is one of the most useful decorative effects. Single bars may be twisted, bars cut, tapered, spread and fullered, or bars twisted together. Essentially, one end of the twist needs to be held while the other end is rotated. A bar may be held at both ends and twisted in the centre. Wrenches and vices are especially useful, and some smiths, like Albert Paley, have developed special expertise in, and equipment for, twisting. Section of bars that have been twisted may be forged into other shapes and joined to other components as required. An even temperature is required for an even twist, so water can be useful for stiffening sections of bars. A secondary heat source, such as a propane torch can be useful for controlling the ease of twisting whilst in progress, especially in the case of longer sections.

POWER HAMMERS AND PRESSES

Whilst hand hammering is adequate for many forging processes, power hammers and presses allow a smith to work on heavier sections, or to carry out tasks where an extra pair of hands would otherwise be needed. Swaging and fullering often require working with a striker using a sledgehammer, but they may be carried out single-handedly using a power hammer. The most basic kinds of power hammer are trip and drop hammers, similar to those that have been used for centuries. Blooms of iron have been hammered to make wrought iron since the Iron Age and fullers have been used since the earliest times to draw down sections. Foot-operated hammers are some of the most basic types and include *Olivers* or treadle-hammers, which use leverage to operate a

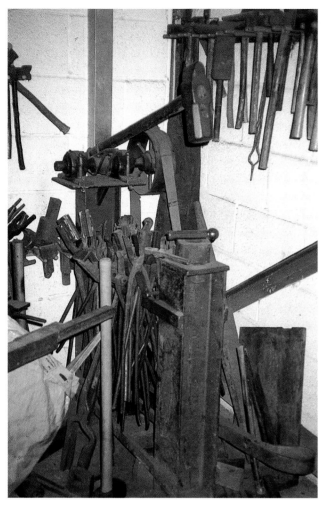

Foot-operated treadle hammer – or Oliver – in Alan Evans' workshop, Gloucester, UK.

Power hammer in Alan Evans' workshop.

sledgehammer and a spring to return it ready for the next stroke. A more sophisticated version is the Blacker Type A, but it is still less convenient to use than the powered Type C and B, the latter having the ability to traverse the anvil so that more than one operation may be done in one heat.

There are numerous spring hammers, such as the Goliath, Little Giant, Hercules, Bradley, which have been made for many years and were mainly driven by belts, powered either by steam engines, water wheels, electric or internal combustion engines. Nowadays, they tend to be driven by electric motors. As many rural forges had no access to electricity until relatively recently in the UK, treadle hammers were about all that was available until well

after World War II. There are still examples of the earlier trip hammer, powered by water wheel, in a number of countries. It operates a little like a see-saw where one end is pushed downwards by a cam or cog-like wheel, raising the hammer end, which then drops down onto the workpiece.

James Nasmyth, a prolific engineer and inventor, first described the general principle of the steam hammer in 1838, the same year that he invented the hydraulic press and the torpedo. In 1843 he produced a practical version, which used a vertically mounted steam cylinder and appropriate valves to propel the hammer or tup up and down. These hammers played an important role in industrial production until relatively recently.

The modern version of the steam hammer, and even former steam-driven hammers, are pneumatic, and capable of quite delicate control as well as delivering heavy blows, as were the early devices. Nasmyth himself demonstrated the level of control by bringing the tup of his hammer down upon delicate objects such as eggs and glasses, without breaking them. Hammers vary in the degree of control they offer, as well as the weight of blows (mainly determined by the weight of the tup, the air pressure used and the system of valves).

Hammers such as the Massey and Allday and Onions, although no longer produced, can be excellent tools if well maintained. There is an increasing number of good quality, pneumatic (air-driven) hammers on the blacksmithing market, including the Reiter (now named the Kühn) from Germany and those marketed by Vaughans in the UK. Power hammers can be dangerous if used without care and proper instruction, in particular because of the speed and weight of blows.

Hydraulic and pneumatic presses are normally cylinders mounted in a framework, allowing pressure to be applied to a work piece, often of many tonnes. Presses vary in their speed and force, and may be hand-pumped or powered; speed presses are becoming popular for hot working in particular.

Power hammers and pneumatic and hydraulic presses can allow the smith to work with larger sections of material than might otherwise be economic. They may be used to produce precise forgings, but also to produce highly textured pieces with great character, where there is an opportunity to emphasise the plastic character of hot metal. Both approaches can be celebrated in the creation of work that is both precise and expressionistic.

There are numerous tools that can be used in conjunction with hammers and presses to bend and forge pieces and describing them all is beyond the scope of this book. However, an excellent series of descriptions, with illustrations, of how to use a power hammer for a variety of operations can be found in *Blacksmith's Manual Illustrated*, re-published by the RDC in the UK in 1991. It contains a wealth of information on how to produce a range of industrial forgings, and is equally valuable for art blacksmithing.

Over the last 20 years or so, various blacksmiths' magazines have produced articles on many aspects of hand forging and of using powered forging equipment. These include *California Blacksmith, Blacksmith's Gazette,* and *Anvil's Ring* from the USA; *British Blacksmith* (now *Artist Blacksmith*) and *Forge* from the UK; *Victoria Blacksmith* from Australia; *Hephaistos* from Germany; and *Kontsmide* from Sweden.

Forge Welding

This is a set of techniques as old as blacksmithing, but probably the subject of more discussion than any other. It requires practise in the judgement of temperature, timing, the weight and speed of blows, and preparation of the components to be joined, etc., or it is all too easy to produce a faulty weld.

Forge welding has evolved as a practical means of joining iron and steel by hammering together at just below the temperature when they melt or oxidise excessively – burn. Burnt metal is weaker and more brittle, so it fails when under stress more easily than metal cleanly welded – it is partly converted to a ceramic after all.

THE THEORY OF FORGE WELDING

Two perfectly clean metal surfaces will stick to each other – weld – if brought together, provided the shapes of the pieces are the same, making a perfect fit. Unfortunately, this chemical cleanliness is only possible under strictly controlled conditions and so it is little more than a theoretical possibility for the smith. The practical solution is hammering hot metal together. Hammering causes the edges of the

Alan Evans holds a demonstration piece showing change of section, forge-welding, punching and bending.

components first come into contact. Temperature control is very important and indoor fire welding is easier than outdoor because the colour of the metal may be seen. Larger pieces may be 'soaked' to ensure an even temperature across the sections to be welded, smaller pieces may burn easily if left in the fire for too long.

There are numerous recipes for fluxes, some of which smiths make up themselves, and some that are bought ready-mixed, but most of them contain borax or clean sand. Fluxes help to disperse and dissolve oxide scale and should be added when the steel is a bright yellow colour. It is important to ensure that the material to be welded is clean, so a clean fire and flux can be very helpful.

material to fit each other, and in so doing, new surfaces are created in the centre of the weld, which are clean enough to stick together. It is possible to help the surfaces to become cleaner by using a flux. Flux becomes molten and picks up surface impurities before being expelled by the hammering process – so it is essential to hammer in the centre and work out towards the edge if there is to be an improved chance of a clean weld. Molten flux on the way out from the centre of the weld may act as a seal, minimising the ingress of air to the weld.

One advantage of wrought iron over mild steel for welding is that it has fluxing agents laminated into it as part of its normal make-up, making it potentially easier to weld than mild steel. However, with a clean fire and skill in the judgement of temperature, soaking time and the weight and speed of hammer blows, it is possible to forge weld mild steel without the use of a flux – although fluxing might reduce the risk of failure.

The preparation of joints for fire welding reflects the need to maximise the area of contact, and ensure that the centre of the weld is where the

PRACTICAL CONSIDERATIONS FOR FORGE WELDING

To maximise the area of contact during the weld, a scarf is made, often by upsetting the end of a bar, then forging the bulge at an angle, and sometimes roughening the surface to further increase the contact area. The scarf is works best if it is convex, so that the weld will start in the centre of the joint. A scarf may also be made by chiselling half way through a bar, bending it back on itself and welding it together, before forging the scarf shape, as an alternative to upsetting, which can take longer.

Correct temperature is very important – in practice it is best to watch an expert do it first and explain exactly what they are doing. Basically, the components are heated in a clean (green coal and clinker-free) fire; some charcoal can be added to clean things up further, until squarish sparks start to appear. Then the blast is reduced to allow the pieces to soak – in other words, to allow all of those surfaces to be welded to reach the same welding temperature. Mild steel should not be soaked for as long as wrought iron, as bits will tend to drop off of the end and oxidise more easily. After soaking, a quick blast of

air is applied, until bluish sparks form, which gradually increase in size until they develop tails and the piece is at welding heat. Large workpieces will probably need to be rotated, and care should be taken to ensure that the air blast does not cool one side down – components should not be put right next to the *tuyère* (nozzle) of the forge. It is important when using coal, coke or ceramic chips as a heat source to make a mound of them in order to retain the heat for welding – an open fire will result in uneven heating and make welding more difficult or of lower quality.

Smiths vary in their preference for tuyères to be mounted at the side of the forge or below, and there are a number of good designs around for different purposes. I have always worked with a side tuyère, but I know others who use both sorts quite happily. In any case a low air blast is best for forge welding because of the cooling effect of the air – even though it is the air which makes the fire burn hotter. Gas forges may be used for welding, but not all get the work hot enough for everyone's taste. Check with the manufacturer, or ask others who have experience of using various types.

Holding pieces together while they are being heated and welded can be awkward, so smiths use various ways to get around the problem. Pieces may be bound together with wire, clips or rivets, which may then be incorporated into the weld or tacked together with an electric welder – a straightforward method sometimes frowned-upon by purists. If two people are working together then these joining methods may not be necessary, as the other person can hold one of the pieces in place for you at least as you start the weld.

If large pieces are to be welded they will require a longer soaking time, and might in some cases be welded in the fire itself. Welds take a variety of forms: scarves may be hammered together, pieces hammered end to end to form *butt* welds, or overlapped to make *lap* welds, one end may be pointed and the other piece formed into a pocket shape, or pieces can be joined together at an angle, and so on.

Small pieces may cool down excessively if you try to forge weld them on the cool face of an anvil. Two ways to mitigate this effect are to execute the first blows of the weld while holding the pieces overhanging the edge of the anvil, or alternatively, heat up the face of the anvil by first putting a large piece of hot metal on it first to warm it up. Whatever the type of joint chosen, the three essentials are correct temperature, matching shape (partly achieved by hammering the pieces together), and clean surfaces. It is important to start the weld by tapping lightly towards its centre, then working outwards, perhaps returning the piece to the fire after a part of the weld is completed.

Sparks and molten flux will fly out of the joint at great speed, so protective clothing is essential. Use eye protection, a leather apron with a bib to cover your chest, and preferably cotton clothing elsewhere – as polymer fibres will melt or ignite too easily for safety or comfort. Forge welding is one of the most magical and spectacular aspects of blacksmithing, but it can also be hazardous if done without due care.

Other Metal-to-Metal Joining Processes

In addition to forge welding, there are a number of other metal-to-metal techniques for joining iron or steel – sometimes to other metals. They fall into two categories: those in which similar metal to the host material is added at the melting point of the metal- fusion welding; and those where a metal with a lower melting point is used, effectively as a metal glue. All of these processes require practise and good quality equipment and expert instruction is strongly recommended.

Fusion welding is dealt with in a host of books and other information sources, so this section will only skim the subject. There are many possible processes, but some are more practical and effective for the smith than others: laser, friction, plasma or

induction welding do not yet find a place in many blacksmiths shops. The most useful electrical processes are: *manual metal arc* (MMA or stick welding) – where a coated rod covered in flux is a sacrificial electrode; *metal inert gas* (MIG) – where a thin wire rod from a reel operates as the electrode and is fed through a shroud of inert gas, e.g. argon, carbon dioxide, or a mixture; *tungsten inert gas* (TIG) – which uses a non-sacrificial electrode to heat the welding area, and a filler rod is fed into the pool of molten metal by hand, also shielded by inert gas.

TIG is a little more difficult to master as it requires both hands to be coordinated, but can give very good quality results. As the heating effect is very localised, it can be useful for welding components which have been partly or wholly cold-formed or adjusted, as distortion is minimised; as the bead is smaller than MMA or MIG, less cleaning up is required.

Although MIG is the most popular and perhaps the easiest to use technique, and convenient for large amounts of welding, MMA, despite being a more old-fashioned technique, can have advantages over it. For example, changing from one type of filler rod is easier than changing a reel of wire, which can be useful if more than one type of steel, is being used. In situations where there is only a small aperture to access a weld, the long thin filler rod of MMA can allow access, where other kinds of welding handset do not allow you to reach. Moreover, if you are only occasionally going to weld cast iron, for example, you only need to keep a few low-hydrogen rods in stock. Welding cast iron is difficult, as the heat is conducted away from the weld more quickly than with mild steel for example, so it is necessary to preheat the area – probably using a gas torch, although there are some electric arc devices with carbon electrodes which can be used, before slowly cooling the metal to avoid cracking. All welding is skilled work and none which is structural or safety-related should be attempted unless you are competent, or have taken appropriate professional advice, such as from a structural engineer or architect.

Oxy-acetylene welding is now almost a traditional process, using a gas torch to heat the weld and hand-fed filler rod. The filler rod is dipped into flux and then into a pool of molten metal created by the torch to form a bead of weld. The process is similar to TIG welding. Oxy-acetylene torches come in various specifications and can also be used for brazing, cutting and heating; it could be considered the most flexible process, although requiring skill and practise to produce adequate welds. For most purposes more effective electrical processes have largely superseded it; propane torches are often used as an alternative localised heat source.

In terms of fusion welding by arc or gas, wrought iron is inferior to mild steel, whose greater homogeneity is an advantage. The alignment of the grain structure within the wrought iron is disrupted and the welded joint weakens the metal, whereas it has been shown that forge-welded joints in wrought iron are slightly stronger than the rest of the iron.

Many special welding rods and shielding gases are available to weld a wide range of metal compositions, and suppliers should be able to advise on the best choice for the materials and uses specified.

Arc welding is used almost universally by fabricators and for many demanding applications, yet many smiths prefer to use forge welding where they can, some for aesthetic reasons, and some because they view it as traditional and therefore preferable. In practice, all kinds of welding and joining have their uses, depending on the priorities of the maker.

Brazing, silver soldering and lead or tin soldering still have a place for joining thinner or cold-formed components, such as repoussé elements, to each other or to steel. The key is to choose one, which has a lower melting point than the components you are fixing together. If a number of smaller components are to be together, different

melting point solders, etc. may be used, starting with the highest melting point for the first piece, then getting lower, although more than one component may be joined at a time if they are wired or clipped together. Brazes and solders are also useful for filling gaps between components, but will melt out if hot-dip galvanising is used subsequently.

Finishes

As the natural state of iron is an oxide, or rust, in many industries a huge amount of effort goes into the prevention of corrosion. For indoor work, many kinds of lacquer, paint, wax, oil-based finish, and others are fine, but outdoor work requires more careful attention.

If steel is treated with wax or oil after being heated to a reasonably high temperature, the grey iron oxide coating which forms will survive without rusting in a fairly dry atmosphere for quite a long time. In hot dry climates this may even be adequate for some outdoor applications; the railings made by Serge Marchal outside the Nîmes house of the Compagnons du Devoir in the south of France are treated in this way, for example. Normally, for outdoor work this scale has to be removed and the material coated with a good quality paint system, or more usually it would be sprayed with zinc or hot-dip galvanised, and primers and paint added on top. Welding can leave residual flux, which is difficult to clean off and might lead to some corrosion of joints. A wire brush mounted on an angle grinder is preferred by many for this job, although some use flap wheels or a combination of approaches for cleaning.

Sand blasting prior to galvanising for outdoor work is a good idea, as then the oxide scale will be effectively removed, and the zinc will stick better to a flake-free surface. Stainless steel is becoming increasingly popular, but is harder to forge. Although it won't normally rust, if you clean stainless steel with a normal steel brush it may actually cause the stainless steel to rust; one of the best ways to be sure it won't rust is to electro-polish it, which adds to the cost but it is very effective. Stainless steel may be patinated using acid solutions – Giuseppe Lund, for example, uses these techniques to produce some excellent colour effects, but there are potential hazards associated, requiring adequate precautions and expert advice.

Two-part epoxy paint systems and powder coating can be reasonably effective, but they may obscure some of the fine detail, as may galvanising. So there is a fine line between providing adequate protection and leaving an aesthetically pleasing surface. There are combinations of paint and graphite dust, which can give outdoor work a similar appearance to wire-brushed and lacquered finishes.

It is possible to electroplate or spray steel with a number of metals, such as copper, chromium and nickel. Aluminium may be anodised, which involves electroplating the surface with a lacquer, which then can be dyed in a wide range of colours and shades. The choice is probably best made by consideration of aesthetic, economic and corrosion issues and developing a range of solutions which suit your needs best over a period of time. Paint companies, industrial finishers, and others can give advice on the huge range of options available.

The use of colour has been an issue, from time to time even an ideological one. Now that just about any colour is available, there is very little reason other than an aesthetic one, for saying that ironwork *should* be finished in certain colours – the decision is one of fitness for purpose and personal taste. The grey and greenish finishes of more than a century ago have more to do with the development of paint finishes than aesthetically driven choice. How you use colour depends on whether you want the viewer to concentrate on the finish or the shape, the construction or overall design, it is primarily an issue of taste and design intention.

Design Considerations

Design can be a controversial subject as it is often confused with taste. In practice it is mainly about producing something which satisfies the requirements, opportunities and constraints of the site, the mode of use, the budget and aspirations of the client, the intentions of the maker, any legal or safety issues, and engineering or structural requirements. It is only when all of the factors affecting how and why a piece was made that the success of its execution may be judged.

Having said that, there are a few things that a designer might consider. The site, or where the piece will be located and used, might be indoors or outdoors, a public or private place. Integrating elements of site and product can provide cues and inform the design. The history or cultural importance of the site may be important, although at other times the intention may be to provide a stark contrast with the surroundings. A client's views on this are likely to be important, since they are a key part of the motivation for the project. Objects have a cultural identity, and ownership or connection with them is part of the development of the identity of the observer, client, or commissioner of work.

The size or scale of the piece will affect its visual impact, its structural design, the cost and difficulty of manufacture and transport – anecdotally; size appears to create an exponential increase in costs and difficulty. Making a small model or maquette of a large proposal, and having structural calculations done would seem to be essential. For smaller projects, experience and rule of thumb, may be sufficient.

The proportions, shape, texture and complexity of a piece will have as fundamental impact as scale, and are linked to it, although these effects are often more important aesthetically. A wide vocabulary may be employed to describe the largely subjective or emotional impact of design decisions made in these areas – words like elegant, strong, daring, innovative, natural, contrasting, etc. may be used to identify exactly why a piece 'works' or not. Some designers use systems of proportion such as the *Golden Mean,* or mathematical series to assist in finding a satisfactory solution; however, a better design is likely to result if these are used as a starting point or basis for comparison, rather than a strictly rigid system.

As has been discussed in earlier chapters, the motivation or intention behind a piece is of paramount importance. The piece may be a functional, or a work with reflective or self-referential elements, or one bound up with rules and regulations, or some other approach may dominate. You can be sure of mixed reactions whichever approach you take – not everyone will like it. From my point of view a design works, when those who were supposed to like it, actually do.

It is often the requirements and constraints of a design, which lead to the most interesting decisions, thereby shaping the project. There are those, who for their own quite legitimate reasons, impose constraints themselves, such as working only in wrought iron using what they see as traditional methods, or working only in bronze; others will use whatever happens to be the best material to suit their intention, and begin to use other materials to take a product design approach. All of these approaches are interesting and legitimate, as they relate to the perceived identity of the maker, and reflect personal choice. Although a piece may have a useful function, and will be judged in part on how well it does its job, it will also be looked at in terms of how well it acts as a vehicle for communicating the intentions of the designer, and how interesting those intentions were.

Makers and their Work

Throughout the development of art metal-forging in the last 20 years or so, many different patterns and approaches to practice have developed. The work of a number of makers is shown in this chapter, arranged by country or region. I've chosen the work because it is interesting, or because it is typical of a genre. There is a great deal of exciting work being made all over the world, a book of this size can only serve to introduce or whet the appetite for more. Each of the sections of this chapter begins with a general introduction and leads on to discuss the work of a selection of makers.

Metalforging in the UK

There is a very wide variety of work being made in the UK, ranging from large to small and traditional to modern. Perhaps the best of the work combines the traditions of blacksmithing with contemporary design concerns.

Paul Margetts has collated a list of the locations and provenance of many interesting works in his *Good Ironwork Guide* listed on his website *Forging Ahead*. His site also features a wide range of his own excellent work and is worth a look.

There is great deal of good forgework being done in the North of England and in Scotland. Alan Dawson in Cumbria, and Brian Russell of County Durham have made some excellent pieces and have been influential members both of BABA and of the international blacksmithing community. In Scotland, Phil and Shona Johnson, Elspeth Bennie, Joyce Hunter and Adam Booth have been influential in promoting artist blacksmithing, organising events and producing some fine architectural and domestic scale objects – as well as a huge set of wind-vanes located in the centre of a large traffic roundabout. Glasgow designer-maker John Creed produces work with balanced and subtle designs. Further south, Peter Parkinson has been an important lecturer, commentator and maker in his own right, working on a domestic and architectural scale. Dick Quinnell's influence upon the development of art metalforging in the UK has been profound and, as with all major developments, many people have been involved. Charles Normandale and Stuart Hill have, amongst others, produced innovative work for a number of years.

In South Wales, David Petersen and his sons Gideon, Aaron and Toby, through Petersen Studios,

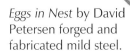

Eggs in Nest by David Petersen forged and fabricated mild steel.

(*Below*) Forged steel door furnishings by Bill Poirrier, Somerset, 1994,

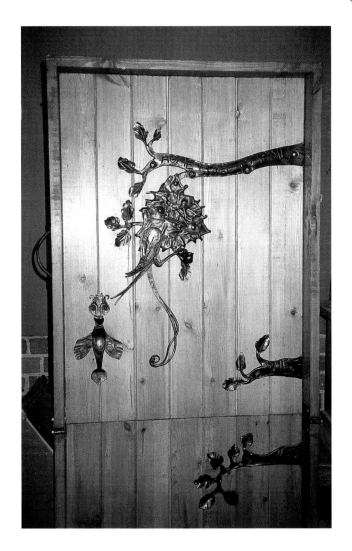

have made much work of interest, both forged and fabricated, including sculptures such as the flamingos made for a garden festival, dragons, wall sculptures, architectural and domestic pieces. David has a background in sculpture, as a practitioner and lecturer. He has written and presented a number of programmes on craft, design, art and architecture for the *Discovery* channel; acted in films, and is involved in Welsh politics. He organised the important FIFI exhibition and conference held in Cardiff and has been an active member of BABA over the years – a busy, erudite man with a great knowledge and enthusiasm for art blacksmithing and for arts and design generally.

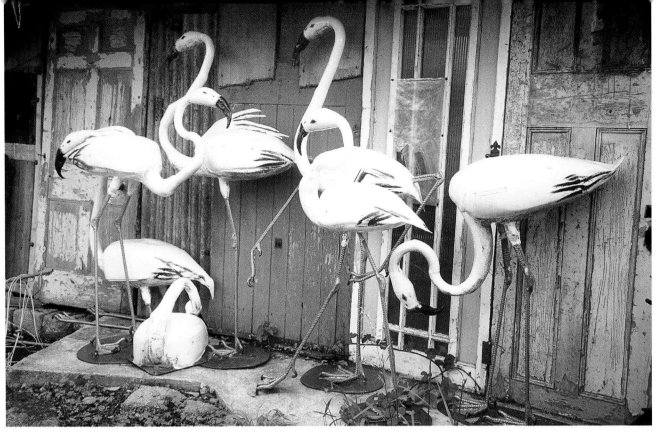

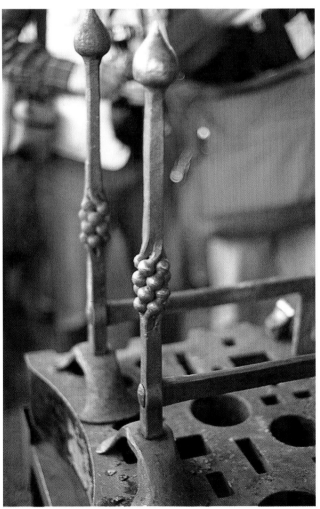

(*Top*) *Flamingos* by David Petersen made for a garden festival – motorcycle petrol tanks form the bodies of the birds.

(*Above*) Forged face on an RSJ, for the Fe exhibition by Alan Dawson, Tully House, Carlisle, UK, 1996.

(*Right*) Andirons by Brian Russell, 1991, demonstration piece at the 2nd World Congress of Smiths, Aachen, Germany, 1991 – still hot!

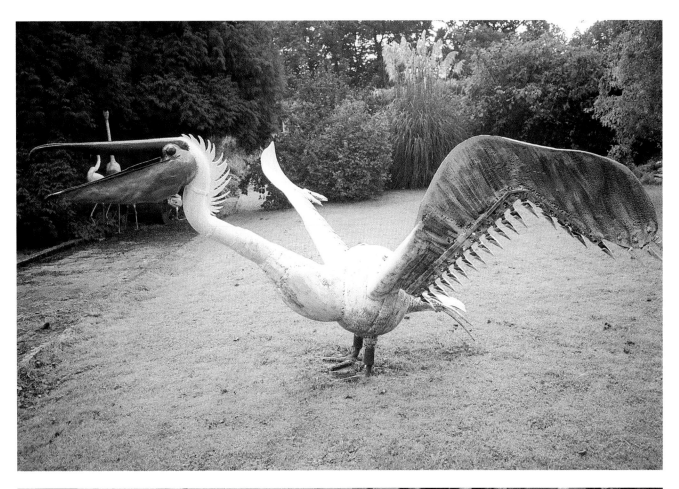

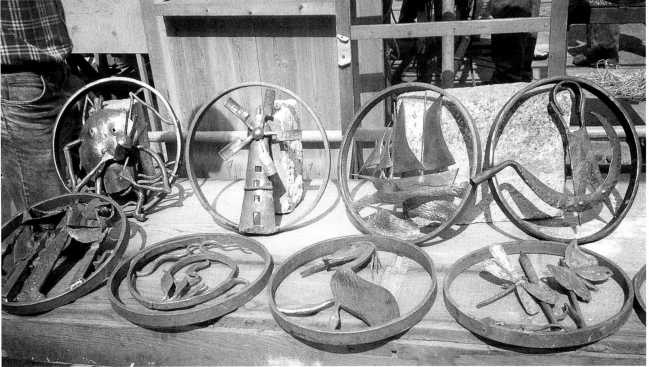

(Top) Pelikan by David Petersen, on his lawn at St Clear, Wales.
(Above) Forged elements made by various BABA members at the Alford Forge-in in 1992, Norfolk, UK.

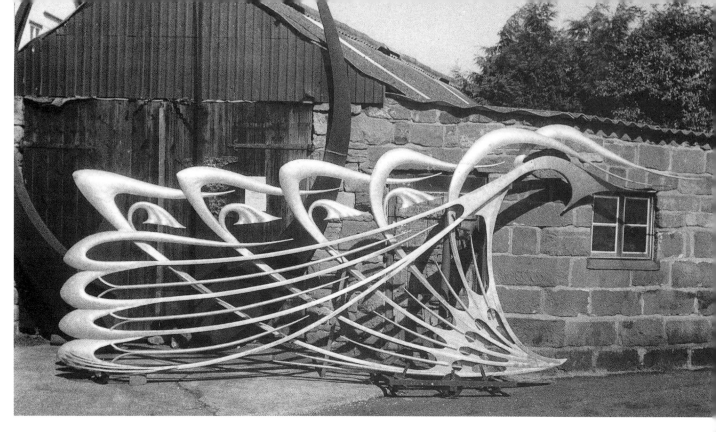

Antony Robinson has been one of the most important and influential figures in art metalforging in the UK. Showing enormous skill, determination and stamina, he made undoubtedly one of the finest works of modern times – the commemorative gates in the Great Hall of Winchester Castle, now the only remaining part of the castle itself. Made from stainless steel, in dramatic and appropriate style, the gates were constructed at less than an economic cost, in a workshop of modest dimensions, after Robinson won a competition to design them.

(*Above*) Screen made by Tony Robinson
(*Right and opposite*) Gates for the Great Hall of Winchester Castle, UK by Antony Robinson.

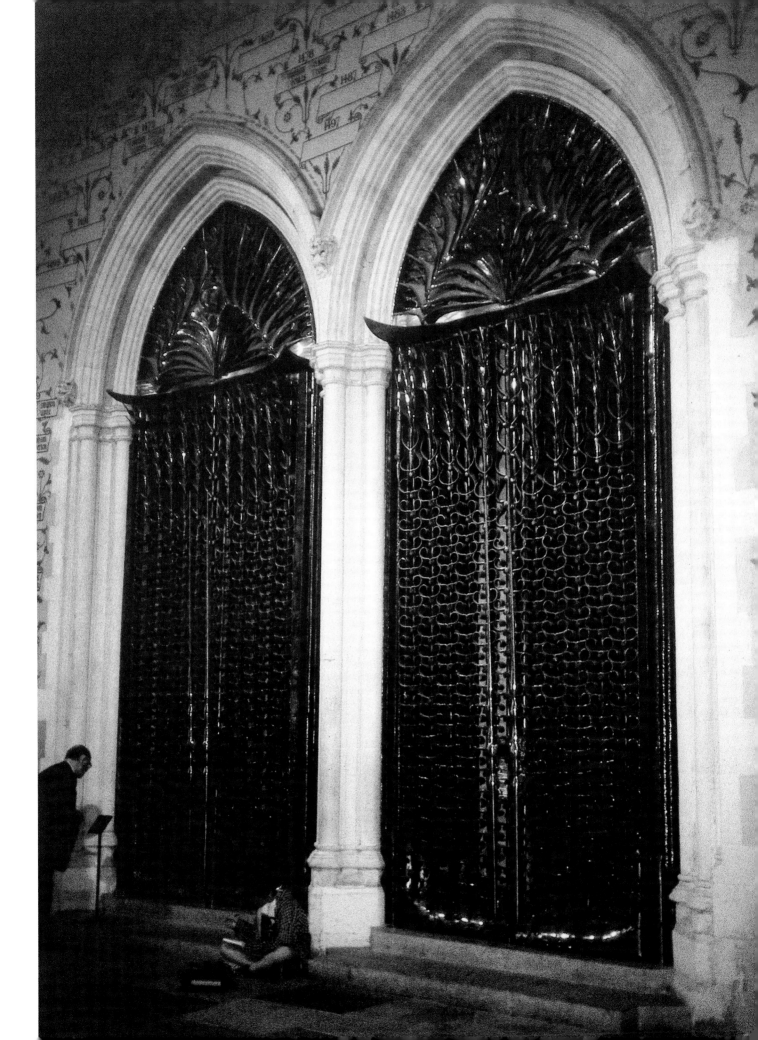

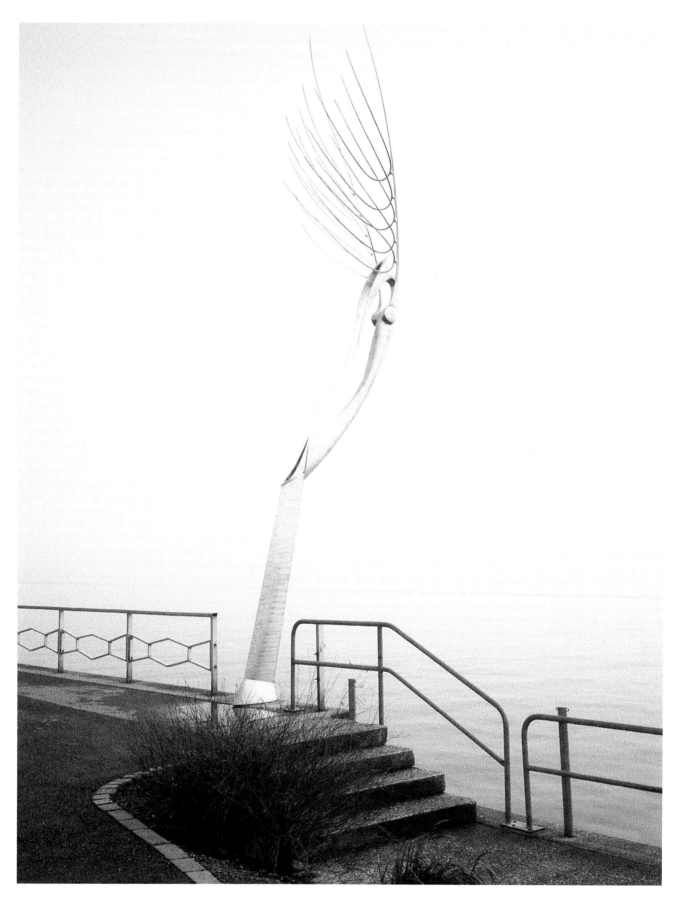

Tony Robinson's sculpture *Resurrection* was bought by the town of Friedrichshafen after it appeared in the local sculpture exhibition. It overlooks the Bodensee, with Switzerland visible in the distance, and is a dramatic and effective work. There is a strong spiritual emphasis in his work, and he gave an eloquent explanation of his views at BABA's Ironbridge Conference, marking his return to the organisation after a number of years of absence. Subsequently, he played an important role in the design and making of the *Spirit of the Sea* sculpture constructed by BABA members as part of the *Festival of the Sea* in Bristol docks.

Sam Garbutt is a relatively recent entrant to the art metalforging scene, graduating in 3D design from Brighton University. Typical of a large number of art

(*Opposite*) *Resurrection* by Tony Robinson, bought by the town of Friedrichshafen.
(*Above*) Bird-like loudspeaker stands by Sam Garbutt – photo by Sam Garbutt.

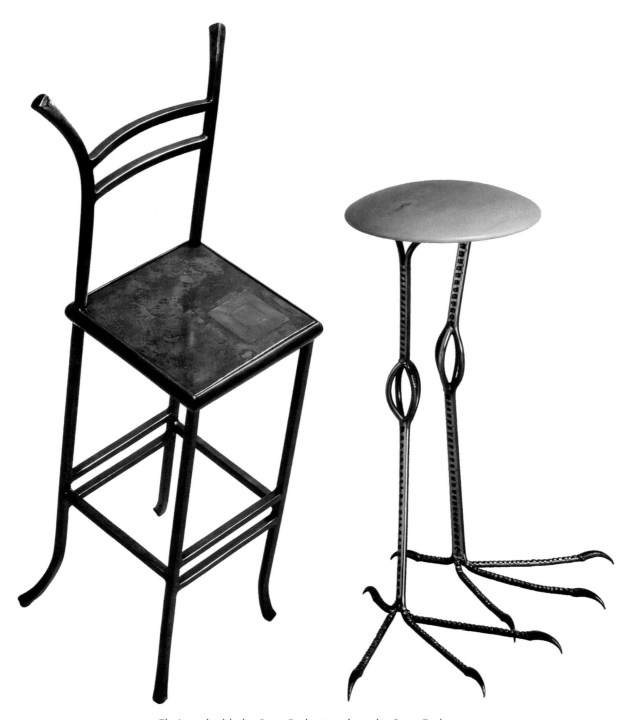

Chair and table by Sam Garbutt – photo by Sam Garbutt.

and design graduates, she has set up a workshop in a small industrial unit, to produce a mixture of bespoke work and a range of practical and interesting standard products, often with contemporary functions – the 'bird's legs' on the seating and speaker stands are both fun and functional.

Neil Hawkins

Originally from Monkokehampton, but now based at Barnstaple in Devon, my father grew up in the shadow of the family forges. His uncle, Samuel Vanstone, operated one in the village, continuing a family tradition of some 250 years on the same site. When younger my father would go down to the forge after school to hold a candle, literally, to his uncle's work in the winter evenings. War work, in the form of pressure from farmers, caused Sam's death from overwork during World War II – the farmers were able to make a good living during the war, and urged him to work ever harder. Vanstone's son, Herbert, took over the forge afterwards, and has remained there until the present. There was no place for Neil as an apprentice at the forge in Monkokehampton, which, in order to survive after the war, had to take on agency work and the retailing of oil to farmers.

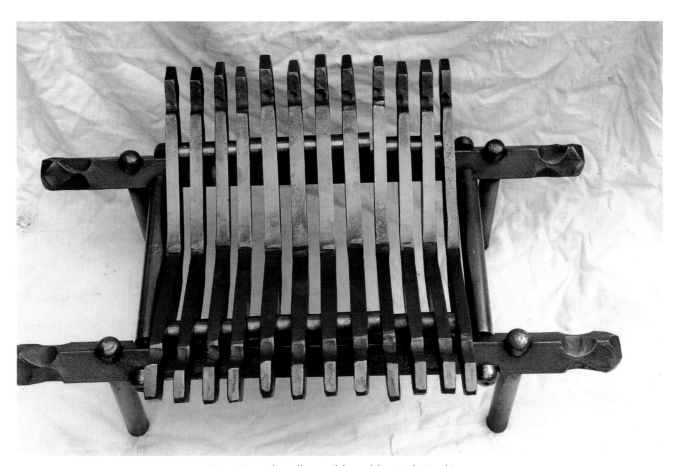

(*Top*) Door handles, mild steel by Neil Hawkins.
(*Above*) Fire Grate by Neil Hawkins – horizontal bars forged from 50mm square mild steel bar.

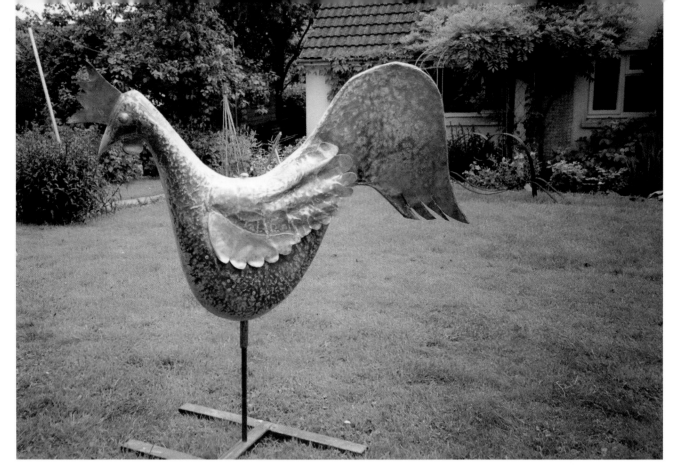

(*Top*) Weather vane for Pilton Church, Barnstaple, Devon, in wrought iron, copper and lead by Neil Hawkins (the forge is in the background).

(*Right*) Detail of centre of garden gate by Neil Hawkins.

(*Opposite*) Garden gate by Neil Hawkins, forged mild steel, galvanised finish, with copper repoussé roses.

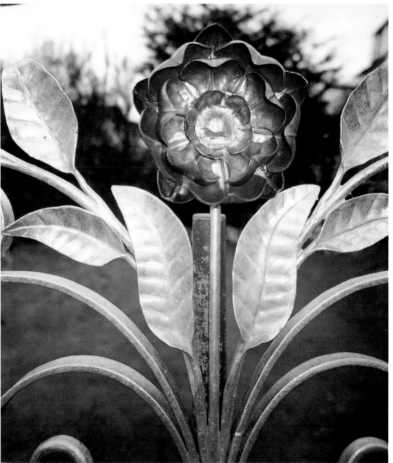

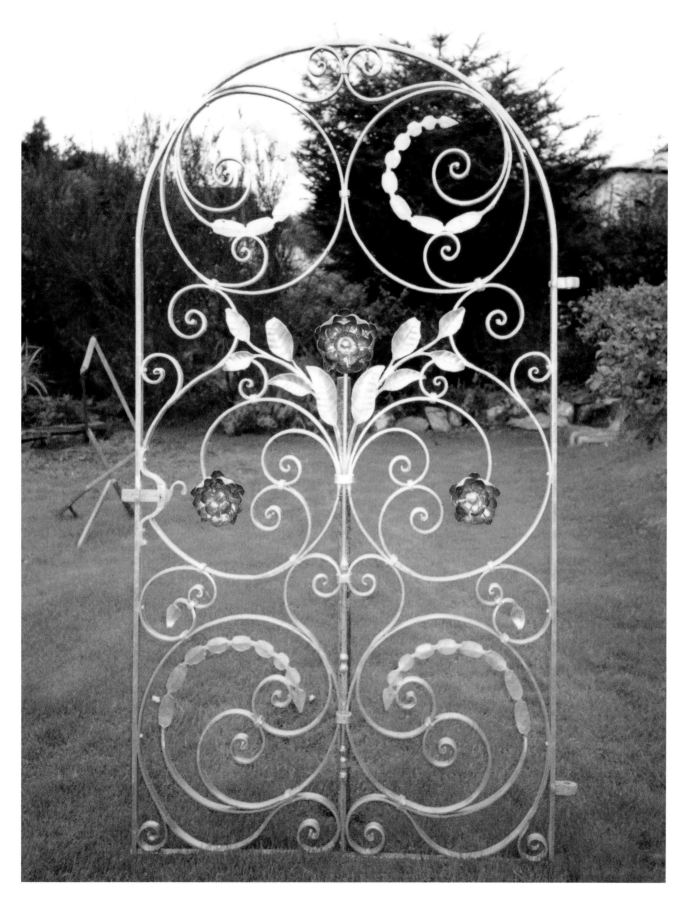

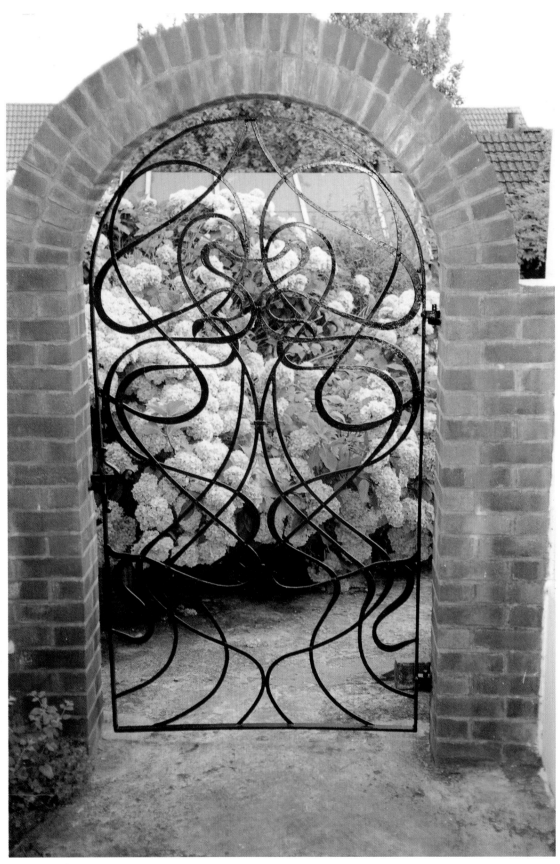

Art Nouveau style garden gate, forged and fabricated mild steel by Neil Hawkins.

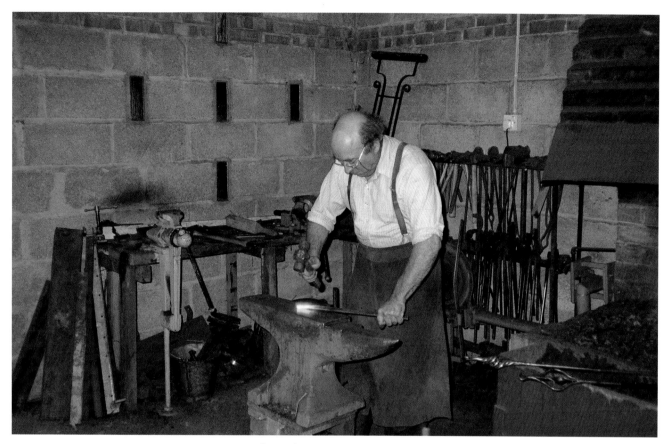

Neil Hawkins at work in his studio.

Jack Vanstone, another uncle, was also unable to take him on at his forge in Okehampton, a few miles south of Monkokehampton, as he had his son George to cater for. Jack was, however, helpful when Neil undertook his apprenticeship, and began to enter shoeing and ironwork competitions to which they would often travel together.

Because they could anticipate the way trade was developing in the post war period, his relatives urged him to take a joint apprenticeship in Blacksmithing, Farriery and Agricultural Engineering, which he did. He began his five-year apprenticeship with Donald Gliddon of Braunton, North Devon in 1946, under the RIB, NMFB&AE Joint Apprenticeship scheme. Block-release training was provided at Exeter College in the three subject areas. Instruction was both by College staff and Rural Industries Instructors, who also made visits to the workplace. During the apprenticeship, and for the next seven or eight years,

he took part in a number of ironwork and horseshoeing competitions and was highly successful, winning a great many prizes, including a Silver Medal from the Worshipful Company of Farriers.

When taking part in the Devon County Show competitions in 1951, he met Edward Bailey and was invited to meet and discuss an idea for a Devon Guild of Craftsmen. A group, including Bailey, Hawkins, Pat Honnor and a local architect later met at Dartington and agreed to shoulder any financial losses the Guild might make in its initial stages. The Devon Guild was officially formed later in a more public meeting in Totnes.

The Guild was largely composed of ex-forces personnel, and art-school-educated middle-class craftspeople in the Leach tradition – Bernard Leach himself joining during the early days of the Guild. Annual exhibitions were held at Dartington for a number of years, until Dartington itself decided to

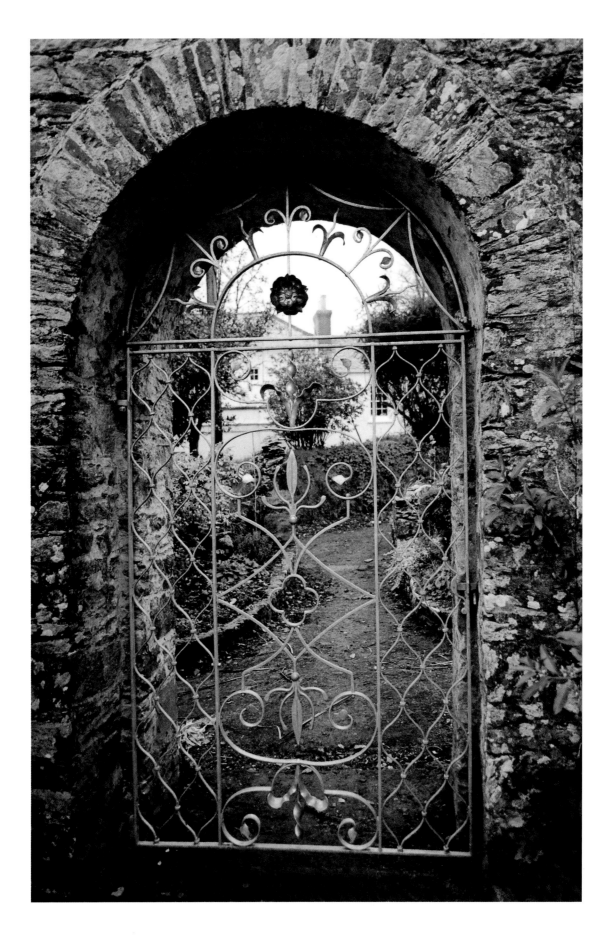

convert the Cider Press into the current craft centre, essentially on the back of the Devon Guild Annual Summer Exhibitions. These exhibitions, unlike the ones in agricultural shows, had selection committees and an expectation of innovative design. This exposure to the culture of design meant that Neil was developing contemporary designs in metal from the early 1950s. His work often involved the typical product range of the blacksmith, but involved experimentation with texture, finish, proportion and scale. Some fire-iron designs made by Hawkins since the early 1960s were included in the Crafts Council's *Maker's Eye* exhibition in 1982, and later shown in a small one-person exhibition the following year at the National Museum and Gallery of Wales in Cardiff. Interestingly, his cousin Willie Vanstone had ran a blacksmith's shop in Cardiff for a number of years up until just after World War II.

In the early 1960s, Gliddons, where he had been apprenticed, was sold to an outside bidder, despite Neil making a realistic offer for it. He was foreman smith at the time, with five smiths working under him. Much of the work came there because of his expertise, and the business declined rapidly after his departure. The break-up of Gliddons was the cause of some resentment and regret at the time, since the firm had worked on a number of major projects, including a Royal Commission for railings at Windsor Park; the development of the first prototype four-furrow plough for Ferguson's; the design and manufacture of a patented form of hay rake; a considerable number of commissions for decorative work; agricultural work, shoeing and general welding and repairs, including work for local author Henry Williamson.

Although blacksmithing has always formed part of Neil's work, and has been important in terms of identity, there have been times when it has had to become a background activity. It was necessary, during the 1960s, a large part of the 70s and early 80s to work largely in agricultural engineering, fitting and welding,

(*Above*) Power-hammered mild steel bowls by Neil Hawkins.
(*Opposite*) Garden gate with fanlight, forged mild steel, with copper repoussé details, Bratton Flemming, Exmoor, Devon, UK, by Neil Hawkins. Note the top and bottom of the gate are mirror images – a modern twist to an otherwise traditionally styled gate. Decorative features from the client's favourite piece of furniture were incorporated into the design.

Church keys, mild steel by Neil Hawkins. These have to be made specially as the locks are often hundreds of years old.

although it was possible to make work for the Devon County Show, and Devon Guild exhibitions, as well as to shoe some horses and undertake commissions. Working at two jobs simultaneously during this period took considerable stamina and determination.

In the early days of the Crafts Council Neil obtained an interest-free loan which, when added to some savings, was sufficient to construct a permanent studio workshop, to replace the previous temporary structures, where making horseshoes by Tilly lantern in the evening was by no means unusual. Weekend horseshoeing during two years in the late 1970s allowed a local bricklayer to be paid, by the day, to build the studio walls and the materials to be purchased in manageable quantities each week. The result was a modern, purpose-built studio workshop, which is in daily use today, with two extensions added for office and storage space.

In 1980 Neil became a member of BABA, having been an active member of NAFBAE for a number of years. He attended the Hereford event, which he found inspiring, but was perhaps less surprised than many British smiths by the potential of a design culture, since he had been involved in this aspect since the 1950s, through the Devon Guild.

The number of outlets for his products expanded during the 1980s, and included a mixture of standard items and commissioned pieces, including architectural work on a large scale and church work. He gave up horseshoeing to concentrate upon ironwork in the mid-1980s, finding it more challenging.

In 1987 he was awarded a Winston Churchill Travelling Fellowship and visited a large number of blacksmiths, farriers and training establishments throughout France. In the second half of the Fellowship in 1988, he travelled through many parts of western Germany, visiting a number of blacksmiths and farriers.

His work in the last ten years has increased in scope and become more sculptural and expressive. However, he still works in traditional styles and methods where the client requires work of this kind, but prefers to work in a contemporary style.

He has perhaps been unlucky in being one of the last of the 'old guard', and not being in a position to expand or take advantage of some of the unique opportunities which were available during the 1980s in particular. However, he has continued his journey through blacksmithing, regularly exhibiting and making commissioned pieces including gates, railings, sculptural pieces, keys and weather vanes for a variety of clients.

Giuseppe Lund

Giuseppe Lund has been one of the most successful and influential workers in forged metal of the past 20 years or so; his work has been at times praised, at others, vilified. He predicted more accurately than others did during the late 1970s and early 1980s the current concerns of the artist blacksmith. He has undertaken some of the largest and most important commissions of recent times, and has been involved

Giuseppe Lund demonstrating at the BABA conference, BLINC, Carlisle, 1996.

in a constant process of self-development and innovation in his work.

After travelling in Africa and Europe, he studied Philosophy and Science of Materials at Bristol University. He began sculpting with stone and wood, but moved to metal because it provided the opportunity '...to bridge the gap between function and art' (email to the author). He began a self-imposed training in the working of hot metal, concentrating upon the use of tools and handling of the material, and making essentially traditional ironwork. Of this time he notes:

It was quite a shock to find that English

metalworkers were so closed in their attitude towards someone trying to learn about forging. At the time my only true support came from Antony Robinson – understandable because he was an outsider and self-taught.

Whilst working with Robinson, Lund was helped through CoSIRA courses to gain a greater understanding of tools and processes, and was able to obtain some financial support from the body.

After his time with Robinson he was able to work as a journeyman with Manfred Bergmeister in Germany and Toni Benetton in Italy, both important metalworkers. Lund notes that it was thanks to those two in particular that:

… I had the confidence to explore the potential of metal as much as I have. So, in short I never

had a preconception of what forged metalwork should look like, and I pursued my relationship with iron in a very personal way. …of course, many blacksmiths have that kind of relationship with iron, but they seemed to have so little confidence when it came to design. I believe this was a reflection of the class status of the manual worker in England in the 50s and 60s.

Lund noted that blacksmiths during this time were not prepared to question architects or clients in the way that a designer-maker in other materials would:

But of course, there were far more educated middle-class potters, weavers and furniture makers about at that time. All this has changed now and probably played a strong part in the emergence of a new type of metalworker/artist

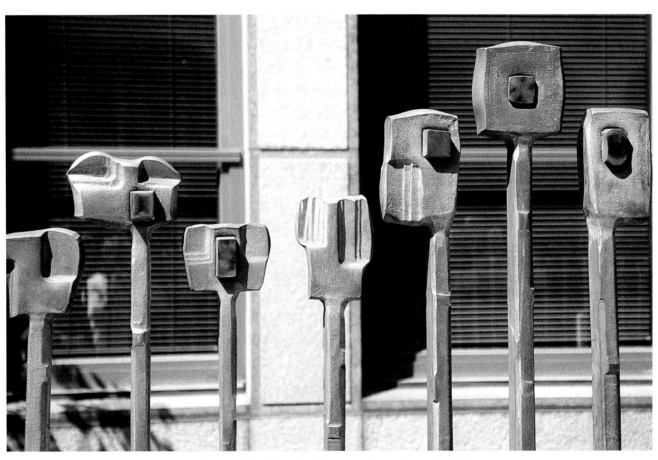

Railings at Blackfriars by Giuseppe Lund, London, UK.

– I reserve the term 'blacksmith' for true believers in the Zen of rivets and fire welding. As an artist I questioned and challenged everything, so it is not surprising that I got into trouble.

Lund later formed a short-lived and unsuccessful partnership with Robinson, but has since established successful businesses in both the UK and Canada. His presence on the Crafts Council's selected index of makers and his links with the CC have been very important to Lund:

The Crafts Council gave me financial and moral support over the years and my presence on their index has gained me millions of pounds of work. Their fresh approach in recent years is hopefully more down to earth, and I will gladly assist them in any way that I can.

Although Lund's work has been largely architectural in context, he also produces sculpture without a site in mind, and work on a domestic scale where there is a much more personal link with the client. Larger commissions are influenced by the setting rather than the client. He also undertakes '…community projects, where the whole thing evolves from a complex collaboration.'

Lund's Victoria Plaza gates are part of a large and impressive body of work. He has completed a number of other prominent commissions, such as for Westferry Circus, Canary Wharf, and Dorset Rise in Blackfriars, London. However, he is perhaps best known for the controversial Queen Elizabeth Gates in Hyde Park, London. The Hyde Park gates were a very public commission, intended as a national celebration of the life of Queen Elizabeth the Queen Mother, and as such were a very high profile work, in a prominent location. Their cost at over £1,000,000 was criticised in a number of places, both publicly and privately. Clearly there was a need for them to be functional as

gates; they needed to close and provide an effective barrier at one of the entrances to Hyde Park. However, their most important function was symbolic, and to that end they are very large, have a Tree of Life situated between the central pillars surmounting a lion and unicorn with a number of crude animal shapes at their base, representative of native Scottish mammals. The gates themselves have a large number of flower and tendril forms, and back stiles composed of bound rods, reminiscent of neo-classical power symbolism and of the 'Tree of Life' gates he made for Westferry Circus. Joining methods such as clips have been employed, making reference to traditional gates, and the gates overall are in a general form which Lund has described as 'cleavage style' – possibly a reference to motherhood.

Discussion amongst blacksmiths about the gates has centred around how the commission for them was awarded, their cost, and the quality of manufacture, which was considered by some to be poor. Wendy Alford and David Townsend published two articles which were highly critical of the design and manufacture of the gates, and the central heraldic beasts. There was disappointment amongst smiths that gates, which are as prominent and expensive to produce, should have been, in their view, so poorly crafted. Lund commented, as early as 1980 (in an article by Lesley Adamson in *The Guardian*, 19 July 1980), that, 'I do not have any great purpose to save the world from badly made gates.' There was a definite feeling amongst some smiths that Lund had somehow let the craft down. It is important to note that the feeling of collective responsibility and group identity of which this is evidence, whilst not unique to blacksmiths, has been important in the recent developments in art blacksmithing, through BABA in particular. To balance this, it is unclear whether there was any intention that the gates should be symbolic of good blacksmithing practice, or any obligation for Lund to 'keep the blacksmithing faith', as they were to be

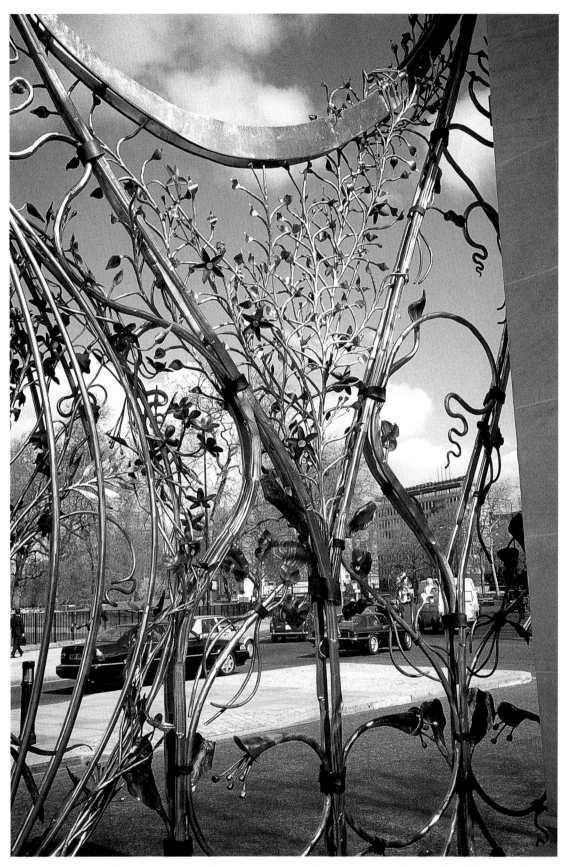

(*Above and opposite*) Queen Elizabeth Gates, Hyde Park, London, UK, by Giuseppe Lund. Forged and fabricated stainless steel.

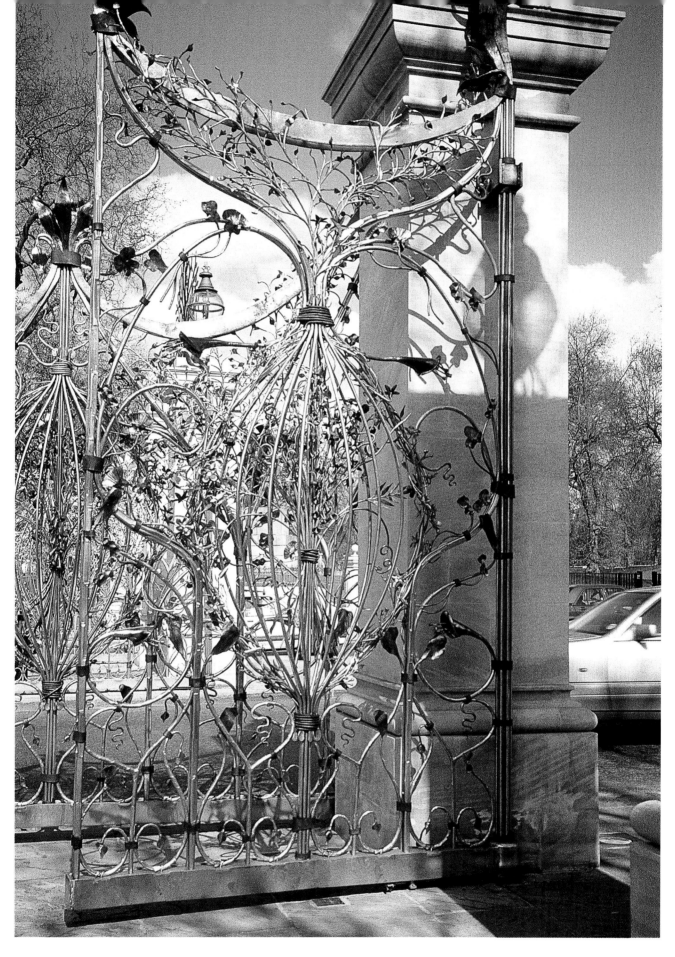

symbolic of the Queen Mother and her life. As Lund noted in *Crafts* (November/December 1993):

> Here was an opportunity to make gates that would welcome people in rather than keeping them out. The sombre tones of mourning for Prince Albert could be lifted – colourfully – from London's metalwork at last.

His references to Prince Albert and colour relate to the common observation that ironwork was normally painted black after the death of Prince Albert, although there may have been other reasons, such as the availability of a good quality black paint at the time.

Ironwork was often painted in other colours such as Gunmetal Green (British Museum) or in white or grey lead based paints and light blues. A recently restored gate in the refurbished Ironwork Gallery of the V&A has been painted in its original blue grey.

Peter Dormer commented in *Crafts* (November/December 1993):

> The new gates in Hyde Park erected in honour of the Queen Mother are appalling; they are an appropriate embellishment of a country in decline. And they are also a terrible advertisement for the applied arts.

Dormer seems to make the incorrect assumption that

Victoria Plaza gates, London – corner detail, by Giuseppe Lund.

Queen Elizabeth Gates, Hyde Park, London, detail, by Giuseppe Lund.

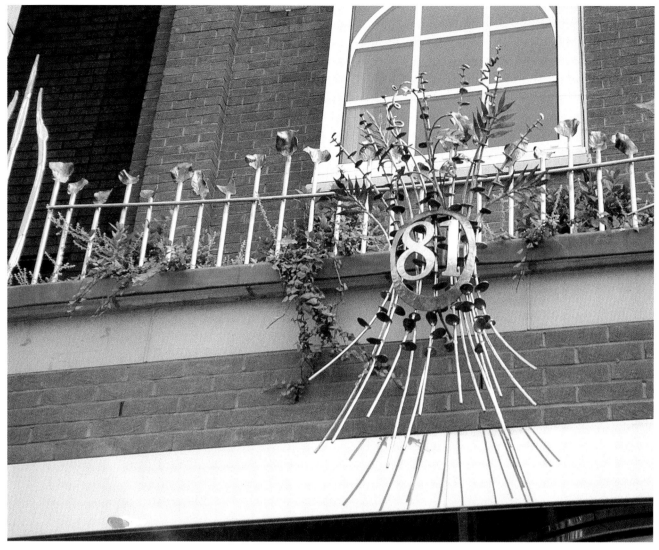

Forged, fabricated and patinated stainless steel decorative railings by Giuseppe Lund,
Marks and Spencer, Kings Road, London.

the Royal family were not involved with the commissioning process, and that the design was forced upon them. Lund's design was selected through a competition, which other artists and applied artists of good standing, such as James Horrobin and Alec Cobbe had entered. Prince Michael of Kent coordinated the process and, as Lund pointed out (in an email to the author) his own design gained the approval of 'Royal Fine Arts, English Heritage, Royal Parks, Westminster, the Royal Family.'

Dormer also criticised the gates on the basis that they were:

...fashionably rough and ready, showing the marks of the maker. But that's not what royalty is about. Royalty means not disclosing the mark of the human hand.

Whilst it is correct that the marks of manufacture feature prominently, Dormer ignored, or was ignorant of, Lund's status as one of the pioneers and most prominent exponents of this way of blacksmithing – for Lund it is not a fashionable approach, but an approach that he, in particular, has made fashionable.

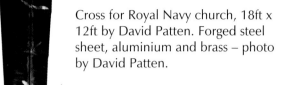

Cross for Royal Navy church, 18ft x 12ft by David Patten. Forged steel sheet, aluminium and brass – photo by David Patten.

The Hyde Park gates were heavy on symbolism and unconventional in structural terms. When visiting the gates after reading the reviews, poor expectations are largely unfulfilled, as the gates are exuberant and individual, and have many features of interest. There are a number of sections which are poorly made in conventional terms, and there appear to be some structural and practical problems. The heraldic beasts in the centre of the two main support pillars are rather naive and out of proportion, the pillars themselves appear to be in a different and conflicting style to the gates. An opportunity to enhance the effect of the gates by appropriate and innovative stonework was lost. However, it was a major step forward in terms of the acceptance of blacksmithing as an appropriate contemporary medium for a national commemorative project, and as such it will be some time before it is possible to gauge whether the gates have had an effect which is positive or negative. It may be a case of any publicity being good publicity.

David Patten and Plymouth College of Art and Design

David Patten has been the driving force behind the Metals course at Plymouth College of Art and Design for a number of years. He is a practitioner in his own right who trained as a sculptor at Manchester, graduating in 1967. He has exhibited widely in the UK, and worked mainly to commission. Alongside this he has been a successful and popular teacher of sculpture, applied arts (3D) and drawing and design to architects.

David graduated towards working with metal in the mid-1970s, and learned most of his early techniques from experienced panel-beaters who, 'seemed to have the most exciting technical vocabulary and the most relevant language for me'.

He regards the relationship between practice and teaching as very close, both informing and guiding the other. Until recently, his work was clearly 'sculpture', although he is becoming increasingly

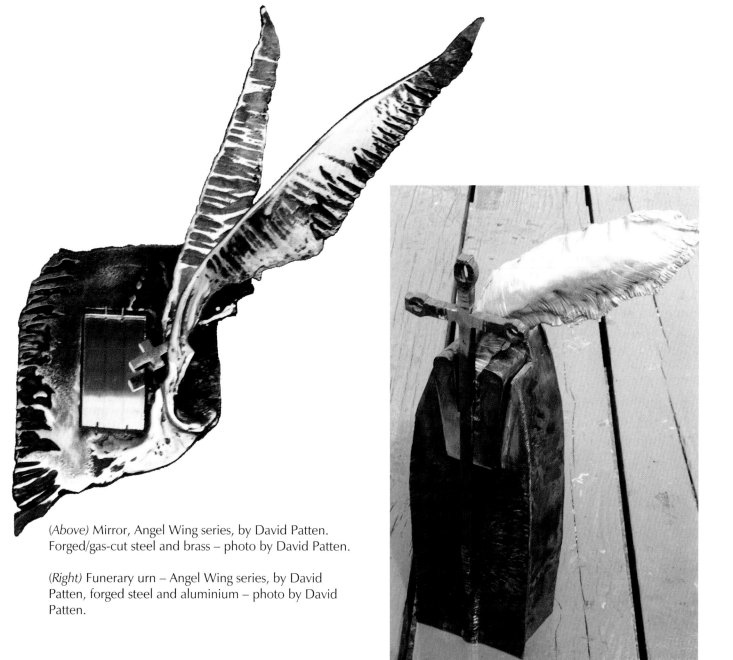

(*Above*) Mirror, Angel Wing series, by David Patten. Forged/gas-cut steel and brass – photo by David Patten.

(*Right*) Funerary urn – Angel Wing series, by David Patten, forged steel and aluminium – photo by David Patten.

involved in the making of functional objects, 'but merging the thinking, and blurring any boundaries that may have existed'. A passionate belief in the role of drawing in the creative process is at the centre of his work and teaching where it has an important beneficial effect on the work of the students.

The Royal Navy commissioned a large cross from him, which was completed in 1997. It was made of steel, brass, and aluminium, and it measures 18 x 12ft (5.5 x 3.7m). It uses the idea of physical light on water, and spiritual light radiating from a centre. 'Small aluminium wings represent either the bird following a ship's wake, or angels hovering in attendance.'

Funerary urns were some experimental pieces with a clear function. The ideas originally came from looking at roadside crosses in the Languedoc in south-west France, where a small linear cross form is installed on massive boulders. This initial inspiration has led to other forms, the idea has evolved, and other images have been added. 'The idea to create mood by surface manipulation is important'. His *Angel Wing* mirrors were, 'just an idea to place your own image within this airborne form, where the mood of the surface shape and form will maybe react with your face.'

Student Work From Plymouth College of Art and Design

The HND Metals course – now extended to a BA in Applied Arts – started around 10 years ago and offered a major new contribution to the emerging interest in metalwork, and in particular in architectural-scale work in forged metal. Caroline Pearce-Higgins of the Crafts Council and Graham Hoggetts, a former editor of *British Blacksmith* exerted an important influence early in the development of the award. The feature of the architectural metalwork course distinguishing it from others has been the effective combination of design and craft skills, in contrast to other more craft-based approaches, where design skills have not been emphasised.

The identity of the department began to develop such that sculptural issues were fused to craft disciplines, and drawing and intellectual debate concerning the potential of ideas set the direction for the technical/making process. Tutor David Patten has noted that:

> Technique followed need and though there has been much argument about this, it has given the work a particularly broad range, and perhaps it tends to occupy a unique position. The idea that a functional piece can have a very strong expressive potential – generate mood and convey emotional potential is fairly central to the critical evaluation.

The graduating students have tended to do well in setting up workshops and continuing to practice at a very high level, many of them getting work from all over the world.

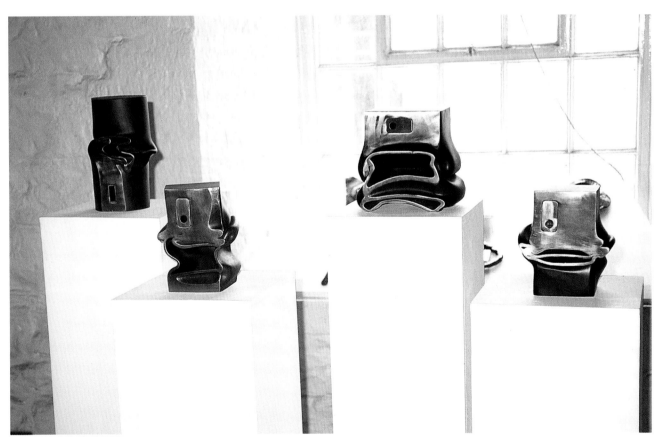

Mild steel vessels formed by squashing, then cutting through them vertically to reveal the distortions, by William Yo.

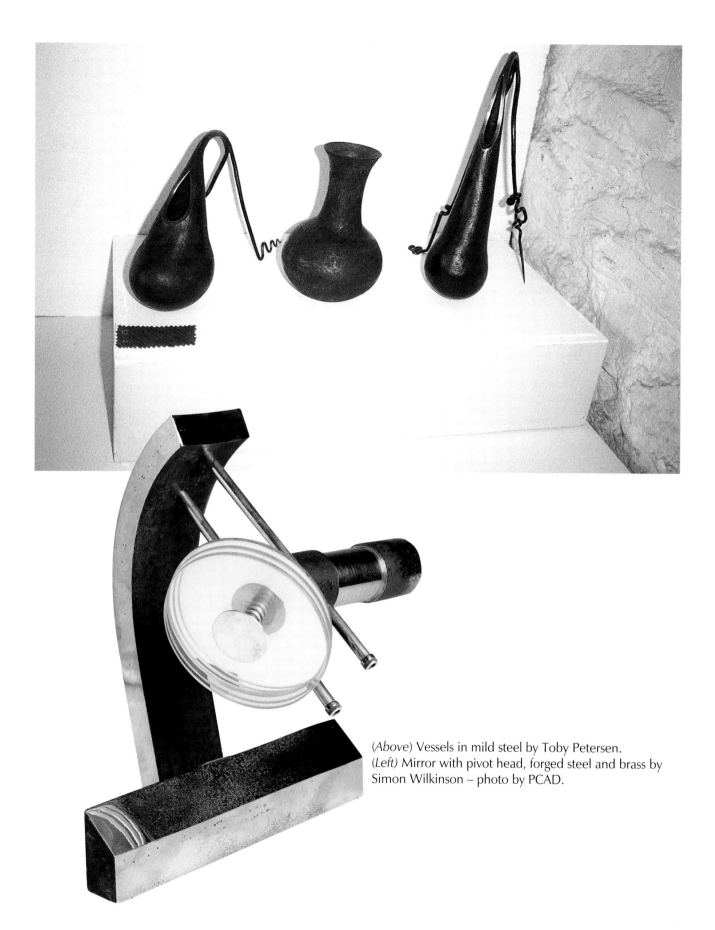

(*Above*) Vessels in mild steel by Toby Petersen.
(*Left*) Mirror with pivot head, forged steel and brass by
Simon Wilkinson – photo by PCAD.

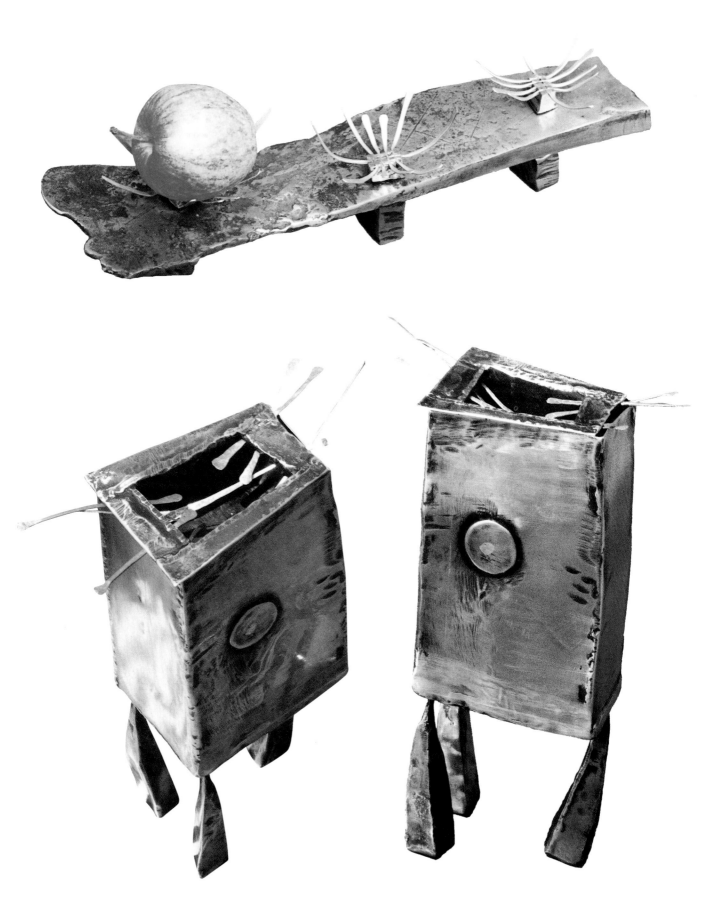

(*Above*) Fruit stand, forged steel and
silver, by Penny Hemming.
(*Below*) Welded and brazed box, with
forged silver closures, by Gail Thomas –
photo by PCAD.

(*Below*) Forged and welded vessel with
anodised aluminium lining, by Tom
Docherty.
(*Right*) Detail of pod from series by
Simon Frend – photo by PCAD.

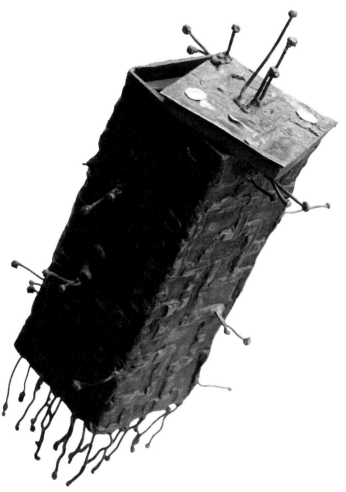

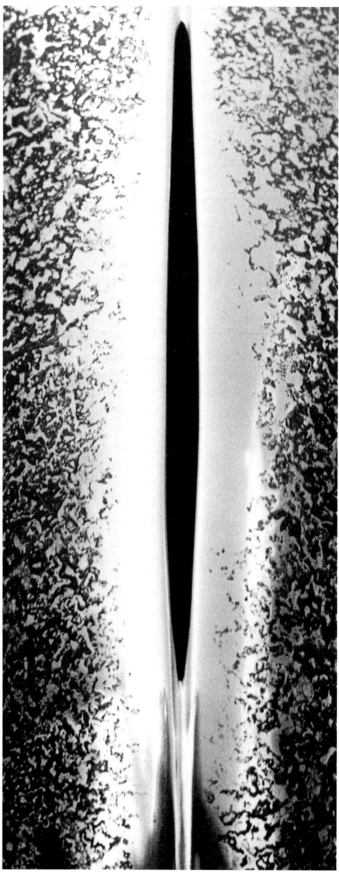

James Horrobin

Jim Horrobin has made some of the most interesting ironwork of recent times, after making the transition from rural general blacksmith to a self-conscious, architecturally aware artist blacksmith with a high international profile. His progress mirrors that of British art blacksmithing in the last 20 years or so.

In 1961 at the age of 15, Horrobin began work as a blacksmith in Bridgetown, an Exmoor village, apprenticed to his father, Harry. He did the Hereford block-release training course, and had Frank Day, Tom Tucker, Len Hodder and Fred Barnes, from CoSIRA, visiting on a regular basis to teach techniques based upon the CoSIRA syllabus. He spoke of this at a 1992 BABA conference:

> That's a pretty privileged thing to have – to actually get one-to-one teaching in blacksmithing today would be quite a remarkable thing – and at the time it was free.

After about four years, he left Bridgetown with his father, where they were shoeing horses and doing general farm work, and began to do 'fancy wrought ironwork' based in Roadwater. They attended the Devon County and Bath and West Agricultural Shows and other suitable venues, to promote their work through exhibitions and competitions. This was sufficiently successful for them both to make a living in what were difficult times. They would take on whatever work came to them, which was typical for rural smiths at that time. One early job was heraldic work for a Lombard bank in Exeter, involving repoussé work in copper:

> That actually is a really terrible piece of repoussé work from a craftsmanship point of view. The armour, instead of being smooth breastplates and finely chased, actually, they are almost as if you had gone in behind with a nail

gun. I was only 20 at the time and that was the best I could do.

Horrobin's later work is characterised by a keen awareness and sympathy for architecture, but he has noted that in the early days he:

> …didn't have any awareness of architects or have any awareness of what architecture was anyway, other than you might get asked to make a gate for a church, but I didn't think 'this is a 15th-century church or a 17th-century church'. I didn't do any research; it was just another job to do really.

In the mid 60s the books of Fritz Kühn began to be available in English translation, and the Horrobins, like many others went through what amounted to a Fritz Kühn stage, with work based upon pictures that they had seen. With few alternatives, these books played an important role in the development of a new understanding of making practices.

In 1969 Harry Horrobin retired, and Jim set up his own workshop at Torre near Washford. A chandelier for a church in the Quantocks was the most ambitious piece of work Horrobin did in 1973. Not really conscious of how old this church was:

> I was just asked to make a chandelier for that space, and that's what I did. It's about 6 ft across, took 500 hours to make, and I got paid £500 at the time – £1 an hour was the sort of going rate. I wouldn't design it in the same way today, and I think, well, that was the best I could do at the time.

It was at this time that Horrobin was responding to the demand for vernacular revival items, making

(*Opposite*) Oriel House, London, work by James Horrobin.

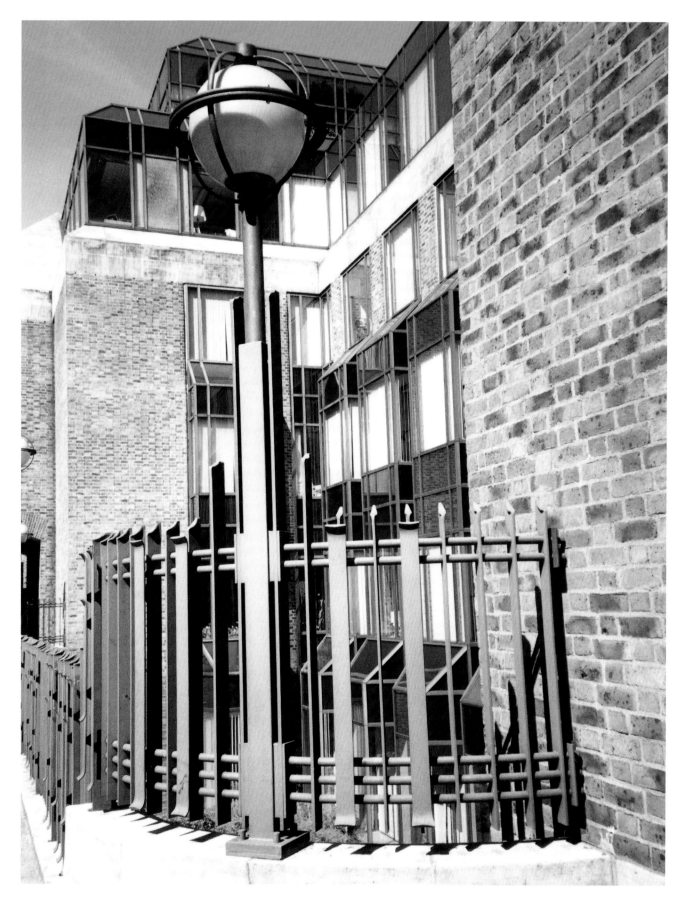

traditional firedogs and fire hoods. He found the work repetitive and boring and in response began to experiment with different approaches to construction.

Later in the 1970s Horrobin gave up blacksmithing for about a year and sold most of his tools in an auction:

> … because I was using a smaller and smaller vocabulary, I wasn't talking to anybody about anything, wasn't learning anything, or didn't feel I was, and that is when BABA came along – I think in overall terms I've been very grateful for BABA coming into existence.

Attending the early events of BABA and beginning to communicate with other smiths began a dramatic change from a vaguely 18th-century style of working to unsubtle electric welds on forged plate and other exploratory work. This included a fire basket for the British Grate exhibition that was part of the 1980 Hereford Forging Iron Conference. Horrobin noted:

> I think for the first time – for all the people who were involved at the time – there was an excitement that none of us had really felt before: (a) we were talking to people of the same craft or industry, (b) we were talking about design, (c) we were talking about techniques. And suddenly, instead of having a diminishing vocabulary to work ideas out with, there was an explosion of ideas.

The late Rachel Reckitt, herself a well known artist in metal and other media, had commissioned a number of gates and other items from Horrobin over the years, about which he said:

> In a way, Rachel's been my greatest patron, certainly work of this scale. Each time she's asked me to design a job, she has simply said

she needs, in this instance, a dog gate, [to keep dogs in the house, but allow the door to be kept open in the summer] no conversation about what the design should be like, no conversation about finance, no conversation about time really, just that she would like a gate there. It is just wonderful to get opportunities like that.

In 1981 he was invited to take part in the competition to design gates and grilles linking the Great Hall in Winchester with the new Crown Court Building. It was to expose his limitations as a designer:

Front stile, back stile, bottom rail, lock rails,

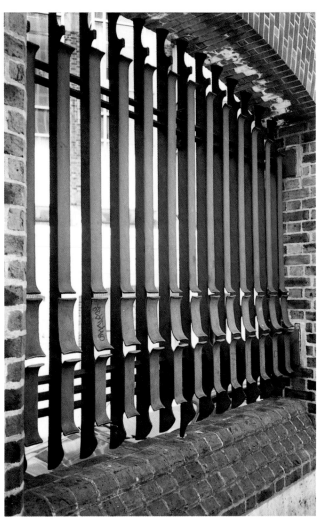

Oriel House, London, work by James Horrobin.

top rail, that was the only form of gate construction that I really had in my head, and I just couldn't get away from it – I was perhaps frightened of the size, and I just remember it as a very difficult thing to try and do – which is perhaps why it didn't win the competition.

Soon after the failure to be selected to make the Winchester gates, he was again asked to take part in a limited competition for gates linking the Music and Ironwork Galleries of the V&A. This time he didn't feel he could go through an extended design process and submitted the first design he thought of, based upon ripples in ponds and sound wave propagation

Barrier detail, Oriel House, London, by James Horrobin.

allied to the techniques of mediaeval ironwork. He won the competition and proceeded to produce the gates now seen in the V&A Ironwork Gallery. Although they were made using traditional techniques, they are very much in the modern idiom. Hammer marks are used as texture; the joints and intersections are used as decorative features; and large sections of material are used throughout. The gates were to serve a security function, which they do in an appropriate, powerful and interesting manner. Horrobin depends very much on hand techniques and simple tools to do his work, although he has a MIG welder and a power hammer. He has only about ten pairs of tongs, half a dozen chisels, and only one pair of dies for the power hammer.

Around the time of the V&A gates, Horrobin engaged in a period of exploration of the function, context, style and construction of his work. He had tired to some extent of making functional objects – he had been making gates for 32 years:

> Well, sometimes you feel you want to make something else. Does it have to have a function? What is the function? …you can have gates that welcome you, gates that tell you to keep out…it's actually the first thing that you come up against.

This exploration included an increased interest in architecture and fine art. He spent time at drawing, sketching and visual research, which were to be useful skills in his later work, as he would often design for someone else to make and need to communicate effectively with both maker and client. As he has noted:

> It's only through education that you can make progress – realising at some point that you can actually learn to draw – that it's not a mystery. You can learn to draw in exactly the same way that you can learn to make an 's' scroll, or forge a piece of metal.

In 1982 Jim was able to go to the ABANA conference in West Virginia:

I think going to the States filled in incredible blanks in my education, not only to do with blacksmithing, but you know, at the age of 15 being locked into a village forge in Exmoor, you actually haven't experienced much in life, you know, toting around the village, and that was about it. To actually do a major piece of travelling like going to the States had a really big effect on my life.

From this time, having gained something of a reputation for the V&A gates and other modern work, he began to work on larger architectural commissions, all of which required the ability to draw, design and be aware of the nature of the buildings. He needed to gain knowledge of the construction industry, the nature of contracts and the dangers of penalty clauses and other legal responsibilities. Other smiths engaged in the new large-scale architectural work were having to learn at the same time, which added to the demands of the job.

Traditional blacksmiths had received no training and little or no advice on these matters in the past and so had to proceed almost on a trial and error basis, helped very much by communication with others, and through BABA in particular.

Eleven gates for the Crown Reach flats near Vauxhall Bridge, London, were Horrobin's first architectural commission. Nicholas Lacy designed the building, and the site architect was Arno Jobst. Horrobin noted:

To go from fire welding and leaf work, to think about cutting RSJs down the middle, turning

Gate at Crown Reach apartments, London, by James Horrobin.

98

them into 'T' section, and doing a little thing at the top to try and soften, you know, harsh material, was really quite exciting.

Horrobin's design entry for the Broadgate competition was unsuccessful, as was his proposal for the British Library gate competition. The selected index of the Crafts Council played a large part in the selection of participants. He noted that:

To keep a long story short, that whole job was a complete fiasco. We were at this meeting and they said, 'You realise that if you take this job on you are going to be responsible for 'Damages At Large'. 'What does that mean, Mister?' 'That means that if your gate moves $\frac{1}{8}$" and cracks the next brick, which cracks the next brick, and it goes like dominoes around the whole building, you are responsible for anything and everything, so that if the finger can be pointed at your work…very off putting! To put it mildly.

Generally, architectural jobs involve getting asked 'are you interested in this?' Then the smith might agree a design fee, and normally produce a scale drawing e.g. 1:10, and a maquette or small full-sized section of the design proposal.

Horrobin's third major architectural commission was for about 50m of railings with grilles and lamps for Oriel House, near the Edgware Road, London. Compared to the small-scale local pieces of work, typical of the rural smith, there were many more aspects to consider, including the nature of the site, the purpose of the ironwork, the aspirations of the client, structural and fixing aspects, relationships with the architect, structural engineers, people responsible for project finance and stage payments, and legal aspects such as penalty clauses.

Horrobin had also to consider the impact and symbolic value of the work:

In this instance I felt that the railings actually were the first thing that you came across after you left the pavement or the road, they form a very important psychological change from being on the street to being involved with the architecture. It's something of a human scale whereas the building itself isn't.

This job presented manufacturing and financial problems, which it was possible to sort out with the help of Dick Quinnell, and because of the fact that he was self employed, enabling him to make decisions at meetings, whereas virtually everyone else present was an employee of someone else's.

The issue of self-employment for artist blacksmiths in general is an important one. Control and decision making are important – there is a degree of control over the work that is done and the way it is done which is not found as an employee. Both Horrobin and Quinnell have said that it is a position of strength, especially in the negotiations, which are inevitable when undertaking large-scale commissions. The position of artist blacksmiths involved in large architectural commissions is an unusual one in the crafts generally, as for example, a cabinet maker or potter is unlikely to ever get into a contractual relationship with a building firm to produce a piece of craft work. Perhaps the difference is that the blacksmith's work can often form a significant part of the structure of the building, or introduce requirements for the structure to be changed to accommodate its size or weight. As Horrobin noted in relation to the Oriel House contract:

McAlpines actually came down to the workshop, which at the time was an about 100 x 20ft (30.5 x 6m) rented builder's yard; there was me, Paul Jobs, one $\frac{1}{2}$ inch drill stand and that was it. They came down to see whether they actually wanted to take me on as

a sub-contractor, this guy who was going to complete a £50,000 job on a penalty clause basis 'So, where are all of your guys?' 'Where are your tools?' 'What is your bank account like?' Anyway, they took me on.

Ironwork at the Department of Social Security building in Whitehall, opposite the Cenotaph, designed by David Lyle of Whitfield Partners, was the next major commission:

> This is where my interest in architecture almost overtakes my interest in blacksmithing really. Meeting up with someone like David Lyle really helped me a lot in my education, to give me some better sense of what it is I'm looking at.

Whitfields employed him to design the ironwork, with the prospect of making it as well, but, although the Public Services Agency agreed to the design, they were not prepared to take Horrobin on under their penalty clause contracts. So Horrobin nominated Richard Quinnell Ltd. to do the making:

> He had the expertise, the facilities, and I felt comfortable about working out both the financial and the aesthetic arrangement with him. And I went up to Dick's and did some of the work – it made sense as it was – at that time Dick only had an elevation drawing, and it would have been very difficult to expect someone to make that, on that sort of basis, as it needed more information as an ongoing thing.

The screen is 13m (42.7 ft) long and roughly 5m (16 ft) high, so it was a very large piece of work for a single smith to handle. The finish is zinc metallised, then gloss Urethane, with a graphite-black on top; the main vertical strips are very strongly forged as a

contrast to the fabricated portions. Working on Oriel House gave Horrobin a sense of Whitfields' architecture, so he had some idea of their intention and was able to produce a suitable design, despite being given rough elevations which gave little idea of the visual complexity of the facade eventually produced. Horrobin treats screens and other work as architectural details; the architects having designed the building, he considers his role is to liven up these details – in that sense, he sees his work as subservient to the architecture.

Not all of his more recent work is on a large scale, an example of this is a clothes rack system for a Japanese clothes designer, Yohji Yamamoto, with architects Munkenbeck and Marshall, who was opening one shop in London and one shop in New York. The influence came in part from Yamamoto's interest in the work of Gaudi and from discussion with the architect and a retail designer.

In 1988 Horrobin set up Doverhay Forge Studios in Porlock, Somerset in partnership with glass engraver Gabrielle Ridler. The building had been a forge for some time as can be seen from a

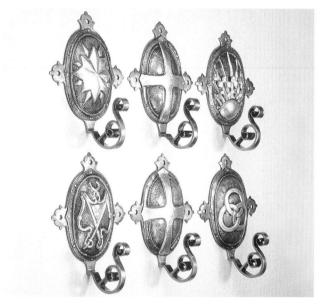

(*Above*) Dorsal Rail plaques, Church of Heavenly Rest, New York, by James Horrobin – photo by J. Horrobin. (*Opposite*) Gates at Antony House, Cornwall, UK, by James Horrobin – photo by J. Horrobin.

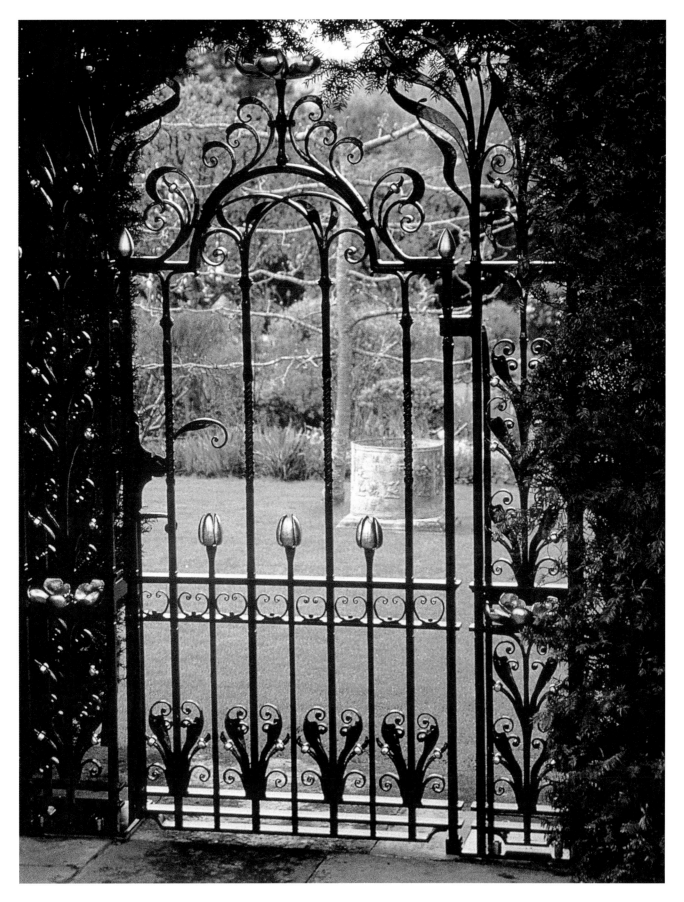

photograph Horrobin uses for promotional purposes. His work often involves a substantial amount of fabrication and welding, so he works there with a skilled fabricator, to whom he can pass on drawings for manufacture, taking on the forging work himself. If extra help is needed in either the fabricating or forging areas either one of them could arrange it.

In a return to a more traditional style of working Horrobin was asked to make a ceiling dome grille for the Sir John Soanes Museum in Lincoln's Inn Field, London. It is over the centre of one of the picture rooms and is only seen from the inside looking out. Claudia Petley and Paul Shepherd assisted:

> I hadn't actually done a job like that for 10 or 15 years and I was no longer sick of that sort of stuff, I really enjoyed doing 102 fire welds, and doing something in a very repetitive way. I built that to an 1895 drawing, from an architect who was doing restoration in 1895 – whether they actually had that dome made, I don't know – there was no evidence of it.

A 1989 balustrade for Charles Saatchi's house is an example of a large-scale private commission, once again working with Munkenbeck and Marshall as architects. The architect, being a minimalist didn't want this balustrade at all and would have had a top rail, a few verticals and possibly a middle rail running through. However, the Saatchis had been to the Picasso Museum in Paris and had seen a massive staircase there, and had a picture of it from a magazine. Horrobin recalled:

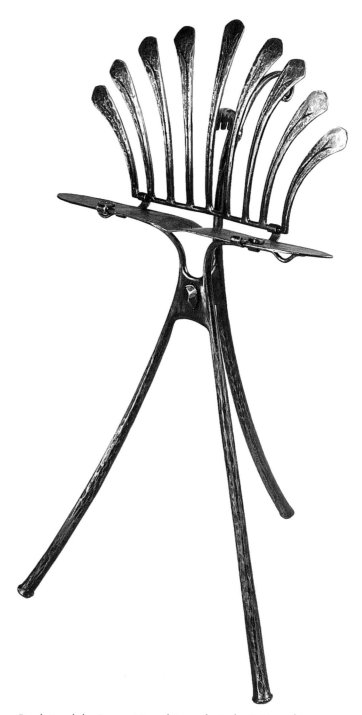

Bookstand, by James Horrobin – photo by J. Horrobin.

> … so the architect said, 'there you go, he wants something like that'. Well, it was obvious that he didn't want something like that because the handrail was about 9in. thick – you know, it was different architecture altogether. What they actually meant was that they wanted the

staircase to have some sort of life in it. They didn't want it to be geometric, so I worked on that basis. The architect didn't actually want a repeat pattern. He said, 'Make it like a piece of music, like a piece of jazz, with some sort of idea running through it.' Actually the design

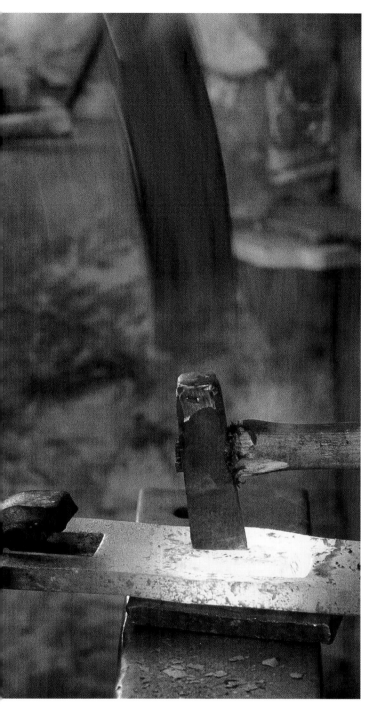

James Horrobin forging-hammering a hot set – photo courtesy J. Horrobin.

In making some fire baskets for the Saatchi house, Horrobin noted a change in the way he had worked over the years. There were some large finials to be put on the ends of some of the bars, which in earlier times he would have made by forge welding a huge collar on, which would have taken about four hours a piece using traditional forging methods. In this case, he cut a disc out of 25mm plate, cleaned up the edges and squashed it under the power hammer, forged it around the edge to get an oval shape, and then MIG welded it to an upright bar before adding more weld to build it up, then reforging it. He found this approach faster and more enjoyable than the traditional method, as well as achieving virtually the same result. This flexible approach to the use of techniques and equipment, allied to forging techniques and an awareness of architectural context, characterises the best of British contemporary ironwork. As Horrobin has said, 'I make work whatever way I fancy really, if the job works'.

A further commission was Horrobin's creation in 1991 of a large Art Deco style screen for the exterior of the Savoy Theatre; and some figures based upon characters from Gilbert and Sullivan works for the inside. Whitfield Partners and David Lyle, who were responsible for the theatre's restoration, commissioned him.

In situations where there is a mixture of fabrication and forge work it is usual for a number of businesses to be involved. When possible, for both legal and practical reasons, Horrobin prefers larger firms such as Dorothea Ltd., or Quinnell's, to be responsible for fixing on site, which in itself is a potentially tricky task:

> ... there is no way that I want to become sub-contracted [to a large construction firm]. If I do then I'm down the plughole as far as time goes... my job changes; I become a pure administrator.

doesn't repeat itself anywhere on the 23m. They decided to spend just under £40,000, which is just under £2,000 per running metre, and they bought that job on the strength of that drawing and that model.

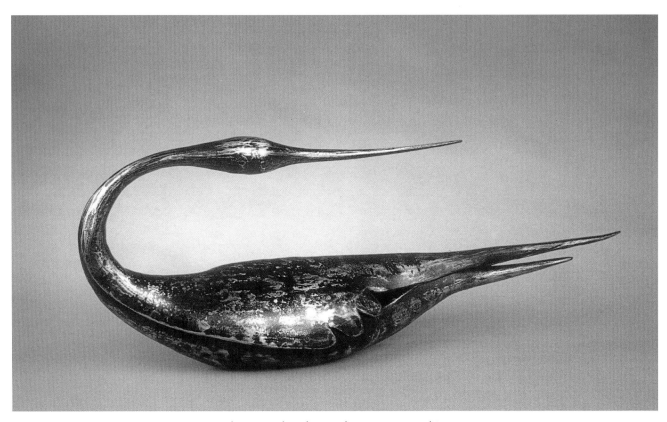

(*Above*) Bird sculpture, by James Horrobin.
(*Opposite)* Walled garden gate, by James Horrobin – photos by J. Horrobin.

A series of changes in Horrobin's working practice and philosophy have taken place, from working as a traditionally trained rural blacksmith effectively producing production-line reproductions of 17th- and 18th-century style work, to a self-aware, businesslike practitioner, prepared to use the most appropriate means to achieve the intended result. Horrobin's work has gone from being local, small scale and old-fashioned, to being recognised as innovative in its design and technique at a national and international level. The love of hand forging and the sense of material quality this gives are still important elements of even the fabricated work. The sense of design and an awareness and sensitivity to material quality are typical of artist blacksmiths like Horrobin, and untypical of fabricators in the conventional mould, who work to the drawings of others, or with structural and cost considerations as the major determinants of design. It would be difficult for Horrobin's Cheapside work, for example, to be described as traditional blacksmithing, but perhaps it could only have been designed by a blacksmith.

In more recent times, Jim has felt able to work again, from time to time, with design elements from earlier ages – in a sense, the re-emergence of the scroll and other 18th-century design elements, but this time by choice. This represents quite a different approach from that of 20 years earlier, when options were limited by lack of knowledge and communication.

Cooperation, networking, and communication, especially at an international level are important elements in describing the way in which Horrobin and smiths like him have made the transition to contemporary practice. A wider experience and heightened awareness of the needs of architects have been essential ingredients of the change.

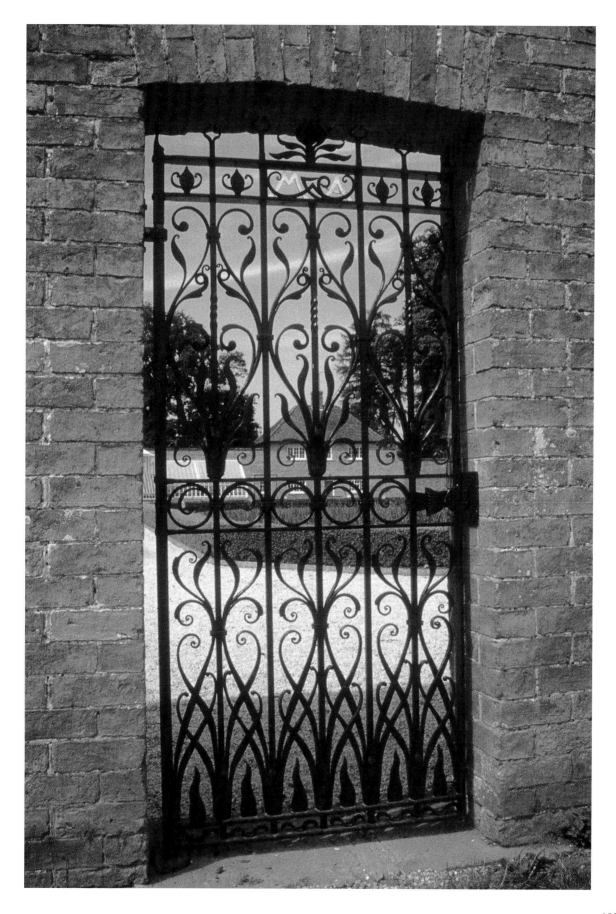

Alan Evans

Alan Evans has become one of the most important European blacksmiths, and in doing so has completed some of the largest and most influential commissions of recent years. In describing what he does, Evans prefers to be referred to as a 'site specific artist or maker' working through the medium of blacksmithing.

He completed a teacher training course, which included silversmithing at Shoreditch College of Education before joining blacksmith Alan Knight at Redditch in 1974. In 1978 he set up his own workshop at Whiteway, in a small shed near to his present workshops and his father's workshop. Evans was brought up in an Arts-and-Crafts-Movement household in the Whiteway Colony in Gloucestershire. After the influence of his parents, both craftspeople in wood, his formative influence was the early 20th-century work of Ernest Gimson and Sidney Barnsley (Exhibition catalogue, *Palazzo dei Conservatori*, Rome, 1996).

It was their aesthetic, developed a couple of miles from here in the Cotswolds, which encouraged me to look for my own vocabulary of forms beyond the sub-eighteenth century style which was, and still is, the style of the majority of architectural ironwork produced in this country.

Evans has completed a number of important London commissions including gates for St. Paul's Cathedral; Broadgate Development Screen; Lewisham 2000 project, and the Public Record Office, Kew, as well as national commissions such as the Cheltenham Museum and Art Gallery Grille; Architectonic Totems for the WHCSA Building, Cardiff.

As with Alan Dawson, his work often demonstrates that site-specific or custom-made functions better and is more cost effective than standard factory bought alternatives. This advantage is

Bench detail by Alan Evans, Gloucestershire, 1995, forged from 80mm square mild steel.

achieved through a combination of factors: sensitivity to the site, effective collaboration within the project as part of the decision-making process; design ability; making ability; the use of appropriate equipment for drawing, such as video and computer equipment to record the site and produce accurate and realistic 3D drawings and renderings; the use of power hammers, power presses and modern furnaces in addition to traditional hand forging techniques. This is allied to an uncompromising creative vision: 'work must be right for me and right for the site – ignore the brief'. He makes his work by:

Sculptural form by Alan Evans for the Fe exhibition, Tully House, Carlisle, UK, 1996.

...following the integrity and the purity of the inspiration, I don't believe the customer is always right. Be prepared to lose the job to do what is right for the time and right for the job.

This can involve getting a job by not doing what the architect wants, and being prepared to express clear views on what will or will not work from a design standpoint.

Evans has confined his work almost exclusively to the use of forged and fabricated metal; he has rarely collaborated with others using different materials or processes. This gives his work a distinctive character, but tends to exclude the use of an alternative material or process where it may be a more appropriate means of achieving the design intention. An exception to this general rule was the screen he made for St. George's Cathedral in London. The screen included 60mm round mild steel, notched to form shoulders, then centred so that it would balance on the anvil and the ends worked. For this piece steel was mixed with canvas and wood by other makers.

He has often regarded design competitions as an opportunity to explore himself and the site. There is a sense of competition with the site to come up with a good idea. Perhaps his best-known work, the gates for the crypt of St. Paul's Cathedral, resulted from a competition between five smiths, organised in 1980 by the Higgins Ney Design Unit, based upon information given to them by the Crafts Council.

Although he would be regarded by most traditionally orientated smiths as a modern smith, he is clear that what he is doing is firmly within the traditional camp:

I'm more a traditional smith than anyone – the real tradition is of innovation and using the latest technology – the real tradition is the philosophy. You should honour the tradition by creating your own vocabulary of forms.

The Public Record Office at Kew is the location of some of Evans' recent work. It is in a Victorian street, with gables and pitched roofs. The work was to provide a link between the public and the private, something which would be interesting and tactile. Alan noted that:

The distance the work is read at is important, contrasts in forms and masses are important. The larger elements have to be tall because of parked cars, and relate to the domestic scale of gardens at each end, planned around focus

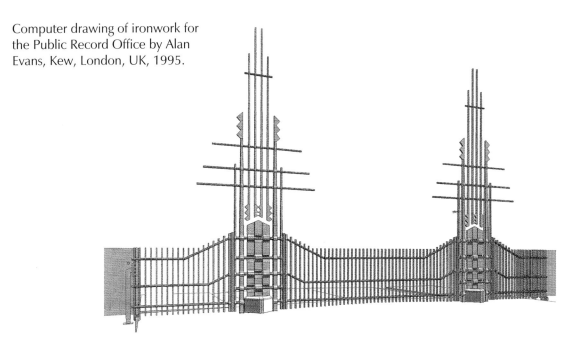

Computer drawing of ironwork for the Public Record Office by Alan Evans, Kew, London, UK, 1995.

points, like counterpoint in music. Scale, distance, relationships are all important.

For the Kew project he was recruited as part of a team which included a sculptor to work together on aspects of the architectural and landscape design and perhaps be commissioned to do pieces of work. This team considered the nature of the bridge, position of the waterfall and the use of the thick slate shelves from the old Public Record Office, for example.

The design drawings for the Kew work were computer generated, a necessary re-drawing taking just six hours. The site engineers ignored the sizes on the original drawings Evans had produced, assuming they were 'artist's drawings'; they made the plinths too big, changing the entire design as a result. Using computer drawing Evans finds that proportion, spaces; weights of metal, and balance are easier to achieve. Hand perspective sketches, however, often describe the quality of the metal more accurately, where light, shadow and the softening of the appearance of forged parts are important.

The punched hole is the main decorative feature of the Kew work. Tally Sticks (notched hazel sticks recording monies owed by government to counties – used until 1830) and the notches used in them for

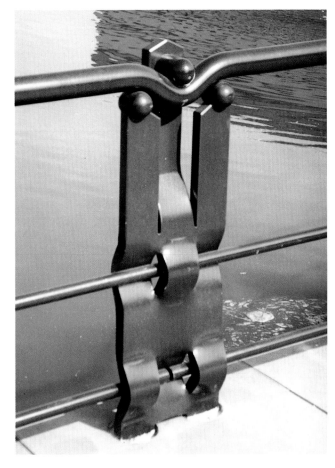

Waterside railing detail by Alan Evans, Public Record Office, Kew, London, UK, 1995 – photo by A. Evans. (*Opposite*) Public Record Office metalwork by Alan Evans, showing tally stick details, 1995 – photo by A. Evans.

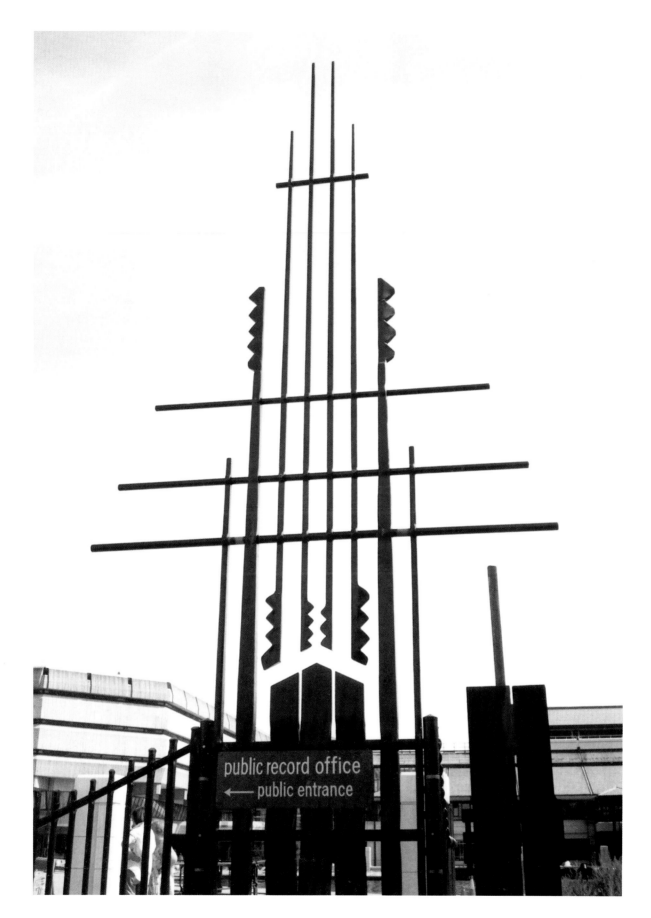

109

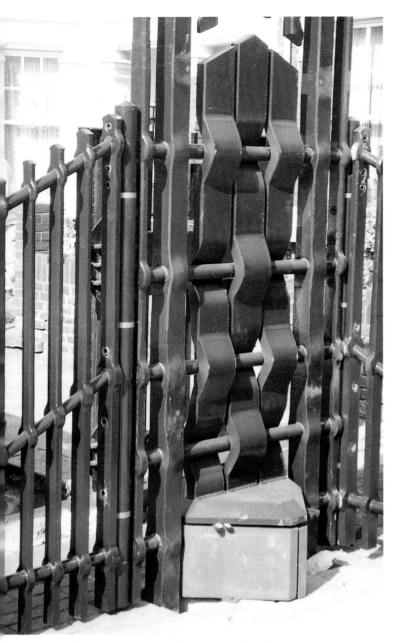

Lower part of tally stick feature showing large scale punched and forged sections by Alan Evans, Public Record Office, Kew, London, UK, 1995 – photo by A. Evans.

the design, the better. When asked to do some figurative work, he felt neither confident nor interested, so for a processional cross he chose to work with a sculptor. Some time afterwards he called at Christoph Friedrich's workshop in Switzerland and discussed it with him. Friedrich has had a lot of experience of figurative work and a particular skill in working with small sections of material.

> I'd hardly picked up a hand hammer in ten years – it had all been power hammer work picked up by a crane – then I felt inspired to have a go. I forged a figure at the end of a bar. A pole with a figure on top of it to be removed from the altar cross with a much heavier frame – the figure on the small pole could then be used as a processional cross, then placed back in the heavy altar cross.

Evans isn't clear how much his work has become geometric rather than organic as a result of using computer drawing, as his work before CAD was starting to go in the same direction stylistically. He uses a Macintosh computer system with a number of peripheral devices such as scanner and A2 printer; as you simply turn it on and use it, rather than spending time configuring it. He is concerned because at times it becomes toylike or hobbylike and can't be always be justified in terms of economic use. Computers have only really been fast enough in the last couple of years to do the kind of sophisticated image manipulation Evans does at an economic price. Originally he used CAD to get an idea of proportion and real perspective, and to lower the risk of mistakes, particularly of a dimensional nature. When drawing on computer he tends to:

> …think of things at an earlier stage, and the unexpected, exploratory feel which used to come through at the making stage is now done at the drawing stage. It could take some of the

record purposes are the reference points, as they were the only 3D objects in the Public Record Office, except for the Great Seals of State – everything else was on paper. Therefore, what appear to be the most obviously computer-generated forms, are actually the ones with reference to the hand-made.

Evans has tried to avoid figurative work because of his Quaker background, where ideally the simpler

fun out of the making. It's quite a fundamental change in working practice; there's less fun or serendipity in practice.

The use of the computer, while it saves time and reduces errors at the making stage, has contributed to back problems Evans has experienced in recent times, because he has spent so long working at a desk. What tends to happen is that during this time his fitness decreases and this has coincided with an increase in the size of the projects he has been working upon. So the physical demands of the work have increased at the same time as his physical capacity has reduced, making him more vulnerable to injury.

Sometimes his work is function specific rather than site specific, as in the case of projects for Lewisham and Cheltenham involving benching, signposts and bicycle racks. For the Cheltenham pedestrianisation scheme, the Art Committee had a requirement for cycle racks and allowed £5,000 for each group of racks. In the first instance they specified a standard rail system based upon cast iron posts linked by tubular steel rails. This system needed 18 tubes to be located in the ground, in order to accommodate 24 bikes. Using his cantilever design, Evans was able to fulfil the requirement with four holes in the ground. The price for the racks was to include £500 allocated to the Engineer's department for the cost of fixing them, as Evans' design required less fixing, the surplus money went to him. Stainless steel loops were fixed to heavy punched and forged bars. Because the drawings were on computer it gave them increased credibility with the Engineer's department, but in order to get the money from the Art Committee there was a requirement for *hand* drawings of the previous computer drawings. So in spite of going against the stereotypical impression of the 'impractical artist', by producing computer drawings, he then had to revert to hand drawing afterwards, to prove his 'artistic' credentials.

Evans buys tools and equipment not as an

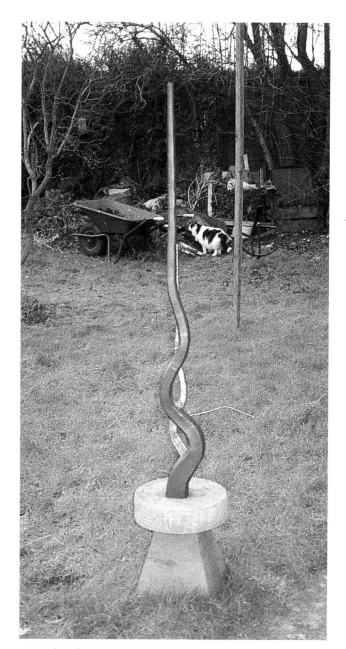

Forged sculptural piece in his back garden by Alan Evans, Gloucestershire, 1995.

economic investment but always to enlarge his metalworking vocabulary, allowing him to make things which would otherwise be impossible. This lack of an economic imperative is exemplified by the fact that between August 1995 and February 1996, he spent his time only on drawing, which in a sense is opposite to normal good business practice, as his manufacturing equipment lay idle. He feels that there

Alan Evans in his workshop, 1995.

is vast potential in blacksmithing, and equipment purchase helps him to explore it more effectively.

Any skills lost over, for example, a ten-year period may, Evans considers, be re-learnt for new projects:

You have got to learn how to make it each time for a one-off. Freshness and immediacy has to be maintained each time. With some practice skills are developed. You are responding to meaning, not to the metal.

When working using a particular vocabulary, he feels that physical prowess and coordination may help, and

practice is important to get 'up to speed'. With the reservation that, as soon as you start to think about it, or analyse what you are doing, you cannot do it with the same fluency.

Evans thinks that competence comes from a use of analytical design processes, but wonderful things come from a creative process, where there is an intuitive response to the site. He sees the design process as a means of testing the original idea, but it is often best to revert back to an original, 'back of the envelope', idea. He notes: 'The theme and the spirit is difficult to maintain as part of a big job – all work should contribute towards the whole, the vision is the key.'

Evans, in reacting to criticism of Lund's Hyde Park Gates, commented that despite some reservations:

Hyde Park is not a copy. It didn't do any harm – it was frothy and fun and that was fine. My own interest is more regulated and controlled; it's not my style of work…Ten feet away there are about a mile of railings, box section, components…bland, soul-less…no-one had complained about this. Why criticise an individual work?…It is worth criticising whereas the railings are not…The railings and others like them are the real evil in our cities…They are so bad they don't exist.

In making this comment he highlighted the existence of a plethora of poor ironwork, often produced industrially, and with little or no sympathy for the site, the material, or their cultural sense of purpose. This work is almost never commented upon, and yet public spaces are full of it. Public work needs, especially, to address both the issues of practical and decorative functionalism. To be practical it must work, or do its job: providing a secure barrier, or easy opening and closing, for example. Moreover, concrete issues need to be addressed: the difficulties of fitting the work on site, safety, structural requirements such as stiffness, sagging or creep; environmental considerations and in particular resistance to corrosion. To be entirely successful, the cultural function of the work needs also to be recognised and addressed.

At present, Evans obtains many of his commissions from Public Art agencies – with whom he has deposited slides of his previous work. He is one of the most effective exponents of Public Art, informed in part by working with his partner Lesley Greene, an important figure in the development of the Public Art movement. An earlier example of a very large public art work is Evans' Broadgate screen in London which, although related to the surrounding architecture, does something to humanise the space and the approach to the area.

Evans has developed his own furnace design, which has become an important aid in completing large pieces such as the Kew work. The traditional blacksmith's hearth uses coal, coke, or more rarely charcoal, and an air blower. In contrast to solid fuel forges, gas furnaces do not require skilled working, as they can be set to a given temperature and left without fear of overheating the material. For the Kew work, it was possible for one person to punch 40 holes in steel bars of 50mm by 20mm in one day, whereas with a conventional hearth two people could do 16 holes per day. The one metre long heating area enables longer tapers to be worked in one heat, so that achieving form is easier and more efficient. A disadvantage is that it is difficult to heat a large three-dimensional piece, and difficult to focus the heat as required for hole punching, for example. Evan's gas furnace consists of two 150mm gutter sections of ceramic pipe, with a gap between, allowing a long or wide heat, as required. It took three months to develop the furnace and tools, and to make it work successfully. He regards the development of equipment and techniques as an important part of his work and part of the creative process.

Peter Osborne

Peter was born and initially educated in Cambridgeshire, UK. He was trained as an engineer at Nottingham, before travelling through North Africa and Central Asia between 1970-72. After this he worked for 18 years in building conservation and developed a variety of skills, specialising in structural repairs; where he began to form a strong interest in architectural ironwork. In 1988 he pursued his interest in ironwork, learning the basics at the excellent series of weekend courses run, initially by Frank Day, and the Guild of Wrought Ironwork Craftsmen of Wessex at Cannington College in Somerset. He then set up his own workshop before attending the two year HND course in blacksmithing at Herefordshire College of Art and Design, which he completed in June 1995.

He now works full-time as a smith in Somerset where, alongside traditional blacksmithing, conservation work and occasional teaching, he produces functional and sculptural pieces for gardens, and site-specific purposes. Natural forms are the inspiration for his work, and he is particularly interested in combining metals with other media, such as mortars, glass, mosaic, water, light, etc. He believes that the organic forms that he uses render his work accessible, at the same time as challenging perceptions of traditional uses of the media.

Peter Osborne, demonstrating at the
Bath and West Show – photo courtesy P. Osborne.

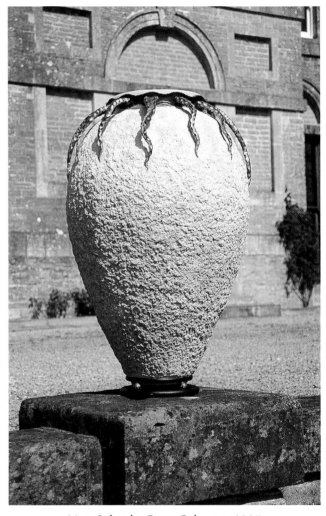

Urn, Solar, by Peter Osborne, 1997
– photo by P. Osborne.

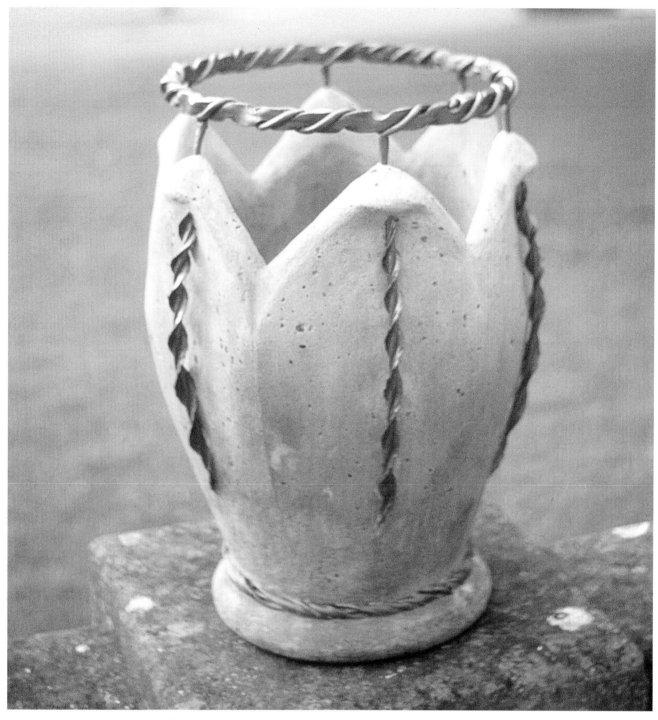

Twist Urn by Peter Osborne, 1995 – photo by P. Osborne.

Some of the most enjoyable work involves public commissions, as there is a link with his work in conservation – it is a good way of using his extensive conservation experience to complement his blacksmithing work.

Mortars have been a special interest, and he has conducted experiments with texture and tonal variation using methods inspired by traditional plastering and pargeting techniques, alongside modern spray-based approaches. Sands, crushed

School entrance, archway and sign by Peter Osborne, 1997 – photo by P. Osborne.

stone, admix, fibre binders and some organic materials have been used to create, for example, tufa-like surfaces.

When investigating site-specific work he takes into account the surrounding landscape, environment and functional requirements. Historical references may provide a starting point, and consulting relevant or interested people often provides a way forward.

Peter was commissioned in 1997 to design and make an entrance archway to Leigh-on-Mendip First School. The school had decided that it needed a sign, and it also wanted to enhance the main pedestrian entrance. He looked at the site, and spent time talking to the teachers, governors, children and parents, after which he made a series of initial designs. These designs were discussed with all concerned, and the final elements were selected. The overall shape echoes other ironwork features in the village church, the mosaic being a reference to the

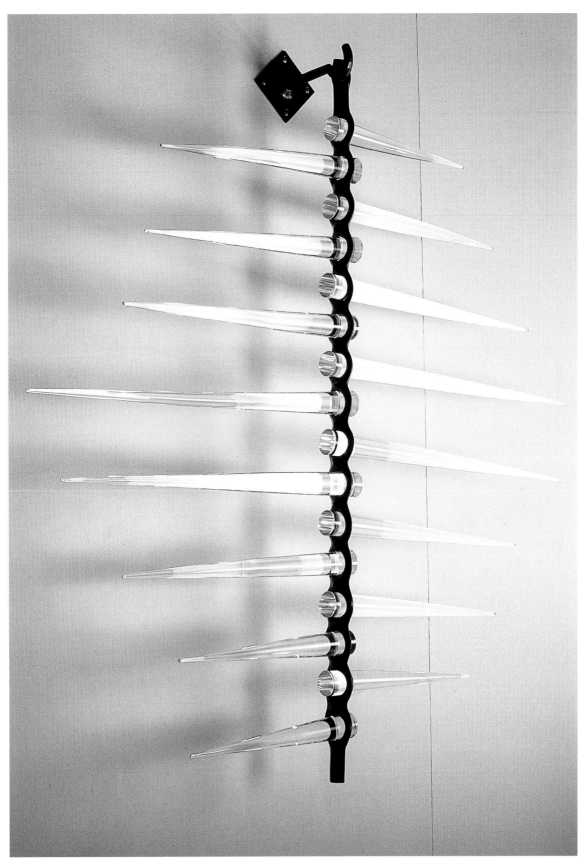

Forest Flower by Peter Osborne, 1998. Glass by Neil Wilkin – photo by P. Osborne.

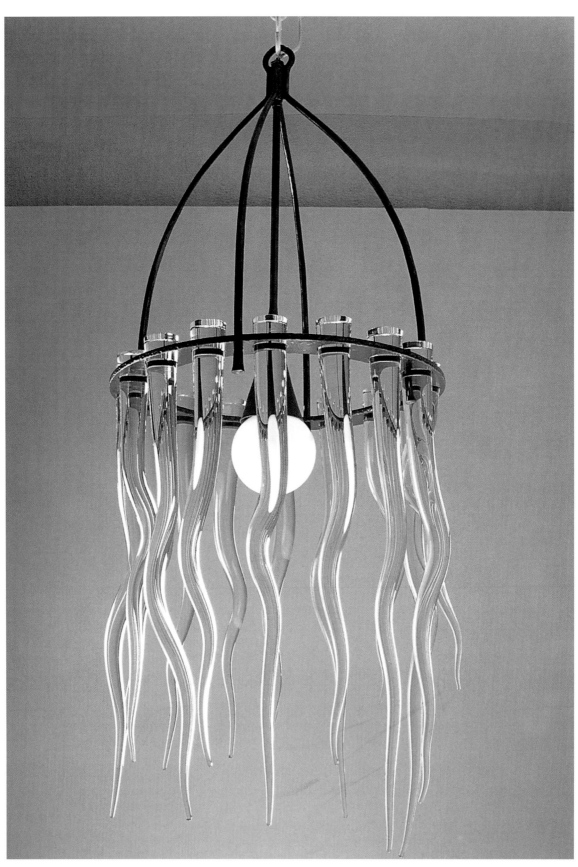

Waterfall Chandelier by Peter Osborne, 1998. Glass by Neil Wilkin – photo by P. Osborne.

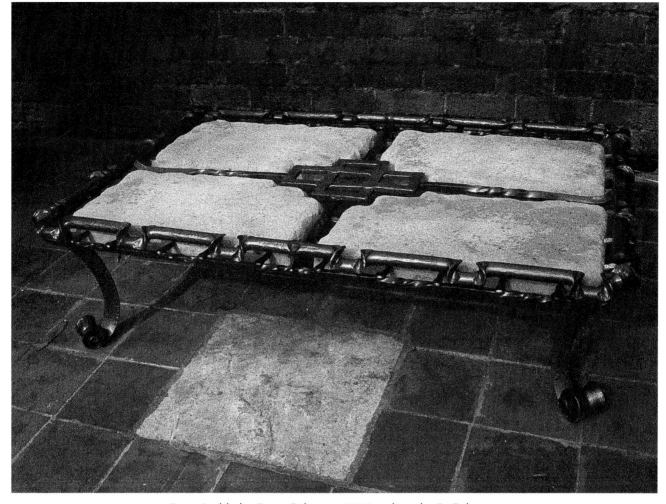

Bonsai table by Peter Osborne, 1996 – photo by P. Osborne.

Roman history of the area; the Griffin is a Somerset County Council symbol, and the swallows are the school symbol. Every child in the school contributed to two small mosaics, which were placed on the reverse side of the lettering. The bars needed to fix the sign to the wall were drilled through and fixed with bolts whose ends were forged ammonites, visible on the outer wall – a reference to the geology of the area. This is a good example of the involvement of the client community, combined with cues from the local environment and the site, to produce a result that is interesting and has a strong narrative content with, as a result, more interest for the local viewer in particular.

Peter's work in combining materials is especially interesting, having a number of possible applications in architectural contexts, where the use of compatible or interesting combinations of materials can be important. Peter's work with glassmaker Neil Wilkin is quite striking, using the qualities of the glass and metal to good effect; punched bars, in particular feature in these pieces.

Often when makers work on their own with combinations of materials, they have a greater sympathy or expertise with one of them, and the others can be a little less well made or designed, possibly reducing the potential effect of the combination. Peter's work with mortar and ironwork, in particular, shows an equal sympathy for both, and has benefited from this.

Malcolm Chave

Malcolm completed a BA course in 3D design at West Surrey College of Art and Design in 1992, during which he spent three months at the Fachhochschule, Fachbereich Design, in Düsseldorf, Germany. He works at present in the University of Plymouth's Exeter School of Arts and Design and has worked as a technician at the Royal College of Art in London and as a silversmith in Plymouth.

Recently he made an entrance feature for a Tesco supermarket in Axminster, Devon, UK. With the exception of the top motif and plaque, which are cast in bronze, it was forged and fabricated from mild steel, and used standard nut and bolt fittings. A constraint of the job was that wall fixings were not possible above 3m high – the structure, therefore, needed to be as light as possible, whilst retaining a solid appearance. This was achieved by fabricating a sheet metal interior with a substantial bar covering the outside, capable of supporting the 4 m structure.

The local church was photographed, both to assess the visual impact of the design and to look for design cues. Elements of the design of the church, such as windows and arches were examined, photographed and interpreted via computer-aided drawing. The computer work enabled the design elements to be manipulated to suit the nature of the site, and to provide an interpretation of the architecture within the space available.

Particular attention was paid to retaining an asymmetry within the work, so that no part of the

Malcolm Chave at work in 1999, cleaning up a cast bronze bust.
(*Opposite*) Sculptural grille by Malcolm Chave, 1990, made at West Surrey
College of Art and Design, forged steel and wood – photo by M. Chave.

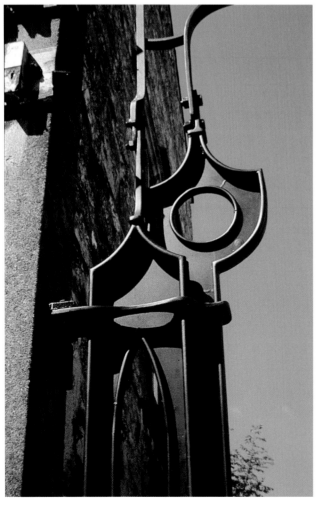

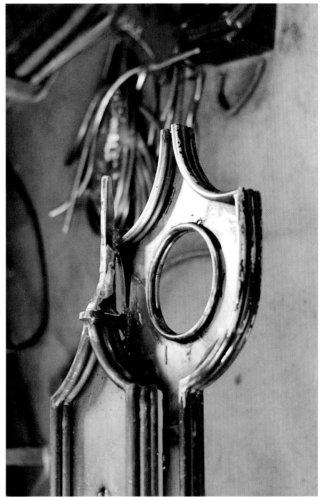

(*Bottom left*) Close-up of forged detail by Malcolm Chave.
(*Bottom right*) Silhouette of Tesco entrance by Malcolm Chave – photos by M. Chave.

design was repeated in another area. As no parts could be duplicated this asymmetry did cause some difficulties during the construction, but was felt to be worthwhile given the visual impact of the design. The elements were sandblasted and coated prior to fixing on site.

This commission is typical of many in that it was given by a large commercial concern, which, no doubt as a condition of being granted planning permission for their development, was obliged to fund the production of features to enhance the local landscape. Various 'percent for art' or other schemes and local enhancement projects have been funded by supermarkets in particular, and have provided a number of interesting commissions for artist blacksmiths.

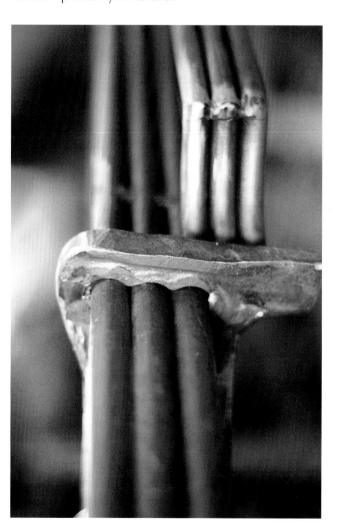

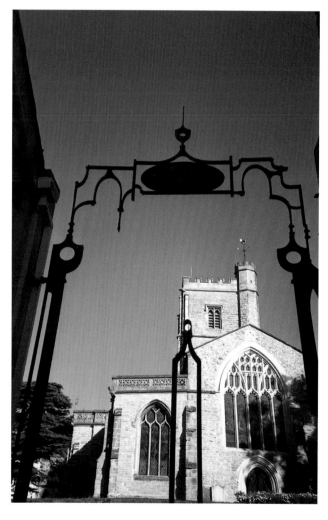

Terrence Clark

Terrence Clark set up his own workshop in 1972, moving in 1981 to Wildfields Farm, Woodstreet Village, near Guildford in Surrey. He draws inspiration from living in the countryside. His workshop is in a former barn where he works with his team to produce a wide variety of work, often on a large scale. Gates, railings, church furniture, spiral staircases and sometimes very small-scale pieces such as jewellery form part of a very varied output.

When working on larger scale commissions, he ensures that they are structurally sound and meet the appropriate regulations through consultation with builders, architects and other professionals. The site is seen as the major determinant of the design, but there will always be some influence from the client.

Terry has been very active within BABA over the years taking on a variety of roles, including editing *British Blacksmith* from 1980 to 1984. He has given numerous demonstrations, and has been *Forgemaster* at forge-ins and conferences, including some in Ireland and Bristol.

His work has featured in a number of specialist and general publications over the years and he is well regarded throughout Europe. He has won the Addy Taylor Cup given by the Worshipful Company of Blacksmiths, as well as their Silver Medal (FWCB). In 1998 he received the Freedom of the City of London as an acknowledgement of his work in blacksmithing. In 1986 he was the first Artsmith to have a gate accepted for the Royal Academy Summer Exhibition under the Sculpture category.

He is a keen conservationist and works hard to blend restoration work into the exact style of the original smiths. He has enjoyed working with the National Trust on a number of restoration projects.

Particularly during the formative years of practice he was able to take advantage of assistance and advice from the RDC, taking forgework training courses himself, and later enabling apprentices of his own to do the same. He is one of only a few smiths to take the requirements of marketing seriously, producing excellent brochures and publicity material, which are able to do justice to his work. Far too many other smiths either ignore this aspect of their businesses, or produce lacklustre material, which does them few favours.

His work involves extensive use of traditional forging techniques and features, but is designed for the most part in a contemporary idiom. He is not afraid to take a pragmatic approach to the use of modern techniques, such as profile cutting, when appropriate. When forging very large sections of material, it makes a great deal of sense to cut material fairly close to the desired final shape, then complete the work by hot forging – the result is identical to that obtained by forging alone, but is achieved at lower cost – giving benefits to both the smith and the client. This is very much in accord with *Commercially Acceptable Craft* – as named by Alan

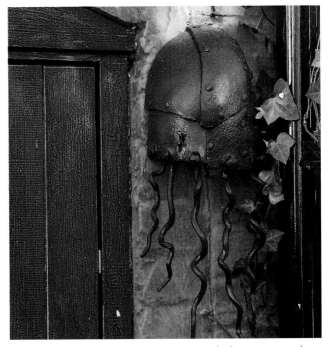

(*Above*) Armadillo light by Terrence Clark, 1995, made for the Grace Barrand Design Centre.
(*Opposite*) Gazebo detail by Terrence Clark,1990, mild steel and stainless steel, Surrey – photo courtesy T. Clark.

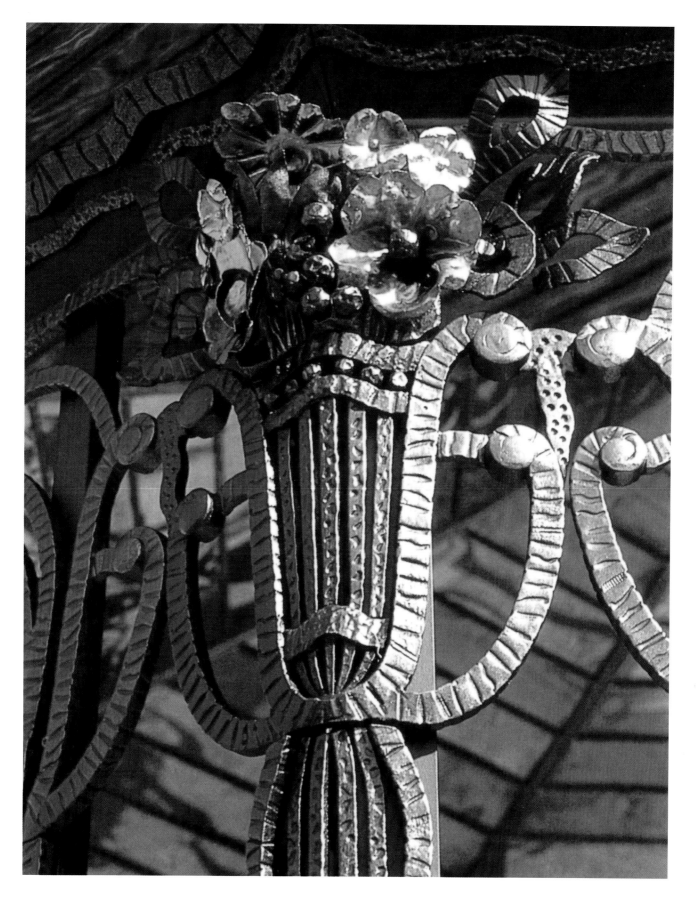

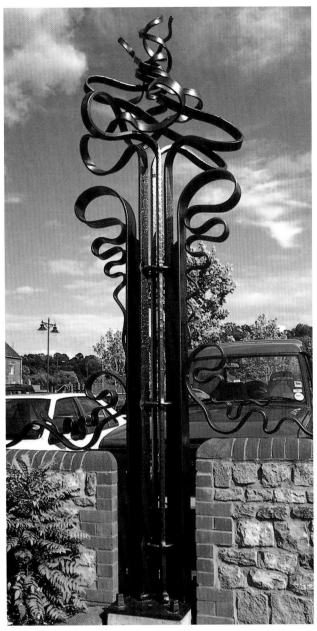

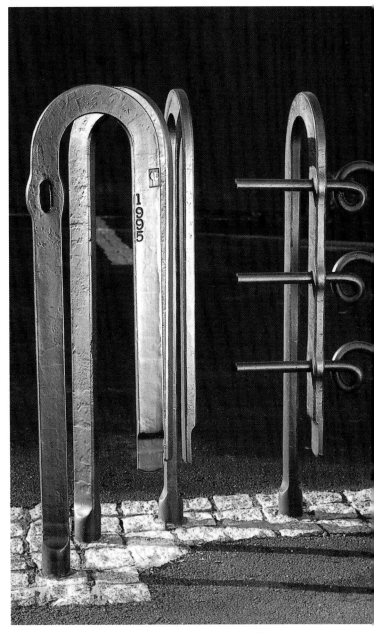

Public commission by Terrence Clark, 1997, Godalming, Surrey – photo by T. Clark.

Sculptural railings made for the Grace Barrand Design Centre by Terrence Clark, 1995 – photo by T. Clark.

Dawson, where the work is made taking a pragmatic and commercial approach to the use of traditional skills.

The design and manufacture of Terry's work owes much to the traditions of blacksmithing, but it is obvious that he acknowledges the need for personal expression; a sensitivity to the site, and the requirements of the client – within the context of running a commercially viable business – very much the approach of an artist blacksmith.

Metalforging in Germany

German smiths, alongside their American colleagues, have been influential in the development of art metalforging worldwide. A concern with the use of texture to personalise work has been a feature common to many smiths' work. Perhaps as a reaction to earlier times when folk-based artwork was dominant, and in a sense recapturing some of the spirit of the Bauhaus, modern design has been seen as important in the last 30 years. Pioneering work by those such as Fritz Kühn, with his fondness for natural forms and texture, has had a wide influence.

As with American work, there has been a huge amount of new work completed in the German speaking countries. The southern parts of Germany from Aachen down to the Bodensee in particular have many fine artist blacksmiths, including Manfred Bredohl of Aachen, Matthias Peters from Stolberg, and Herman Gradinger of Mainz. Achim Kühn of Berlin, Fritz Ulrich, Paul Zimmerman of Pliezhausen and Klaus Apel, have also been influential.

Manfred Bredohl was a politically and commercially astute designer and maker with a very large forging facility, gallery and design studio known as *Vulkanschmiede* in an industrial estate in Aachen. His international training facility allows journeymen smiths to take up a placement for three months or so – Albert Paley, for example, took part in this scheme some years ago. Bredohl organised a number of important international events and conferences, and was involved with the editorial content of *Hephaistos* magazine. He was known for the production of heavy-duty sculptural pieces made with a particularly large power hammer. He had also done much good work in Togo, Africa in making links with smiths producing ritual metal objects, and raising money to improve water supplies.

Matthias Peters from Stolberg followed his father in working as a smith. His work is varied and includes architectural and domestic scale pieces using both ferrous and non-ferrous metals. He has a

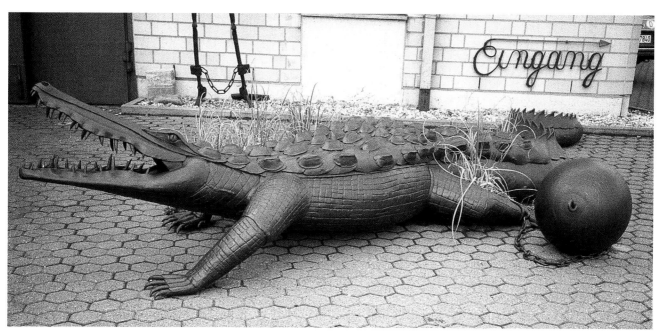

(*Above*) A life-sized crocodile guards the entrance to his workshop by Manfred Bredohl, Vulkanschmiede, Aachen, Germany, 1988.

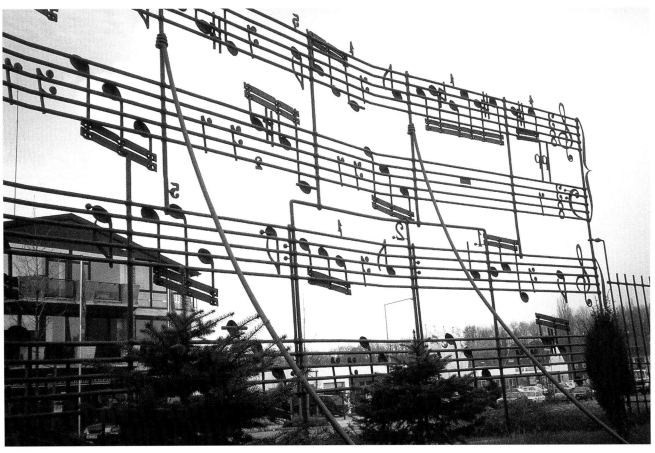

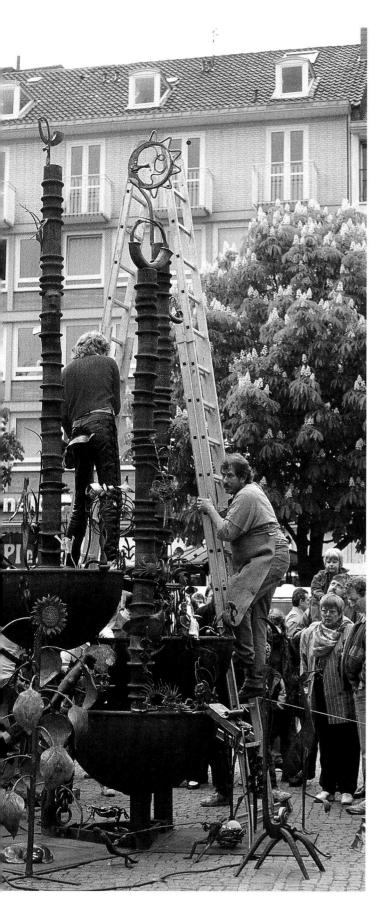

particular facility with copper forging, producing doors, some excellent bowls with brass decorative elements, doors, and other products using braze and silver solder embellishments. Many pieces of his work may be found in the Stolberg area, often linked to a strong German interest in the quality and importance of the building entrance. Matthias has also been a guest demonstrator with BABA in the UK.

Paul Zimmerman is well known for the high quality of his work; in particular his attention to, and expression of, the poetic quality of forged steel. He has good international links and has been an ambassador for artistic blacksmithing.

Oskar Hafen has a large workshop in the south of Germany, near the Bodensee (Lake Constance) at Friedrichshafen. He has strong expertise in the production of forged grave crosses, non-ferrous forging and architectural work. He has been one of the organisers of the important Friedrichshafen exhibitions, which have provided an important showcase for artist blacksmiths worldwide, following on from the earlier Lindau events.

The influence of what some have called 'the German style' of working was particularly important in the early days of BABA, before domestic smiths had come to terms with the potential of modern work. Although difficult to claim a national style for any country, it is clear that German smiths have been amongst the most influential in an international context.

(*Left*) Manfred Bredohl ascending a ladder at the Aachen International Blacksmith's Symposium, 1992.

OPPOSITE
(*Above*) Für Elise by Beethoven by Manfred Bredohl, interpreted in steel at his Vulkanschmiede workshop in Aachen Germany.
(*Bottom left*) Hotel entrance and overthrow by Matthias Peters, Stolberg, Germany, 1988.
(*Bottom right*) Chain link gate by Matthias Peters, Stolberg, Germany, 1987.

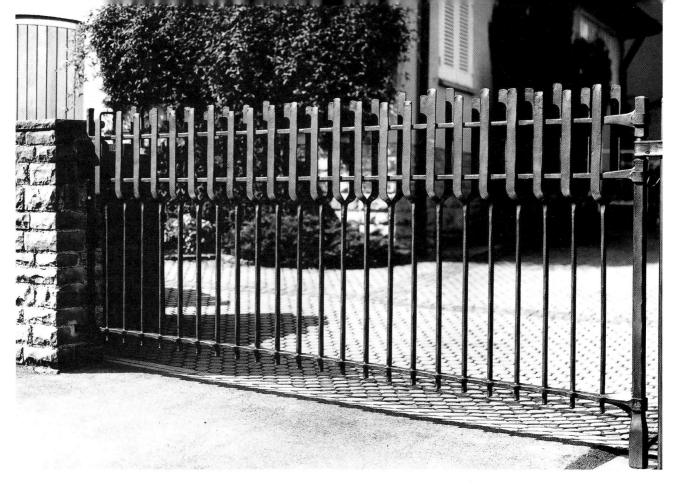

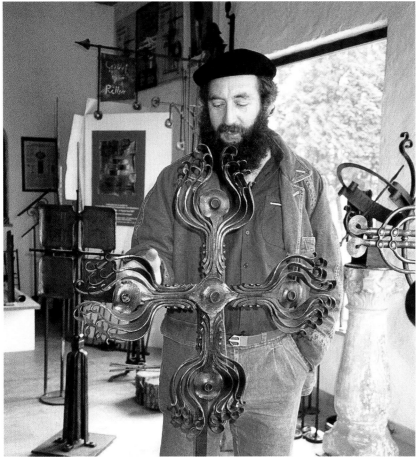

(*Above*) Garden Gate by Paul
Zimmerman, Pliezhausen, Germany,
forged steel. Photo, Karl Scheuring,
1990.
(*Left*) Oskar Hafen with a grave cross
in his workshop near Friedrichshafen,
Germany, 1988.

Keith Thomas

Keith's engagement with metal stems from working with his father, who was a craft teacher; he became intent on making at an early age. If the environment was right, he would be making things. At his pre-diploma course, which he did at Taunton in Somerset, he was surprised to be told that no-one on the course was likely to turn out to be a professional artist. However, John Phillips, his tutor, helped him to see that sculpture was his 'thing', and Keith helped him make a large sculpture for the University of Wales at Aberystwyth. In particular he learnt about the foundations required for large pieces of sculpture.

Keith studied later at Newport, for his DipAD degree in Fine Art. At the time, most students were engaged in conceptual art and only he and one other student were making conventional sculpture – this meant he had plenty of access to workshops and materials. His work was exhibited in the Royal Academy's *Young Contemporaries* exhibition in 1971. Although he was pleased to be selected, he was somewhat put off by what he saw as the rather false character of the art world. After this he was offered a place to study at Glasgow, but decided in the end not to take advantage of it. Instead he went straight into working in the car industry, making fibreglass vehicle fronts for three years. He then decided to get

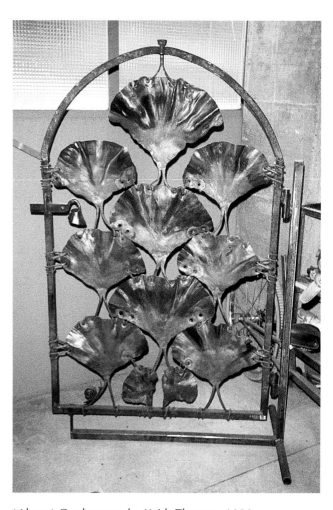

(*Above*) Garden gate by Keith Thomas, 1988, power-hammered leaves in steel.
(*Left*) Flower forged in one piece from a bar like the one next to it by Keith Thomas, 1998

131

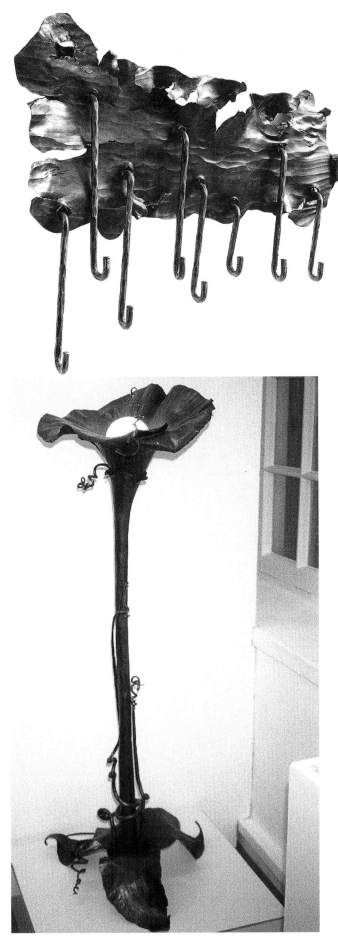

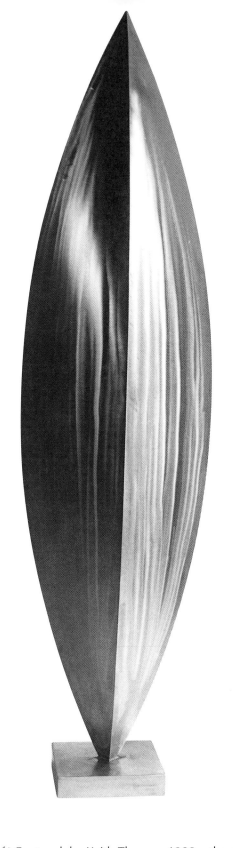

(*Top left*) Coat rack by Keith Thomas, 1989 – the original
steel section can be seen on the right.
(*Left*) Sculptural steel light form, bindweed by Keith
Thomas, 1988.
(*Above*) Fabricated sculptural form by Keith Thomas,
1990 – photo by K. Thomas.

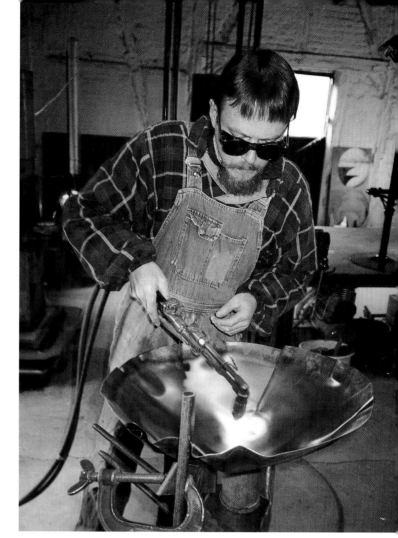

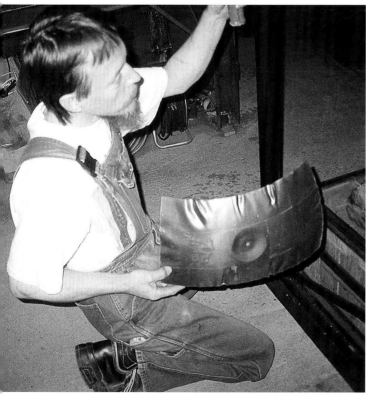

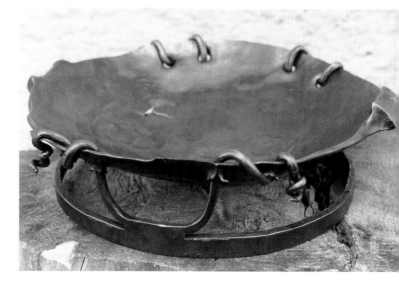

(*Top left*) Keith Thomas' drop hammer, forming a bowl, 1998.
(*Top right*) Keith Thomas heating a bowl form with an oxy-acetylene torch, 1998.
(*Left*) The completed bowl form, 1998.
(*Above*) Forged bowl, mild steel by Keith Thomas, 1988 – photo by K. Thomas.

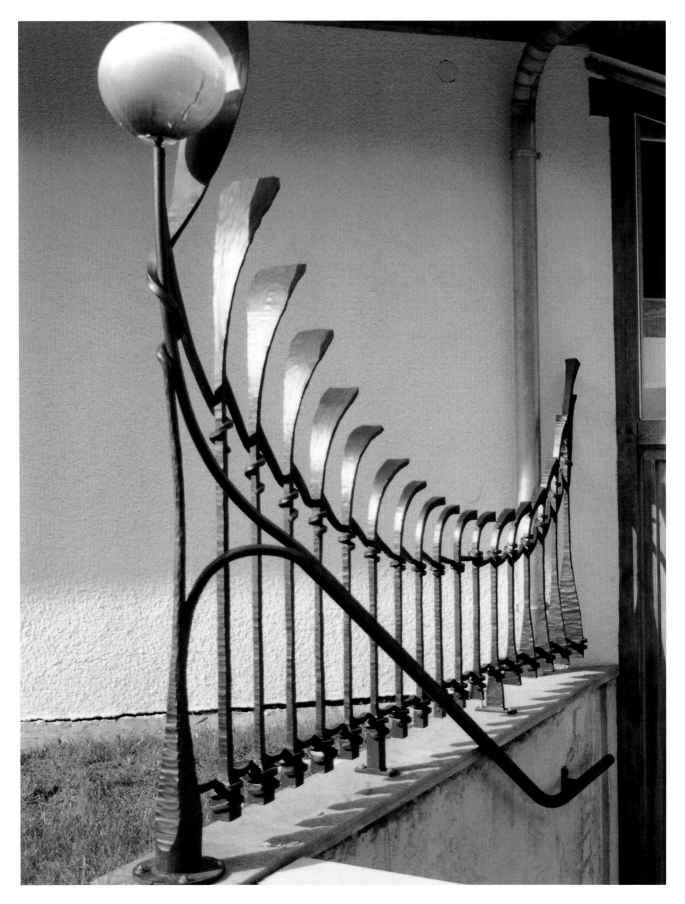

involved in art again, and studied for an Art Teacher's Certificate at Brighton, afterwards, working for four years as an art and craft teacher.

After a three-month period of wondering what to do next, he decided to travel, converting a bus to live in. During this time he got to know Alan Dawson, and was invited to his workshop for a while, becoming Alan's first employee. Within a month of this, Alan took on his first apprentice (Graham). In three months Keith was able to learn the basics of forging, thereby laying the foundations for his later work.

As a teacher he had learnt to make baskets, and he had heard of a travelling group of people who made a living from basket making in Germany. He went to meet them, but finding they had sufficient basket-makers, he set up as a smith in a tent at the back of his bus. He and his brother, who had accompanied him, were thought of by the locals as rather exotic. Keith remembers that it was at 11 o'clock on the 1 January 1981 that his first customer knocked on the door and asked for a lamp to be made, in an Art Nouveau style. This lead to further work, and eventually he was able to buy a house, with a good-sized workshop.

He received lots of financial and other help from the locals, and orders were given with money up front. Through word of mouth he gained a steady flow of orders to make railings, gates, etc., earning enough money to enable him to enter a large stainless steel sculpture *either or,* into the 1987 sculpture exhibition held at Friedrichshafen, on the shore of Lake Constance. This finally convinced him

to become a sculptor although not, at this stage, quite as concerned as he had been a few years earlier with the writings of the art world.

Now based at Sweskau, about halfway between Hamburg and Berlin, in an old farmhouse, he has a large workshop in the same yard as his wife Treez's painting and sculpture studio. Although he likes to work alone, he has taken on a few apprentices for short periods of time. He sees sculpture and ironwork as problem solving activities, and he likes to make the problems he sets himself as difficult as possible. It is important to do all of the work himself, and he feels that this is one of the reasons why customers come to him to get work made.

Recently he has started to develop designs for very large sculptures, and in particular has entered sculpture competitions. One of these is for a very large pelican sculpture, showing the bird diving into water, in a design that is part abstract and part figurative. Keith regards all his work as part of a gradual process of development. He sees the process of forging as 'work at its best – the making is fun, but in terms of combining work and aims'. It is an ideal combination of making and conceptualisation.

Keith makes a very wide range of work, including sculptural and functional pieces, but it is important to him that everything is done very well – the range is not as important as the quality. Large sculptural work and a growing involvement in a variety of exhibitions are seen by Keith as important for his future development.

(*Opposite*) Forged fence and railing by Keith Thomas, 1996, mild steel – photo by K. Thomas.

Metalforging in France

France has a strong tradition of metalforging reinforced by its place in the Serrurier section of the Compagnons du Devoir, and by museums such as the tools museum in Troyes and the wonderful collection of the Musée Le Secq Des Tournelles at Rouen. Two of the most interesting art metalsmiths in France are featured in this section.

Raymond Morales

I met Raymond Morales when travelling around France with my father on his Winston Churchill Travelling Fellowship, during 1987. We were visiting Serge Marchal in Nîmes, and asked him where else we could visit interesting work – he made three recommendations. The first was to visit Daniel Souriou, with whom he had been apprenticed; the second was to visit the extraordinary Ideal Palace at Hauterives; the third was to go and see Raymond Morales.

Raymond Morales' workshop and sculpture park is situated in a large compound at the Zone Industrielle at Port de Bouc, on the coast between Nîmes and Marseille in the south of France. There is a high wall around his compound, as he makes some

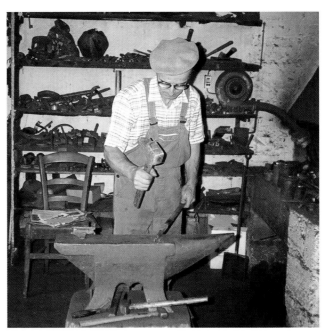

(*Above*) French blacksmith M. Reboulet, at his anvil – he is a Compagnon smith. His hammer and anvil are typically French.
(*Left*) Wheel of feet, steel and stone by Raymond Morales, 3m high, 1987, Marseilles, France.

OPPOSITE
(*Above*) Figures by Raymond Morales, 1987, Marseilles, France, steel and rubber.
(*Below*) Sculpture park, Raymond Morales, 1987.

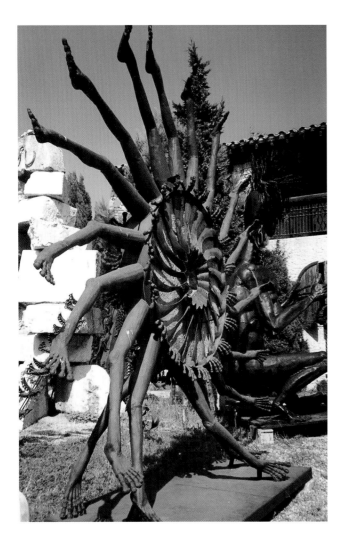

Serge Marchal

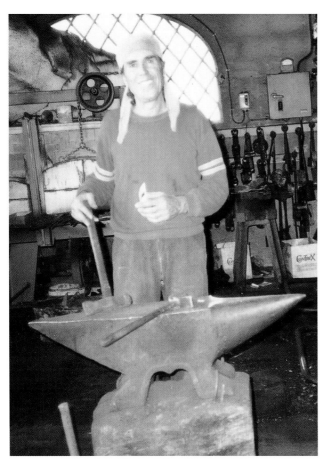

Raymond Morales in his studio workshop, Marseilles, France, 1987.

of his income from charging an entrance fee to see his incredible metal sculptures. He produces a wide range of forged products such as candelabra and architectural fittings, for sale and to commission.

His workshop is very large, with a range of heavy-duty forging and fabrication equipment. He was very welcoming when he found out that we too were smiths, and showed us around the world that he had produced. Many of the figures and sculptures have their roots in myths and legends, some are responses to society, and others express private thoughts and fantasies. In the main the figures are 3 to 4m in height, in forged and fabricated mild steel, and are not specially treated to prevent rust because of the local climate, despite being so close to the sea (about 50m away). He does not sell his sculptures as they contain too much of himself.

Serge is one of the most respected of modern French smiths and describes himself as a Sculpteur Forgeron. He is based in Nîmes in France, but works on an international basis. He trained through the Compagnonage system – essentially an amalgam of many of the ancient building trade-related guilds formed into the Compagnons du Devoir, the Companions of Duty, or Work. He worked with Daniel Souriou under the Serrurier, or locksmith section of the companions. There is no blacksmithing section per se, but the locksmiths cover the territory of the blacksmith as well as the specific locksmithing elements. There is a very high standard of craftsmanship amongst the organisation in all of the crafts covered – there are impressive examples of stone carving, plumbing and roofing in the houses of the Compagnons throughout France. Students live in the houses, working with local Masters, and studying in the workshops and studios of the houses during evenings and weekends. It is possible to be a basic craft worker, or to take on the Tour du France (not the cycle race!) as a journeyman, and enter a higher category greatly respected in France. In recent years this Tour has been extended to other countries, including the UK. In the past a Compagnon farrier would advertise completion of the Tour by erecting a sign outside of their workshop containing examples of horseshoe styles from the various regions where they had worked, as proof of qualification.

During the early 1980s, Serge completed a huge sculpture representing the Ascent of Man from the earth to spiritual realms, in the centre of the main staircase in the Compagnons House in Nîmes. This took three years to complete and is one of the best pieces of contemporary forgework to be found anywhere, all the more extraordinary when you consider it was the work of an individual working alone, in what was a fairly low-tech workshop. He approaches his work with great seriousness and integrity and has been a great influence upon

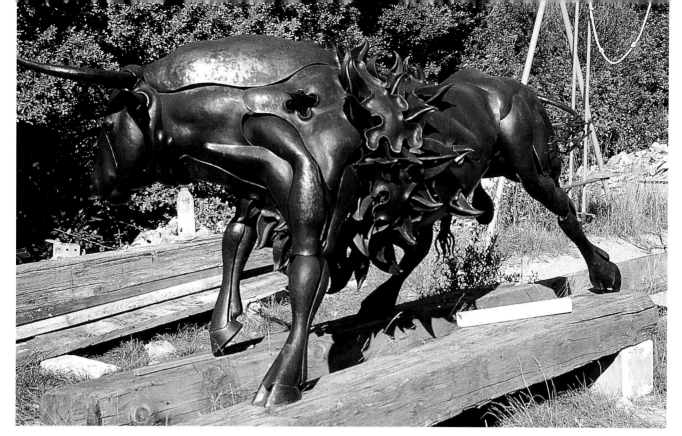

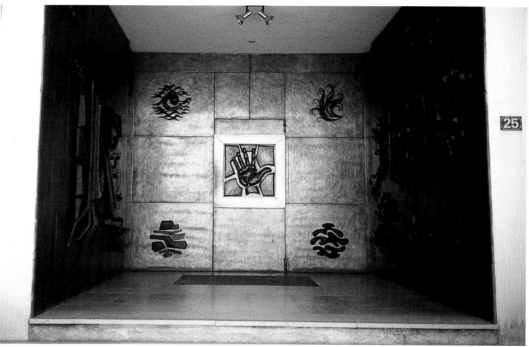

(*Top*) A full-sized forged steel bull sculpture by Serge Marchal, 1987, temporarily sited outside his workshop near Nîmes in southern France.
(*Above*) Fntrance feature depicting the four elements in bronze by Serge Marchal, Maison des Compagnons du Devoir, Angers, France.

trainees in the Compagnons, other blacksmiths and art blacksmithing in general.

The bullfighting tradition of Nîmes is represented by the full-sized bull sculpture which, when photographed, was located just outside his workshop in the hills near his home town.

Metalforging in the USA

Blacksmiths in the USA have been amongst the most influential and interesting of the past 25 years, especially in terms of promoting and working for a revival of art metalforging, but in a modern setting and idiom. The early development of ABANA (The Artist Blacksmiths' Association of North America) in 1972 via Alex Bealer and others, was pivotal in the development of a new spirit in blacksmithing in the UK. It is beyond the scope of this book to attempt a comprehensive survey of the hundreds of smiths and thousands of interesting pieces of work to be found in the USA, but a flavour is given by the examples shown. Some work by important makers Rick Smith of Carbondale, Illinois and Tom Joyce of New Mexico is featured earlier. They, like Albert Paley, are worthy of publications in their own right.

Frederick Crist and David Munn trade under the name of *Metalsmiths* in Waynsboro, Virginia, USA, and have produced some strong work, in a variety of styles and forms. Some of the most interesting involves working with steel, using techniques culled from joinery. Writing in *British Blacksmith* they note:

> Remember the old time in making the new, that is the reason for good blacksmithing. There is every reason for using traditional joinery methods in good forgework; it makes sense in the forms that come from slitting and drifting, and riveting and fullering, etc. They become a visual product of the design that relates to the process. The styles can be traditional or they can be abstract. The thrill for us is to find a way that they can be merged together to make a finer object.

These are sentiments that many modern smiths would share, in the sense of combining the old with the new in terms of style and technique.

James Wallace, who works at the US National Ornamental Metal Museum in Memphis Tennessee,

(*Far left*) Metalsmiths of Virginia, USA, detail of Burden IX 1990, forged steel.
(*Left*) Metalsmiths of Virginia, USA, detail of Burden VIII, 1990, forged steel piece exploring joint detail – photo by Metalsmiths.

OPPOSITE PAGE
(*Above*) Stair and balcony railings for a house in Memphis Tennessee by James Wallace, 1991, USA. Jim directs the National Ornamental Metal Museum in Memphis.
(*Below*) Forged steel balcony rail, Memphis, in an Art Nouveau influenced style by James Wallace, 1991 – photo by J. Wallace.

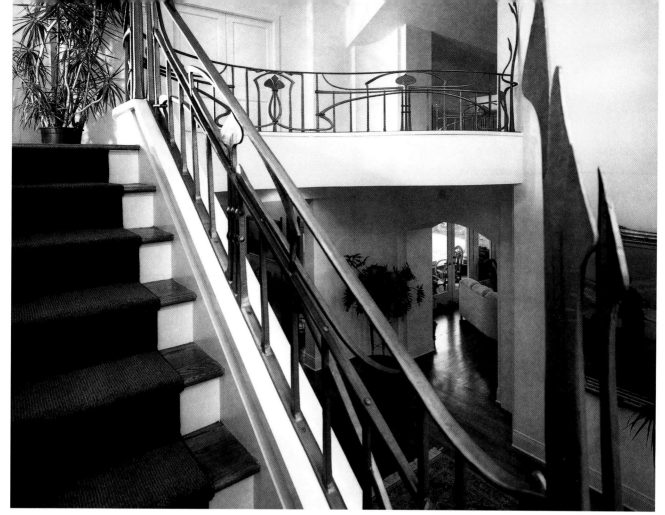

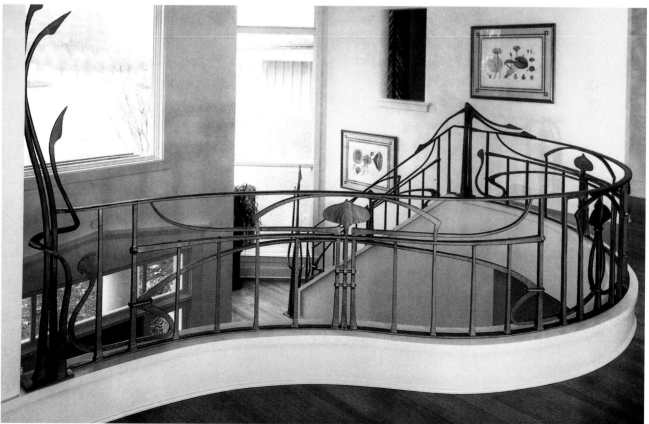

has produced an excellent balcony and stair railing in a style derived from Art Nouveau, and using joining methods from the traditional repertoire. However, it is clearly a modern piece in the scale and proportion, the design elements, the use of steel, and its power-hammered texture, with its roots in the work of Samuel Yellin of the USA and Fritz Kühn of Germany. An example, therefore of work in a modern idiom, drawing upon the best of work from the past, and doing so very successfully.

Albert Paley

Albert Paley has been the subject of numerous reviews in books, magazines and other media and is perhaps the best known of those working in the medium of forged metal anywhere in the world. Edward Lucie-Smith's book, *The Art of Albert Paley* (1996) discusses his work and is worth a look.

In a talk that Albert Paley gave at a V&A Symposium in October 1994, when the Museum unveiled the bench commissioned from him, he made a number of interesting points about the motivation and potential of his work; saying, 'Metal, I see not just as a material or as a technique but mainly as a process and a means of perception'. He noted that his training as a silversmith was influential in the development of his early forged work, in particular, the clarity of line. When he showed illustrations of work in which extensive and dramatic twisting was used he commented:

My initial response to iron was the aspect of plasticity upon heating – I built several machines to twist and bend iron, you can see this kind of reverse pattern being developed – actually I used this on the bench downstairs. As you know the twist is one of the most basic things to happen with iron, it has been used since the beginning of metal work, but I didn't use it for years because it was such a cliché. So I

thought I would try to take it to its total extreme, and you can see here the metal even starts to shear itself – these pieces are about 4in. (10 cm) diameter. They are reversed, they are cut, they are burnt, anything to create surface and texture.

He was also of the view that it was the advent of post-modern approaches in architecture, which had allowed ornament to be considered once again. In creating eight 30ft high sculptures for the Houston Opera House, which he thought had a very crystalline design construct, he used the theme of garlands and banners to act as a counterpoint, to humanise and create an air of festivity. In terms of the pedestrian they could be seen as tree-like structures, providing a sense of intimacy in what is otherwise a very large space. This humanising characteristic of ornament within the context of post-modern architecture has been important in the development of metalforging on both sides of the Atlantic.

Paley alluded to the appeal of hot worked metal:

The sense of movement and vitality that you get with the iron, the sense of movement yet at the same time it's latent, it is very interesting because I think that so much of the appeal of iron lies in paradox – you know it's hard, you know it's resistant and unyielding – yet at the same time emotionally you are experiencing something which is very ephemeral, very plastic and very emotional – this is an element that I think is incredibly intriguing with iron. Everyone thinks of iron as hard and structural yet I find it very sensual, very submissive – you can see in its play and the elegance of its form.

(*Opposite*) Early ironwork completed on a study visit to Manfred Bredohl's Vulkanschmiede in Aachen, Germany by Albert Paley.

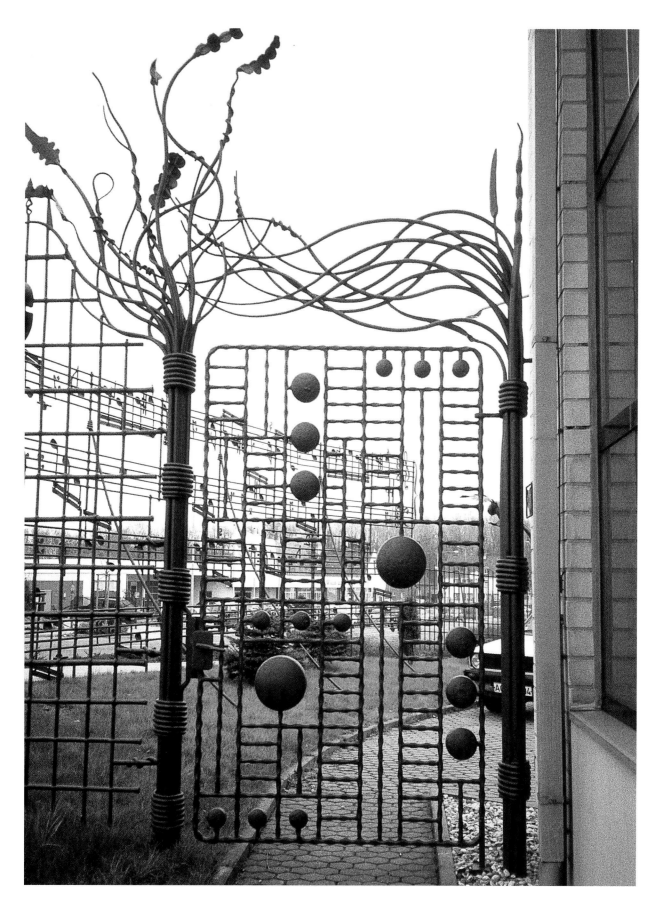

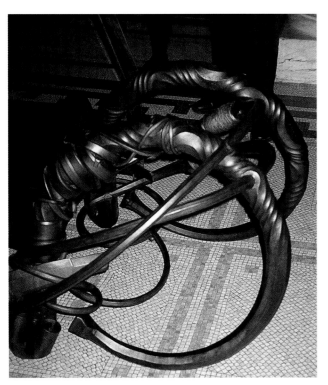

Detail of his bench for the Victoria and Albert Museum, London by Albert Paley, 1994, forged steel.

Having commented upon the special quality of forged steel, and the emotional attachment he has with the process of transforming metal shapes, it is clear that Paley is specially concerned with visual issues, and that steel is a vehicle for communicating them:

> At the time when you are forging a taper or a coil in space, your prime concern is the clarity of line and resolution of line and extension of line. Actually that same sensibility is the same as a drawing discipline and so a lot of these things are brought together. ...

Paley has influenced many students and others with his distinctive and adventurous work. He has kept ahead of his emulators by continuously developing and evolving his technical and visual language. Others look to the more subtle and smaller-scale work of those such as Tom Joyce and Rick Smith for inspiration.

Metalforging in Australia

Mike Petersen and Tracey Clement from Australia take very different approaches to the knife as a form. Bladesmithing is popular worldwide and in the USA in particular, where well-known exponents such as Don Fogg and Daryl Meier produce spectacular pattern-welded blades.

Mike Petersen

Mike works in an unusual way, in that he smelts his own steel from ironsand using charcoal, which he also produces. He uses hardwoods such as redgum, box and bush hickory as they make long-burning charcoal. The furnace for reducing the ironsand is made from locally produced bricks with high clay content. A typical working of the furnace uses about 60kg of ironsand and just over 250kg of charcoal and takes 13 hours to complete. The furnace is rectangular, 600mm long, 250mm wide and 1m high. It has a cast iron pipe inserted at an angle about one third of the way up from the bottom, and a large hole (stack) in the top where the material is fed in and from which fumes escape.

Charcoal is lit in the bottom and more fed in for several hours, setting the clay and preparing the bed for smelting. A forge blower is used as an air supply – although bellows can also work – producing a temperature of 1200 – 1400°C, capable of producing a spongy bloom. Charcoal and ironsand are fed alternately into the stack every 15 minutes or so. This

Pattern-welded steel knife by Mike Petersen – photo by M. Petersen.

Grain structure of steel made by Mike Petersen in Australia.

is kept up for an hour or so and the slag is tapped out from a hole near to the bottom. Mike finds that the larger the bloom produced, the greater the chance of obtaining one with the right amount of carbon, as well as enough softer steel. Then the final blend will produce a steel that is both hard and tough. The amount of carbon can vary from 1.2 to 0.5% or less. After about 13 hours, the blower is disconnected and the bloom allowed cooling for 20 hours or so.

When cool, the bloom is broken up and sorted for carbon content, after which it is forged and folded over repeatedly, to produce about 12,000 laminations, at which point it is a very uniform and high quality steel very appropriate for use as a knife blade. A specimen sent for analysis at the Grant Pearson consultancy company showed that the overall carbon content is about 0.75%, and composed of 85-90% medium to coarse pearlite

with 10-15% pro-eutectoid ferrite precipitated along the original austenite grain boundaries. Fewer laminations would be required if an etched decorative grain was desired, but the more uniform structure may make a better blade. Mike makes some very good, practical knives using the steel he makes in this way.

Tracey Clement

Tracey is an artist with a very different worldview, looking at the relationship we have with objects and, in particular, tools. Her curly stainless steel and ebony knife Impotence, with its cutting edge on the inside, invites a consideration of both the aesthetic and functional characteristics of knives and implements. She has produced double-bladed knives, and other compound objects such as spanners with multiple ends, and non-functional egg-beaters. Her work has been exhibited in the Centre for Contemporary Craft at the Customs House on Circular Key in Sydney, Australia. As Wendy Parker, curator of the implements exhibition in Sydney, 1998, commented:

> Implements of everyday life carry multiple codes.
> They speak of human lives and tasks undertaken,

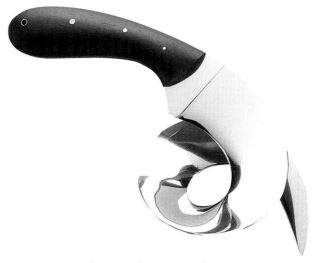

Impotence – knife object by Tracey Clement, Australia, 1998 – photo by T. Clement.

145

recalling experiences from the personal to the familial and extending often to symbolise community memory; those memories which are ascribed to a nation are often represented by such objects, the object in such case becomes a magical emblem, ritually described and potent.

This cultural value attached to tools says quite a lot about our relationship with the hand-made, and the tools we use to produce hand-made work – the hammer and the anvil in the blacksmith's case, the hammer and sickle in the case of communism. Many people collect tools, knives and other functional objects, and admire their functionality, design and history. Tracey's objects aid reflection on our relationship with tools and the products of tools.

Metalforging in Russia and Eastern Europe

The enormous changes in the more eastern parts of Europe and the countries of the former Soviet Union have meant that many more contacts and visits have been made between them and smiths in Western countries. This has highlighted both the depth of the talent in the east, and the depth of the economic difficulties with which the smiths are struggling. There is no doubt that conditions are difficult, but improving, and that two-way contacts have enriched the lives and work of all those involved.

Yori Kharlamov

Yori Kharlamov is a blacksmith and bladesmith from Tula in Russia, an area famous in earlier times for the quality of its decorative metalwork. The V&A has a rather nice polished steel fireplace from Tula amongst its ironwork collection, for example.

The economic climate is rather difficult at present for smiths in Russia, and the supply of information to them is rather limited. However, the standard of work can be high. David Petersen of Wales has spent a lot of time over the last few years working with smiths from St Petersburg, who have

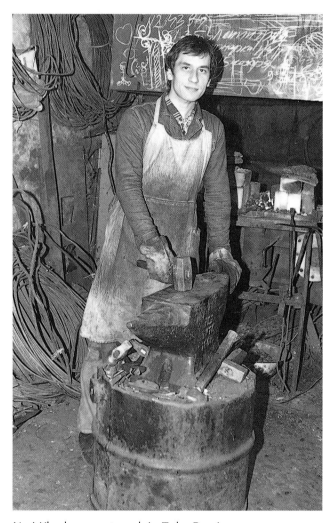

Yori Kharlamov, at work in Tula, Russia
– photo by Y. Kharlamov.

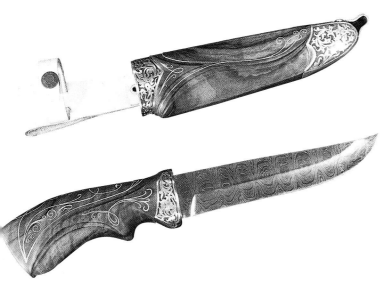

high levels of skill but few opportunities to exercise it.

Tula has a population of around 600,000, amongst which there are fewer than ten artist blacksmiths. In the last few years they have been attempting to revive the gunsmithing and blacksmithing traditions of the city. Yori has found that working with pattern-welded steel to produce decorative arms, such as the knife and the two swords illustrated, is more commercially successful than straightforward blacksmithing. Because of the economic climate, it is not possible to produce work for exhibitions – all work has to be sold as soon as it is made.

Heigo Jelle

There is a strong tradition of artistic metalwork amongst the countries of the former Eastern Block. Within the former Soviet Union itself, there have always been strong local traditions and pools of talent. Following independence, the Baltic states of Latvia and Estonia have made extensive contact with other European countries; Scandinavian countries were the

(*Top*) Pattern-welded knife by Yori Kharlamov, Tula Russia.
(*Centre*) Sword showing hilt detail with circular guard by Yori Kharlamov.
(*Bottom*) Sword hilt with inlay detail, by Yori Kharlamov – photos courtesy Y. Kharlamov.

(*Top left*) Forseshoe shaped brooches by Heigo Jelle, 1991, Estonia – photo by H. Jelle.

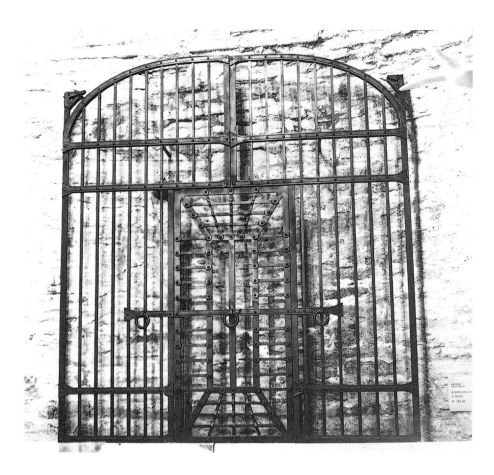

first to develop closer ties because of geographical proximity, but BABA has made very good progress. Even during the period of Soviet dominance, there was contact with smiths further east, especially with those in Germany and the former Czechoslovakia. Alfred, and Leopold Habermann, for example, have been important and influential contacts.

Heigo Jelle, a member of the Estonian Blacksmith's Union was born in 1963 and graduated from the Tallin Art University in 1986, having specialised in metal work.

The gate shown is 3.2m high and about 3m wide. The design of the gate shows respect to Northern architecture and has dragons heads as guards on the corner posts.

Jelle's smaller-scale work includes decorative brooches forged from steel. Historically these were mainly made from copper, bronze and silver. Other ornaments are of his own design and are shaped like wheels, ring-formed crosses or coin shapes.

(*Top*) Large gate – 3.2m x 3m, forged steel by Heigo Jelle, Estonia, 1991.
(*Above*) Circular ornamental pieces by Heigo Jelle, Estonia, 1991 – photos by H. Jelle.

Reading List

The publications in this list are divided into sections, but often contain information about other aspects of the subject. For example, books which are largely technical can have a lot of information on history, or business topics, and a number of the books contain technical, biographical, historical and other information. Especially useful, interesting, or important publications are noted with an asterisk.

TECHNICAL

Andrews, Jack: *Edge of the Anvil* (Rodale Press, Emmaus, PA, USA, 1977)*

Andrews, Jack: *New Edge of the Anvil, A Resource Book for the Blacksmith* (SkipJack Press, Ocean Pines, MD 21811, 1994)*

Bealer, Alex: *The Art of Blacksmithing* (Funk & Wagnalls New York, 1978)*

Cain, Tubal: *Hardening, Tempering and Heat Treatment* (Argus Books 1984)

Cathcart, W. H.: *The Value of Science in the Smithy and Forge* (Griffin, London 1921)

Countryside Agency: *Metals for Engineering Craftsmen* (Countryside Agency, London 1979)*

Countryside Agency: *Decorative Ironwork* (Countryside Agency, London 1973)*

Countryside Agency: *The Blacksmith's Craft* (Countryside Agency, London 1976)*

Countryside Agency: *Wrought Ironwork* (Countryside Agency, London 1974)*

Countryside Agency: *Catalogue of Drawings for Wrought Ironwork* (Countryside Agency, Salisbury 1979)

Countryside Agency: *Catalogue of Drawings: Wrought Ironwork Gates* (Countryside Agency, Salisbury 1991)

Harries, David: *The Blacksmithing Instructor's Guide* (Intermediate Technology Publications, London 1993)

Harries, David & Heer, Bernhard: *Basic Blacksmithing* (Intermediate Technology Publications 1993)

Lillico, J. W.: *Blacksmith's Manual Illustrated* (Countryside Agency, Salisbury, 1991)*

McCreight, Tim: *The Complete Metalsmith* (Davis, Worcester, Mass. 1991)

McRaven, Charles: *Country Blacksmithing, A Complete Step-by-step Guide to Working with Iron* (Harper Row, New York 1981)

Meilach, Donna Z.: *Iron Menagerie, Step by Step Instruction* (Guild of Metalsmiths. St. Paul, MN 1992)

Richardson, M. T.: *Practical Blacksmithing* (Crown Publishers, New York 1978)

Streeter, Donald: *Professional Smithing, Traditional Techniques for Decorative Ironwork* (Charles Scribner and Sons, New York 1980)

Tylecote, R. F.: *A History of Metallurgy*, 2nd Ed (Institute of Materials, London 1992)*

Untracht, Oppi: *Metal techniques for craftsmen* (Doubleday, New York 1968)*

Weygers, Alexander G.: *The Recycling, Use, and Repair of Tools* (Van Nostrand Reinhold, New York 1973)

Whitaker, Francis: *Blacksmith's Cookbook, The Recipes in Iron* (Jim Fleming Publications, Vail, CO 1986)

Young, D. W.: *The Practical Blacksmith, Comprising the Latest and Most Valuable Recipes for the Iron and Steel Worker* (U.B. Publishing House, Ohio 1896 – reprinted by Yonna Valley Forge, Bonanza Or.)

CRAFT HISTORY AND ISSUES

Amery, Colin, Ed: *Three centuries of Architectural Craftsmanship* (Architectural Press London 1977)

Ashwin, Clive: *Education for Crafts* (Crafts Council and Middlesex Polytechnic 1988)

Bolton, J. E.: *Report of the Committee of Inquiry on Small Firms* (HMSO, London, 21 September 1971)*

Brigden, Roy: *Agricultural Hand Tools* (Shire, Aylesbury 1983)

Briggs, Asa: *Ironbridge to Crystal Palace* (Thames and Hudson 1979)

Davis, J. P. S.: *Antique Garden Ornament* (Antique Collector's Club, Woodbridge, Suffolk, 1991)

Derrick, Freda: *Country Craftsmen* (Chapman & Hall, London 1945)

Dormer, Peter: *The Art of the Maker* (Thames and Hudson, London 1994)

Dormer, Peter: *The Meanings of Modern Design* (Thames and Hudson, London 1990)

Elinor, G. et al, Eds: *Women & Craft* (Virago, London 1987)

Frayling, Christopher: *The Crafts. Introduction: concepts of 'craftsmanship' since the War* (In: The Cambridge Cultural History of Britain, Volume 9, Modern Britain. Cambridge University Press 1992)

Gale, W. K. V.: *Ironworking* (Shire, Aylesbury 1981)

Harrod, Tanya: *The Crafts in Britain in the Twentieth Century* (Yale University Press 1999)*

Harrod, Tanya: *Contemporary Applied Arts* (Telos Art Publishing 1998)

Jekyll, Gertrude: *Garden Ornament* (Antique Collectors Club, Woodbridge 1982)*

Jencks, Charles: *Modern Movements in Architecture*, 2nd Ed (Penguin, Harmondsworth 1985)

Julier, Guy: *The Thames and Hudson Encyclopaedia of 20th Century Design and Designers* (Thames and Hudson 1993)

Kelley, D. W.: *Charcoal and Charcoal Burning* (Shire Publications (Shire Album #159) 1986)

Khan, N. & McAlister, S.: *Study and Work in the Crafts* (Crafts Council, London 1992)

Knott, C. A.: *Crafts in the 1990s* (Crafts Council, London 1994)

Leach, Bernard: *A Potters Book* (Faber & Faber, London 1940)

Lucie-Smith, Edward: *The Story of Craft the Craftsman's Role in Society* (Van Nostrand Reinhold, New York 1981)*

Margetts, Martina, Ed: *International Crafts* (Thames and Hudson, London 1991)

Pye, David: *The Nature and Aesthetics of Design* (Herbert Press, London 1983)*

Pye, David: *The Nature and Art of Workmanship* (Cambridge University Press, London 1978)

Read, Herbert: *Art and Industry* (Faber & Faber, London 1956)*

Rural Industries and Intelligence Bureau: *Leaflet No. 4: The Village Blacksmith and His Outlook* (HMSO 1924)*

Ruskin, J.: *Lecture V: the Work of Iron, in Nature, Art, and Policy. In: The Two Paths – being Lectures on Art and its Application to Decoration and Manufacture* (Wiley, New York 1889)*

Walker, John A.: *Design History and the History of Design* (Pluto, London 1989)

Williams, W. M.: *The Country Craftsman* (Dartington Hall Studies in Rural Sociology. Routledge and Kegan Paul, London 1958)*

Exhibition Catalogues

Anon: *Chillida* (Museum of Art, Carnegie Institute, 26.10 79-6.1.80. Pittsburgh International Series, 1979)

Anon: *David Smith 1906-1965* (Exhibition catalogue, Tate Gallery, 18.8. – 25.9.66. Arts Council of Great Britain, London, 1966)

BABA: *Fe: An Exploration of Iron Through The Senses* (exhibition catalogue – BABA Touring Exhibitions Ltd., 1994)*

Crafts Council: *Exhibition Catalogue: The Maker's Eye* (Crafts Council 1981)

Sotheby's: *Auction Catalogue: 20th Century Ironwork; Contemporary Metalwork designed and made by Members of the British Artist Blacksmiths Association* (Sotheby's 23 Sept. 1991)

V&A: *The Craftsman's Art* (V&A, London 1973)*

V&A: *Towards a New Iron Age* (V&A, London 1982)*

Articles from Periodicals

Anon: An Interview with Mr. Charles F. Annesley Voysey. *The Studio, 1,* 6, Sept. 1893

Anon: Artists as Craftsmen. *The Studio, 1,* 1, April 1893*

Anon: Rural Crafts, the smith comes back. *Architects' Journal,* Nov. 14, 1928

Bailey, Christopher: Progress and Preservation: The Role of Rural Industries in the Making of the Modern Image of the Countryside. *Journal of Design History,* 9, 1, 1996

Crosby, Theo: The New Iron Age. *British Blacksmith,* No. 49, Sept. 1988*

Dormer, Peter: Dyed in the Wool. *Crafts,* No. 69, August 1984

Dormer, Peter: Gate Debate. *Crafts,* Nov./Dec. 1993

Floud, Peter: The Crafts Then and Now. *The Studio,* April 1953

Fowler, Peter J.: The Nature of the Times Deceas'd. *Int. J. Heritage Studies 1,* 1, 1994

Frayling, C. & Snowdon, H.: Crafts – With or Without Arts? *Crafts* No. 55, March/April 1982

Frayling, C. & Snowdon, H.: Nostalgia isn't what it used to be. *Crafts* No.59, Dec. 1982*

Frayling, C. & Snowdon, H.: The Myth of the Happy Artisan. *Crafts* No. 54, Jan/Feb. 1982

Houston, John: Middle-class Art? *Crafts,* June 1989

Hughes, Richard: Towards a New Iron Age. *Crafts* Sept./Oct. 1982

Rathbone, R. Ll. B.: New Publications: Ironwork: From the earliest Times to the End of the Mediaeval Period. by J. Starkie Gardner. *The Studio 1,* 1, April 1893

Seling, Helmut: The Genesis of the Museum. *Architectural Review, 141,* 840, Feb. 1967

Smith, Ivan. & Pearce-Higgins, Caroline: An Experiment In Iron. *Crafts* November-December 1979

Strong, Sir Roy: Hooked on Heritage, *The Times,* London, 24 Sept. 1983. Also in *Crafts* No.66, Feb. 1984*

Tebbutt, Holly: Industry or Anti-Industry, *Crafts* May/June 1991.*

The Editor: From the privilege of the few to the habit of the many. *The Studio 104,* 475, October 1932

The Lay Figure: On the Responsibilities of the Craftsman. *The Studio 44,* 205, April 1910*

Yanagi, S.: The Unknown Craftsman. *Crafts* No.2. May/June 1973*

Biographies

Andrews, Jack: Samuel Yellin, Metalworker. *Anvil's Ring,* Summer 1982

Dunkerley, S.: *Robert Bakewell Artist Blacksmith* (Scarthin Books, Cromford 1988)*

Edwards, Ifor: *Davies Brothers Gatesmiths* (Welsh Arts Council/Crafts Advisory Committee, Cardiff 1977)

Goad, T. W.: *'My Valley' The Story of Jonty Wilson The Blacksmith of Kirkby Lonsdale* (T. W. Goad, Kirkby Lonsdale 1993)

Kahr, Joan: *Edgar Brandt: Master of Art Deco Ironwork* (Harry N Abrams, 1999)*

Lucie-Smith, Edward & Paley, Albert: *The Art of Albert Paley:Iron, Bronze, Steel* (Harry N Abrams 1996)*

Books about Blacksmithing

Architect and Building News: *Wrought Iron Railings, Doors and Gates* (Architects Detail Library, Volume I. Illife Books, London, 1964)

Ayrton, M. & Silcock, A.: *Wrought Iron and its Decorative Uses* (Country Life 1929)

Bailey, Jocelyn: *The Village Blacksmith* (Shire Aylesbury 1977)

Baur-Heinhold, Margarete: *Decorative Ironwork: Wrought Iron Latticework, Gates and Railings* (Schiffer Publishing Ltd. 1996)

Belanger Grafton, Carol: *Treasury of Ironwork Designs* (Dover, New York 1992)

Bredohl, Manfred: *Die Zauberschmiede des Voodoo* (Vulkanschmiede, Aachen 1986)

Campbell, Marian: *Ironwork* (V&A, London 1985)

Campbell, Marian: *Decorative Ironwork* (V&A, London 1997)*

Chatwin, Amina: *Cheltenham's Ornamental Ironwork* (A. Chatwin, Cheltenham 1974)

Chatwin, Amina: *Into the New Iron Age: Modern British Blacksmiths* (Coach House Publishing, Cheltenham 1995)*

Clouzot, Henri: *Art Deco Decorative Ironwork* (Dover Publications 1997)

Cope, Dorothy: *The Scythemen of Belbroughton* (Belbroughton Historical Society 1988)

Coote, Jeremy: *African Metalwork* (Crafts Council 1995)

D'Allemagne, Henry René: *Decorative Antique Ironwork a Pictorial Treasury (1924 catalogue of the museum of Le Secq des Tournelles, Rouen)* (Dover, New York, 1968) Durenne, Eugene-Antoine, et al: *Ornamental Ironwork: 670 illustrations* (Dover Publications 1998)*

Eudes, George: *Ferronnerie Rustique et de Style* (Librarie Centrale Des Beaux-Arts, Paris 1986)

Faure, Philippe: *La Ferronnerie D'Art Dans L'Architecture Des Origines A Nos Jours, Tome 4, 1895-1981* (CNDP CRDP, Dijon 1981)*

Gedded, Jane: *Medieval Decorative Ironwork in England* (Society of Antiquaries of London, 1999)

Geerlings, G. K.: *Wrought Iron in Architecture* (Bonanza 1957, Dover 1983)

Gentle, R. & Feild, R.: *Domestic Metalwork 1640-1820* (Antique Collectors Club, Woodbridge 1994)

Harris, John: *English Decorative ironwork from Contemporary Source Books 1610-1836* (Alec Tiranti, 1960)

Hoffmann, Gretl & Maurach, Jürgen, Ed: *Schmiedearbeiten Von Heute* (Hoffmann, Stuttgart 1986)

Hollister-Short, G. J.: *Discovering Wrought Iron* (Shire, Tring 1970)

Holstrom, John Gustaf and Henry Holford: *American Blacksmithing and Twentieth Century Toolsmith…*(Distributed by Crown Publishers Inc., New York 1982)

Hubert, Christian, Ed.: *La Ferronerie* (Metiers d'Art, No.18/19, April 1982)

Kapp, Leon., et al: *The Craft of the Japanese Sword* (Kodansha Europe 1987)*

Kühn, Fritz: *Decorative Work in Wrought Iron and Other Metals* (Harrap, London 1967)

Kühn, Fritz: *Wrought Iron* (Harrap, London 1965)*

Lister, Raymond: *The Craftsman in Metal* (G. Bell & Sons, London 1966)

Lister, Raymond: *Decorative Wrought Ironwork in Great Britain* (David & Charles, Newton Abbot 1970)

Mandel, Gabriele: *Wrought Iron* (Magna Books, Wigston 1990)

McNaughton, P. R.: *Mande Blacksmiths* (Indiana University Press 1993)

Meilach, Donna Z.: *Decorative & Sculptural Ironwork* (Schiffer Publishing 1999)*

Menten, Theodore: *Art Nouveau Decorative Ironwork* (Dover, New York 1981)

Moore, C. & Marshall, R. I.: *Steelmaking* (Institute of Metals, London 1991)

NBCC: *Handbook for Judges, Stewards & Exhibitors in Wrought Ironwork Competitions* (NBCC, Exeter 1993)

Poston, David: *The Blacksmith and the Farmer* (Intermediate Technology Publications, London 1994)

Schiffer, Herbert, Peter and Nancy: *Antique Iron, Survey of American and English Forms* (Schiffer Publishing Co. 1979)

Schmirler, Otto: *The Art of Wrought Metalwork for House and Garden* (Harrap, London 1980)

Schmirler, Otto: *Wrought Iron Artistry* (Ernst Wasmuth Verlag GmbH & Co. 1984)

Seymour Lindsay, J.: *Iron and Brass Implements of the English House* (Alec Tiranti, London 1964)

Starkie Gardner, J.: *English Ironwork of the 17th and 18th Centuries* (B T Batsford, London 1911)

Starkie Gardner, J.: *Ironwork Part 1 from the earliest times to the end of the mediaeval period* (V&A, London 1927)

Starkie Gardner, J.: *Ironwork Part II Continental Ironwork of the Renaissance and Later Periods* (V&A, London, 1930)

Starkie Gardner, J.: *Ironwork Part III the Artistic Working of Iron in Great Britain From The Earliest Times* (V&A, London 1922)

Stevenson, J. A. R.: *The Din of the Smithy* (Cambridge University Press, London, 1936)**

Tuckett, Angela: *The Blacksmiths' History – what smithy workers gave trade unionism* (Lawrence and Wishart Ltd., Swindon 1974)*

Waite, Diana S.: *Ornamental Ironwork* (Mount Ida Press, New York 1990)

Waltz, Klaus, et al. Ed: *Kunstschmieden. Metallgestantung in Baden-Würtemburg* (Charles Coleman Verlag, Lübeck, Germany 1987)

Waltz, Klaus. Ed: *Zeitgemste Kunstschmiedearbeiten und Skulpturen* (Internationale Ausstellung in Friedrichshafen 4.7.87 – 6.9.87. Fachverband Metall Baden-Württemburg, Stuttgart 1987)*

Watson, Aldren A.: *The Blacksmith, Ironworker and Farrier* (W. W. Norton, New York and London 1968, 1977, 1990)

Weygers, Alexander G.: *The Modern Blacksmith* (Van Nostrand Reinhold, New York 1974)

Zimelli, U. & Vergerio, G.: *Decorative Ironwork* (Cassell, London 1987)

Useful Information

Organisations

ABANA – Artist-Blacksmith's Association of North America, P.O. Box 206, Washington, MO 63090 *www.abana.org*

American Bladesmith Society, P.O. Box 977, Peralta, New Mexico 87042

American Craft Council, 72 Spring Street, New York, New York 10012 212-274-0630 Fax 212-274-0650

Australian Blacksmiths Association, RMB 1155 Tongala, Victoria; Australia 3621 03-58-590736 – (alt) 03-58-521728 email: *wake@river.net.com.au*

British Artist-Blacksmiths Association: *http://www.baba.org.uk/*

California Blacksmiths Association P.O. Box 438, Mokelumne Hill, CA 95245 530-666-7541 650-323-1002

Compagnons du Devoir – France

Crafts Council – UK

French Guild Of Bladesmiths: *http://www.multimania.com/couteliers/english/*

http://www.metalsmith.org Guild of Metalsmiths

http://www.Angele.de/ifgs International Assoc. of Designing Artist Blacksmiths

http://www.wild.net/~lama Louisiana Metalsmiths' Assn.

http://wuarchive.wustl.edu/edu/arts/metal/News/BAM.html Blacksmith Association of Missouri

NOMMA (National Ornamental and Miscellaneous Metals Assoc.) 804-10 Main Street, Suite E, Forest Park, Georgia 30050, Phone 404-363-4009 Fax 404-366-1852

Suppliers of materials

Atlas Metal Sales – Blacksmith Materials, 1401 Umatilla Street, Denver, CO 80204 Phone: (800) 662-0143 (303) 623-0143

Atlantic Steel Corporation 35-27 36th Street, Astoria, NY 11106 718-729-4800 718-937-2411 fax (tool steel)

Bayshore Metals, Inc. P.O.Box 882003, San Francisco, CA 94188-2003 415-647-7981 or 800-533-2493

http://www.dfoggknives.com/ Don Fogg knives, supplies, resource site.

42 PRODUCTS – Miscellaneous Blacksmith Materials, P.O. Box 1081 Scottsbluff, NE 69363 Frank Rogers e-mail:*eed@ricochet.net*

Meier Steel – Custom mfg. clad & pattern welded steel *ad/dms.htmad/dms.htm* 75 Forge Rd., Carbondale, Ill. 62901 618-549-3234 Fax 618-549-62 Daryl Meier e-mail:*darylmeier@aol.com* Web Page:*www.meiersteel.com*

Online Metals http://www.onlinemetals.com/

The Real Wrought Iron Company – supplier of genuine wrought iron, Lyndhurst, Carlton Husthwaite, Thirsk, North Yorkshire city, United Kingdom YO7 2BJ +44(0)1845 501415 Fax: +44(0)1845 501072 email: *c.topp@daelnet.co.uk* *buyersguide.co.uk/document/chris_topp/*

Saturn Technology (titanium and titanium alloys, nickel based alloys and tool steel alloys)
Contact: Larisa Vasyakina at *Placogroup@mtu-net.ru*
Phone: + 7 095 150 3559, Fax: + 7 095 150 3762
Address: 7 floor, 5 th Voykovsky pr.28, Moscow, Russia, 125171

Suppliers of equipment

Amsterdam Blacksmith Supply 185 Amsterdam Road New Holland, PA 17557 717-354-3186 (blacksmiths' supplies)

AP Tool Company 201 Porter Road Conroe, TX 77301 409-756-5477 (anvils, anvil stamps, forges, tools)

Armstrong Bros. Tool Company 5200 West Armstrong Avenue Chicago, IL 60646 312-763-3333 (blacksmiths' supplies)

Australian Blacksmith Supplies – Old, New & Reconditioned, 6 Quinlan Ave, St Marys, South Australia 5042 Phone: (08) 8277 0500 e-mail info@blacksmithsupplies.com.au Url: *http://www.blacksmithsupplies.com.au*

Bull Hammer – powerhammers
http://www.bullhammer.com/

Centaur Forge Ltd.- Blacksmiths tools, equipment, books, tapes, 117 N. Spring St., Burlingon, WI 53105-0340 414-763-9175 *Http://www.centaurforge.com/*

Edwards Co.- Metalworking shears, 100-T James St.; P.O. Box 37, Wales, WI 53183-0037 414-968-3393

Forge & Anvil Metal Studio – Blacksmith Tools & Supplies, 30 King Street, St. Jacobs, Ontario N0B 2N0; Canada Phone: 519-664-3622 Fax: 519-664-1828

Forge & Anvil Metal Studio 30 King Street St. Jacobs, Ontario Canada N0B 2N0 519-664-3622 (blacksmith supplies)

Glendale Forge Monk Street, Thaxted, Essex, England Telephone: Thaxted (0371) 830466 (wide range of anvils and blacksmith tools) *http://www.armoury.demon.co.uk/glendale* Glendale Forge Tools

Custom Hardware, Inc.– New air hammers, anvils, hammers, tongs 100 Daniel Ridge Road, Candler, NC 28715-9434 828-667-8868 828-665-1988 *ad/kas/kas.htmad/kas/kas.htm* e-mail *kaynehdwe@ioa.com* Web Page: *www.kayneandson.com*

HandiLinks to Machinery & Machine Tools
 http://www.ahandyguide.com/cat1/m/m222.htm
Lehman Inc.- Shears; Bantom Ironworker, P.O. Box 578, Dept T,
 Mineral Wells, TX 76067 940-325-7806
Modern Machine Shop, *http://www.mmsonline.com/*
Sahinler Air Hammers; US dealer, *http://www.powerhammers.com/*
Smithy Co. *http://www.smithyco.com/*
Taiwanese Metalworking Machine Suppliers
 http://www.wwstaiwam.com/wws-new/o2/index.htm Taiwanese
 Metalworking Machine Suppliers

Education, museums and historical information

John C. Campbell Folk School – Craft school, many blacksmith courses,
 One Folk School Road, Brasstown, NC 28902 800-365-5724 828-
 837-2775
National Ornamental Metal Museum, Memphis, Tennessee
 901-774-6380
University of Georgia Center for Continuing Education, 1197 S.
 Lumpkin Street Athens, Georgia 30602-3603 Fax: (706) 542-5990
 http://www.gactr.uga.edu/index.html
Herefordshire College of Arts and Technology
University of Hertfordshire The BLUEPRINT project is run by the IDER
 group in the Manufacturing Systems Engineering Centre.
 http://www.ider.herts.ac.uk/school/
http://www.swissarts.org/coffrets/teil1.htm Musée historique de Lausanne
Sherbrooke Village Blacksmith Shop
 http://www.ednet.ns.ca/edec/museum/sv/blaksmth.htm
Fort Steele Forge Museum (British Columbia, Canada)
 http://www.fortsteele.bc.ca/
'The Wonderful World of Casting' from Metalbot
 http://www.metalbot.com/cast.html
Finishing.com (metal finishes)
 http://www.finishing.com/ Metal finishes – resource site.
Musée Le Secq Des Tounelles, Rouen, France.
Peat Oberon's School of Blacksmithing
Plymouth University, Exeter School of Arts and Design, Earl Richards
 Rd North, Exeter, Devon, EX2 6AS; Tel. O1392 475022
 http://www.plymouth.ac.uk/
Staffordshire University, An Engineering Design Information Network.
 http://www.staffs.ac.uk/
TWI's Job Knowledge for Welders
 http://www.twi.co.uk/bestprac/jobknol/jobknol.html
The Victoria and Albert Museum, Kensington, London
West Dean College…

Magazines and publications

http://www.anvilmag.com Anvil Magazine
Blacksmith's Gazette-Monthly newspaper for blacksmiths, 950 S. Falcon
 Road Camano Island, WA 98292 360-387-0349
Blacksmith's Journal- Monthly publication, tools, tech, design, 300
 Cedar St., P.O.Box 193, Washington, MO 63090 314-239-7049
 http://www.blacksmithsjournal.com
Anvil's Ring – from ABANA
Artist Blacksmith – from BABA
Hephaistos

Website addresses

The Blacksmith's Ring
http://nar.webring.org/cgi-bin/narcgi?ring=smithing;home
http://www.gactr.uga.edu/Forge/index.html Forge & Anvil PBS TV Show
http://www.seanet.com/~neilwin Virtual Junkyard for Blacksmiths
http://www.celticknot.com/elektric/anvil.html Elektric Anvil Blacksmith's
 Compendium
http://www.firesong.com FireSong Forge
http://forging-ahead.co.uk Paul Margetts Photos of Art in Iron
http://www.webpak.net/~rreil/theforge/scrapbook.htm Ron Reill's the Forge
 Scrapbook
http://ldl.net/~myzr/myzr.htm Jack Yates Home Page
http://www.spanishlake.com Spanish Lake Blacksmith Shop
http://www.csn.net/metal Metal Machining & Fabrication Directory
http://www.crucibleservice.com/cruheat.htm Heat Treatment of Steels
http://www.anvilfire.com Anvilfire
http://wuarchive.wustl.edu/edu/arts/metal/ Art Metal Project
http://www.nets.com/bsmithplaza/ La Plaza del Herrero
http://home.t-online.de/home/H.Klein-schlosserei/ Herbert Klein, Murr
http://www.wite.de/berlin/peikert/ Bau- und Kunstschlosserei Peikert, Berlin
http://www.handwerker-online.de/hoeffl-metall.html H…FFL GMBH
 STAHLBAU UND METALLBAU, Mannheim
http://www.village-blacksmith.com Mountain Village Blacksmith Shop

Index